The Alaskan Art of Charles Gause

Table of Contents

Production: Todd Communications
Typesetting: Computer Composition
Editor: Patricia Linton
Printed in Korea

Publisher of Charles Gause prints:

Stephan Fine Art Galleries
600 West 6th Avenue, Anchorage, AK 99501
907-278-9555 Toll Free 800-544-0779

Library of Congress Cataloging in publication data
Gause, Charles
Library of Congress Pre-assigned Card Number: 90-71773

First Edition

ISBN 1-878100-50-5

Book Published by:
Stephan Fine Arts, Inc. Publishers of Fine Art
600 West 6th Avenue
Anchorage, AK 99501
907-278-9555 or 800-544-0779

Front Cover: "Night on the Trapline" watercolor
Back Cover: "Roaming Free" watercolor

This book is dedicated to all those who believed in me and encouraged me to draw and paint, and especially my Lord Jesus, the giver of all good and perfect gifts.

Foreword

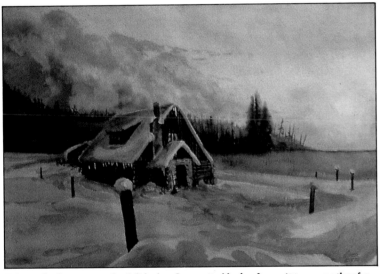

"This is the first watercolor I did when I came to Alaska. I gave it to my mother for her birthday. She still displays it proudly in her home."
— *Charles Gause*

One of the most frequent comments heard after a collector meets Charles Gause is "I thought he'd be an older man." Most people feel talent such as his must come from decades of experience. With Charles Gause, the ability to tell a story with a brush comes from God-given talent to communicate and share his experiences and dreams. His paintings say a thousand words. Gause has made his dream and his visions of the Alaska he knows available to us. We can be a part of his story or incorporate his into our own when we collect his work.

Painting Alaska — be it a lifestyle, a dream, a freedom, but definitely a pioneer spirit — is portrayed through the brush of Charles Gause as he sees and experiences it.

Dawn Kelly — Gallery Director, Stephan Fine Arts, Inc.

Statement from the Publisher

We first met a young artist in 1978 who had the rare ability to tell a story with a brush. Although he did not have formal art training, it was obvious that a special talent was awaiting the opportunity to be presented to the public. From the very first painting displayed at Stephan Fine Arts, it was clear Charles Gause would become a "People's Choice" artist. The comment heard most often when someone stops to admire a work by Charles Gause is that "it looks just like a place I have been . . . or seen."

Charles has a unique way of capturing a mood with his brush. It's the way he paints the light bathing a mountain or the incredible sunset that lasted only a few minutes. Those fleeting moments when a gigantic rainbow or fabulous Northern Lights whisked across the sky and you wish you had your camera at hand to capture its essence. Indeed, emotions are stirred when viewing a Charles Gause painting.

We have the privilege of working with Charles on a regular basis as we select and review ideas for upcoming prints, titles for paintings, special projects such as Iditarod and Fur Rendezvous programs, and this book. We feel like children at Christmas every time Charles brings a finished work to us for review. Each painting is better than the last.

Charles is dedicated to authenticity. He is constantly striving for additional knowledge of the Alaskan lifestyle and habitat. He meticulously researches historical details before he paints scenes from an earlier time. We have a tremendous amount of respect for Charles. His blend of creativity, craftsmanship, integrity and genuine regard for humankind and the total of God's creation make him a unique individual and exceptional friend.

We felt it important that the work of an artist of Charles Gause's caliber be chronicled and this is when the idea for this book was born. This volume represents a collection of all the limited edition signed and numbered prints published and distributed by Stephan Fine Arts up to the date of publication. The majority of the originals used for production of these limited edition prints remain in the personal collection of gallery owners Patrick and Pamela Stephan. The balance of this text contains a portrayal of posters and in conclusion a sampling of original works painted between the years 1978 and 1990. These originals were graciously provided by various avid collectors of Gause. We trust that this book will become a valued and unique addition to the collection of each of his devotees.

It is with much excitement and anticipation that we look toward the years ahead. Charles' wealth of talent promises to keep us all enthralled and eager to see "what is next."

Our best regards to Charles, his lovely wife Joyce, and their beautiful family.

Patrick J. Stephan
President, Stephan Fine Arts

Dawn M. Kelly
Vice President, Stephan Fine Arts

About the Artist *by Patricia Linton*

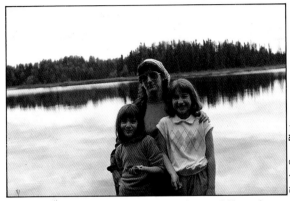

Artist's wife Joyce, and daughters Charlene and Christel. They hiked in about 10 miles to Red Shirt Lake to fish and take pictures.

One of the most striking characteristics of the art of Charles Gause is its strong narrative element — the sense it creates of a story which extends beyond the frame.

Viewers think about what brought the figures in a scene — whether animal or human — to that spot and they reflect on what will happen next. This narrative impulse is evident in several themes which recur in Gause's work. One revolves around myths of Alaska's past. In a series of paintings a single figure reappears, a Sourdough prospector or trapper. Gause comments that this character is drawn from the Alaska of the imagination, the Alaska of song and legend, the Alaska of lonely cabins, isolated caches, solitary treks, man and dog against the wilderness. Interestingly, this Jack London Alaska, which is now and maybe always was mostly fiction, is linked with a contemporary drama which is very real. The development of the sport of dog mushing has given that legend of Alaska new substance and has given women a new place in it. Gause has recorded in his art modern dog teams as well as mythic ones, particularly those of Libby Riddles and Susan Butcher, the first two women to win the Iditarod Race. In still other scenes, like "No Turning Back," the mushers and their teams are associated neither with past nor present, but symbolize the interplay of caution and confidence, self-reliance and interdependence, which is timeless.

Charles Gause with a 38 lb. King Salmon on the Kenai River in 1987.

5

The narrative force of Gause's work is felt in a different way in his depiction of wildlife. The drama of life and death, so much a part of the unsentimental natural world, is represented in many scenes, such as "Meal in Sight," "Night Hunters," "Pursuit," and "Watching and Waiting." Even in paintings such as "Narrow Ascent," where no confrontation is implied, a viewer's awareness of the drama of nature is sharp. Gause portrays animals in motion, or still but alert, suggesting a tale of the quest for food which dominates life in the wild. Finally, territoriality is a dramatic theme which is

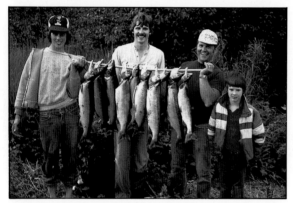

With the artist, to his right, is his younger brother Rick and to the left his father, Paul Gause, and son Jon, on a very successful trip for red salmon in 1980.

central to many works, like "The Challenge" and "Territorial Trouble," and implied in others, like "Two Kings."

Art and interest in nature have preoccupied Gause for as long as he can remember. He grew up in Yakima, Washington, where his family encouraged his drawing and painting from an early age. He remembers his grandmother showing him a sketch by one of his uncles (now a math professor) which inspired him to draw when he was quite young. Another formative experience occurred when he was in the second grade. The young Gause made an egg shell mosaic of a Texas longhorn bull. The artist remembers that the teacher was so impressed that she took it down the hall to show to others, the last he ever saw of it. "But I realized that people appreciated my

art." He started doing cartoons, big bulletin boards, and murals in tempera, getting out of other classes to work on them. Throughout his early years, Gause continued to sketch animals, and viewers continued to respond to his work. In fact, paintings done in high school were stolen from the walls of the art display at the state fair.

Gause also had an early interest in learning principles of design.

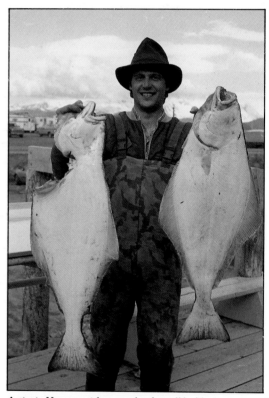

Artist in Homer, with a couple of small halibut.

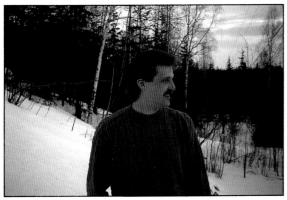
This was taken in artist's back yard in January 1990.

Following high school, he spent a year at Yakima Valley Community College, studying drawing, design, and art history. He remembers with mixed feelings his instructors' efforts to channel his interests toward modern rather than traditional, representational art. Looking back, however, from the vantage point of a successful artist, he comments, "Few people can pursue that type of art as a full-time career. There are more collectors of representational art than modern, especially in America."

In 1975, at the age of 19, Gause made a decision which was to prove as central to his art as his longtime interest in animals — he moved to Alaska. Originally intending to stay only long enough to earn money for art school, he lived in Fairbanks for about six months, then moved to Franklin Bluffs on Alaska's North Slope, where he took part in the construction of the trans-Alaska oil pipeline. To a young artist who was already interested in recording nature and wildlife, exposure to the wilds was an unrivaled opportunity. Scenes from the northernmost reaches of the Alaska Bush are still imprinted on his consciousness and influence his work.

Even during the period when he worked on the pipeline, Gause was unable to suppress his artistic urges. Using a vibrating, hard-to-control tool from Sears he made engravings on hard hats and scraps of pipeline steel. Finding discarded fragments, he would burn off the paint and polish them to a mirror finish, then engrave images of wildlife on the pieces, which were avidly collected by his supervisors and co-workers.

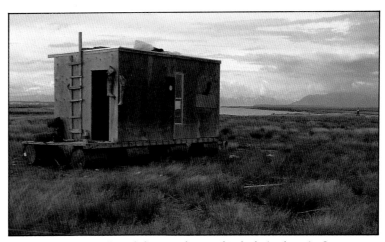
This is one of Charles Gause's favorite places — his duck shack on the Susitna River. Many good paintings have been inspired there.

7

Since the age of 21, Gause has supported himself through his art. At first, he says he was painting to survive — to put food on the table. "Every artist who paints for a living has to battle bread and butter issues versus the impulse to paint for his own interest. Now a measure of success has freed me to let nothing out of my studio that doesn't excite me. I'm an incurable fiddler. Sometimes I'll abandon something, and then find I have to go back to it.

Artist giving watercolor demonstration at Stephan Fine Arts Gallery.

It's hard to stop because the amount of detail you can put in is almost limitless. I want my paintings to seize the viewer's interest from across the room, but to intrigue a viewer up close too. I want to show the hairs inside the ear."

Now married, with two young daughters and an older son who has already left home, Gause's family life, as well as his professional life, revolves around art. His wife, Joyce, is also an artist, also working in watercolor. Both daughters show an early aptitude for drawing; his daughter Christel both paints and writes poetry.

Gause spends much time preparing for his painting, collecting Alaskan scenes and images and researching the information necessary for the accurate depiction of wildlife. He finds himself looking through reference books to learn about anatomical details like the patterns of leathery skin on an eagle's foot. He makes photo studies in winter and thumbnail sketches in summer, sometimes pausing while driving to make note of an arrangement and to record colors. His attention to direct observation offers some insight into the motivation behind his art: "I am inspired by what I see, rather than what I imagine."

Charles Gause stresses in his life and in his art a spiritual dimension which lies at the heart of his view of reality. He credits his Christian faith with bringing to his life a sense of direction which it had previously lacked. He emphasizes that religious conviction is central to his whole art, central to what he chooses to paint and how

Artist in Eagle River Valley, Fall 1990.

he paints it. "Now I understand that only one thing is original and everything else is imitation. Belief in the Creator of all that I see helps me to see design in the world and to desire to imitate it." Summing up his sense of commitment, he says, "I try to capture certain moments, brief frames of eternity, when everything is right."

Limited Edition Prints

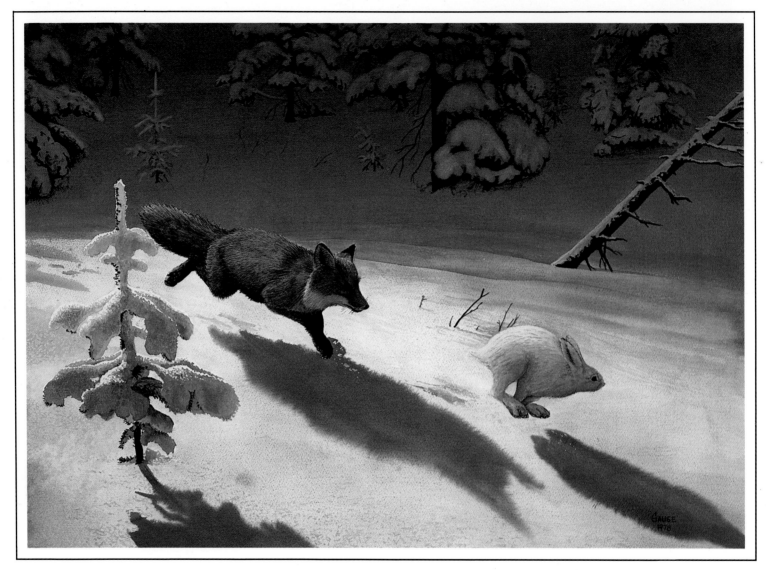

"Pursuit"

Artist's Comments: My first home in Anchorage had a greenbelt behind it. In the winter there were always rabbit tracks. I would spend time wondering what they were all running from; thus the inspiration for "Pursuit." I hoped the piece would draw viewers into the picture and let them imagine the ending for the story. Did the rabbit outrun the fox or did the fox get the rabbit? For this picture, I built clay models of a rabbit and a fox and suspended them over white paper to get the shadow on the snow right. This was my very first limited edition print.

Edition Size: 300 signed and numbered
Release Date: 1978
Published from an original watercolor

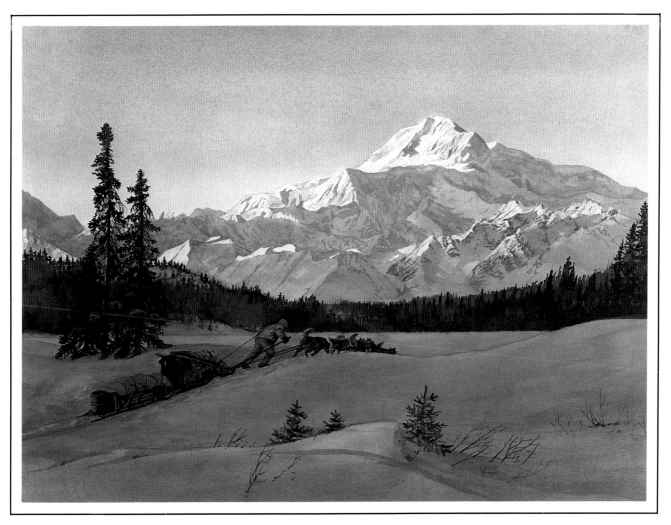

Heading Home – Mt. McKinley

Artist's Comments: In the old days when dog teams were used for transportation it was easier to make supply runs in the winter because rivers and lakes were frozen and easy to travel. This trapper lives at the base of Mt. McKinley and is returning with two freight sleds of supplies. Because the load is so great, he is helping his dogs with the load over the hill.

Edition Size: 300 signed and numbered
Release Date: 1979
Published from an original watercolor

11

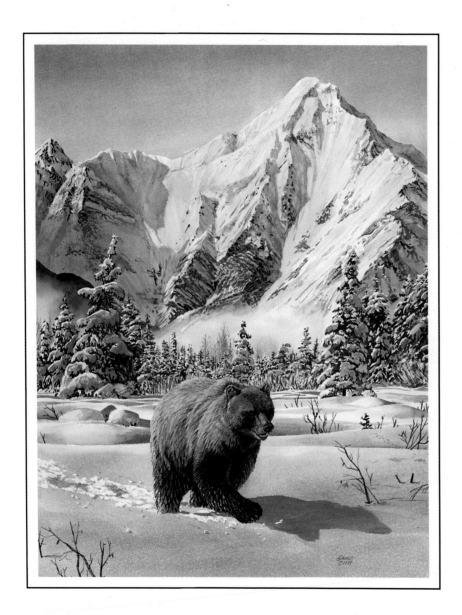

"Grizzly Winter"

Artist's Comments: I read an article once by a Native writer which said that when you meet a grizzly bear in the winter, it's the worst time. If it is early winter, the bear probably didn't have enough food to sustain himself through the winter months; and if he is out and about early in the spring, he still didn't have enough to eat. Either way, he is in a bad mood. This is my version of a winter grizzly encounter. I hoped to capture his aggressiveness, contrasted with the tranquility of a sunny winter day.

Edition Size: 300 signed and numbered
Release Date: 1979
Published from an original watercolor

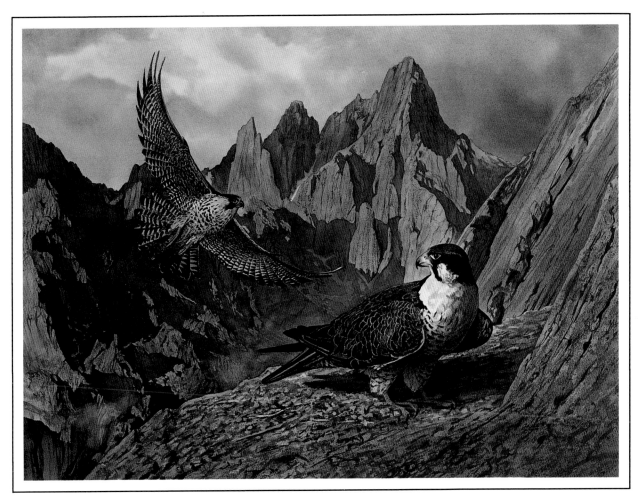

"Falcon's Flight"

Artist's Comments: A neighbor and pilot friend of mine, Lee McElhaney, took me on a flight-seeing and photo shoot in the Denali National Park area. We flew around Ruth Glacier and viewed many of the peaks in the foothills of McKinley. This flight provided me with the inspiration for the background in "Falcon's Flight." I remember thinking, as we were flying by the rugged areas called Cathedral Spires, what an inhospitable place to carve out a life and that it would be a good setting for Peregrine Falcons. Since I have always been fascinated by birds of prey and falcons in particular for their speed, I decided to paint this male and female pair in the area I saw around McKinley.

Edition Size: 300 signed and numbered
Release Date: 1979
Published from an original watercolor

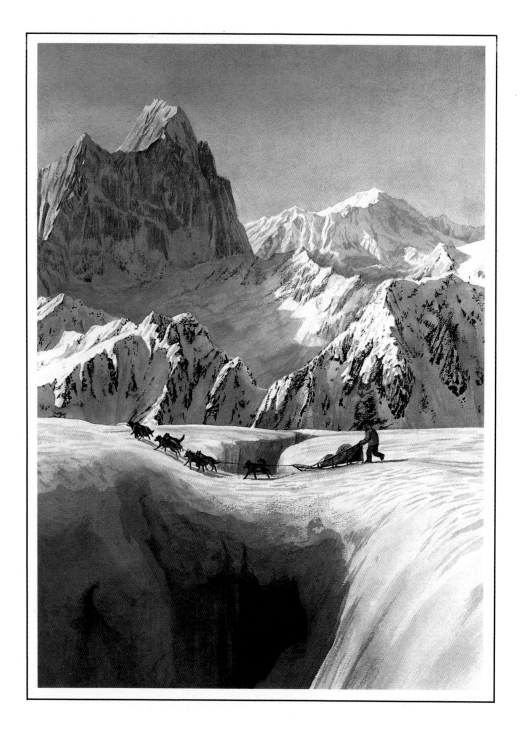

"No Turning Back"

Artist's Comments: In this painting, I wanted to leave the viewer with a sense of tension. I saw a photo that inspired the scene. The snow blows across these crevasses and forms bridges. Once the musher starts across, he's got to trust his dogs to be able to pull him out. To heighten the dramatic effect, the crevasse has no visible bottom. The title also has the double meaning of the way I view my Christian faith.

Edition Size: 300 signed and numbered
Release Date: 1979
Published from an original watercolor

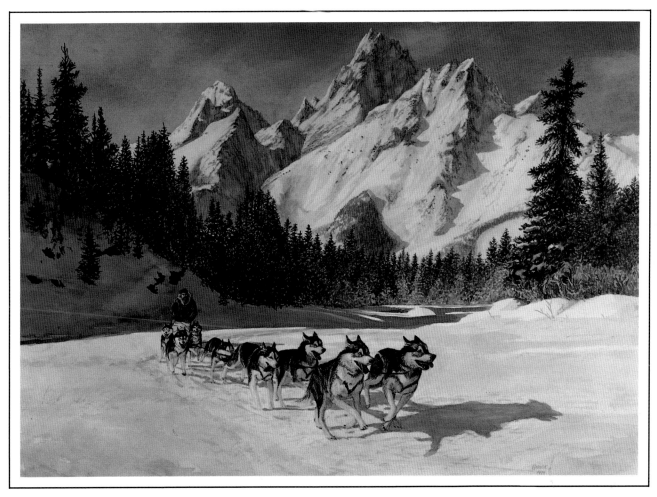

"Hitting the Trail"

Artist's Comments: "Hitting the Trail" was inspired by my first Fur Rendezvous in Alaska. I had spent considerable time on the North Slope and finally had a chance to experience Rondy! I spent hours on the race trail with my video camera. Veteran musher Earl Norris had a team that caught my eye; they were a well-matched team of Siberian huskies. The mountain range in the back is from my imagination.

Edition Size: 300 signed and numbered
Release Date: 1979
Published from an original watercolor

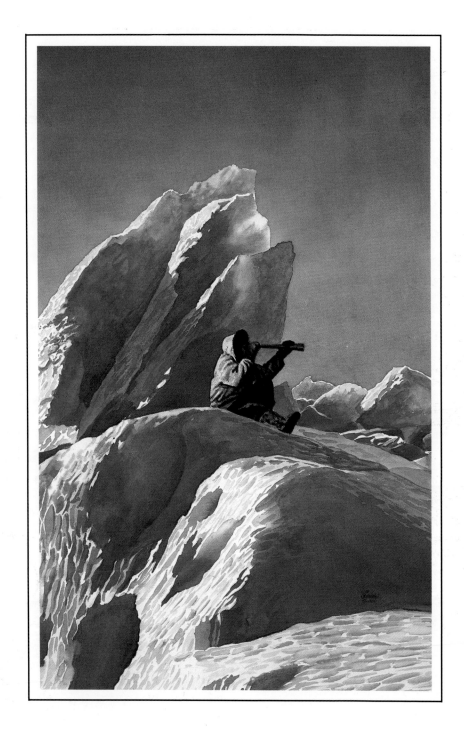

"Searching"

Artist's Comments: The ice in this painting was inspired by ice I saw at Portage Glacier, which reminded me of pack ice when it is thrust up in pressure ridges. It has been my experience that men are always searching for something from the time they are born until the time they die. In this case, the man is searching for whales on the horizon. Men tend to search horizontally, but the thrust of the ice suggests a search upwards.

Edition Size: 300 signed and numbered,
Release Date: 1980
Published from an original watercolor

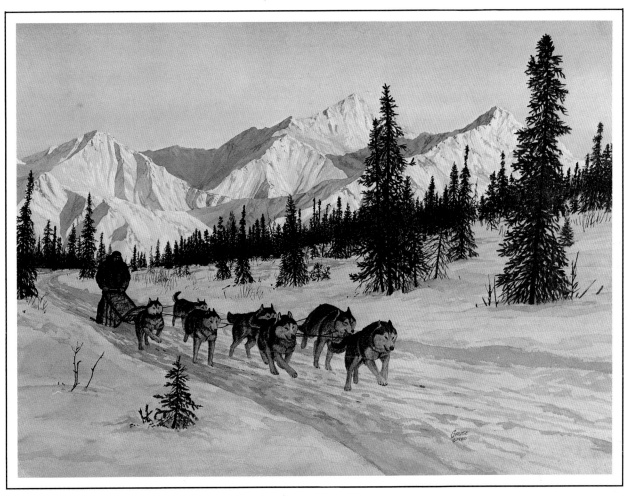

"Pushing On"

Artist's Comments: This musher has still not reached his destination, but we can see that the day is ending by the first tell-tale signs of sunset — called alpenglow — hitting the mountains. He's urging his team to keep up their pace so that dark won't catch them on the trail.

Edition Size: 300 signed and numbered
Release Date: 1980
Published from an original watercolor

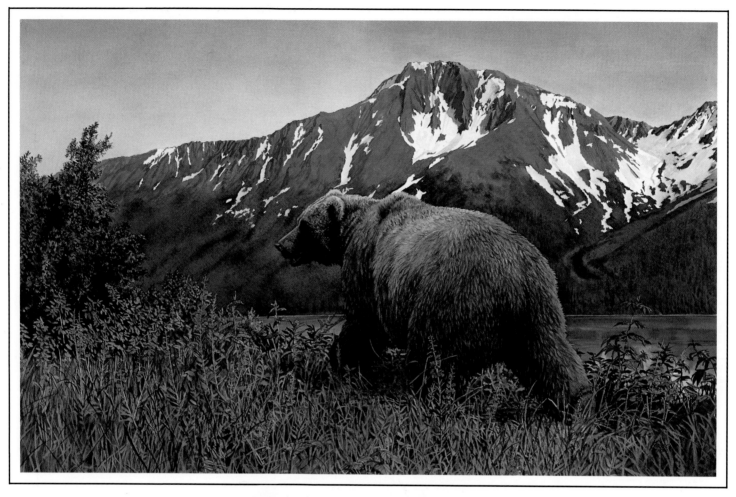

"Roaming Free"

Artist's Comments: There is something about the words, "Last Frontier." They carry with them a sense of freedom — that man or beast can still be free to roam, to enjoy an unspoiled wilderness. This bear is roaming; we don't know where to, but he's heading away. We see him for only a moment and then he's gone in the underbrush.

Edition Size: 300 signed and numbered
Release Date: 1980
Published from an original watercolor

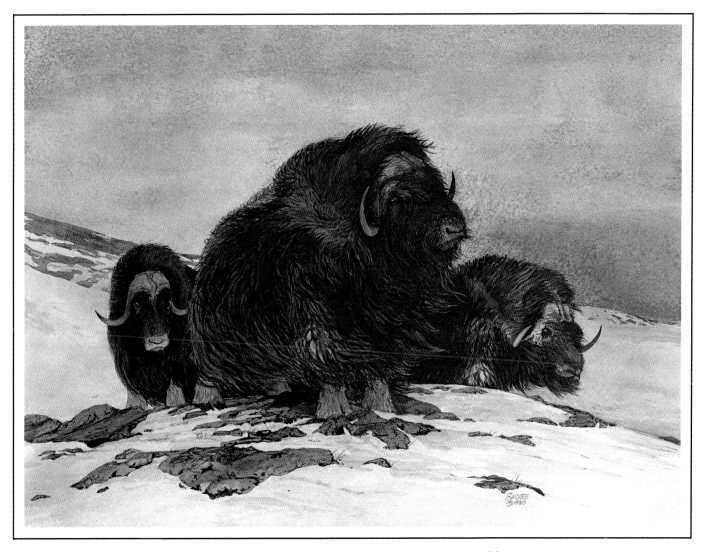

"Wild and Woolly"

Artist's Comments: Musk oxen in their defensive stance look almost prehistoric. They look soft and furry, but they have a look in the eyes that convinces you that you don't want to challenge them. In the painting, on all the silhouettes, I've shown a horn sticking out. Musk oxen know how to take care of themselves.

Edition Size: 300 signed and numbered
Release Date: 1980
Published from an original watercolor

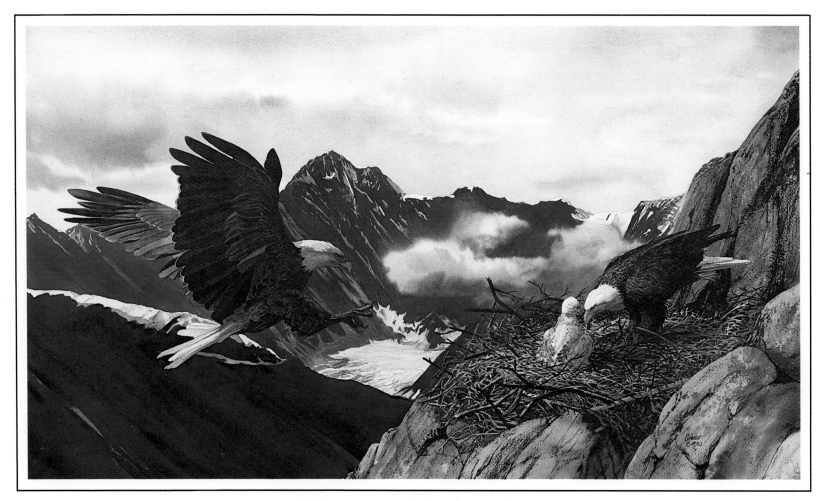

"Majestic Wings"

Artist's Comments: Although this is a horizontal piece, I wanted to make viewers feel that they are near the tops of mountains. I've always liked the deep blue colors. I was happy with the dramatic contrast between the dull brown wings and the deep blue of the distant mountains; it makes the eagle seem to hang in the air. Much of my work has a dynamic trellis — strong diagonal lines. There is also the contrast of one bird hanging suspended while the bird on the other side of the painting is solid and secure — nestled in the rocks.

Edition Size: 300 signed and numbered
Release Date: 1980
Published from an original watercolor

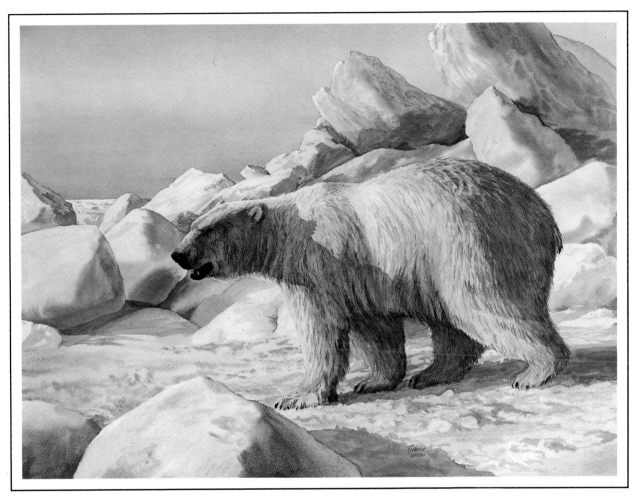

"White World"

Artist's Comments: The light in this painting is an attempt to capture the reflection of the sunset on the opposite sky — the pale pink reflection of sunlight refracted off the ice. To me, that's what makes the scene cold: the sky. Actually, "White World" may not have been the best title because there is nothing completely white except a few fragments of ice. I admire any creature that has the capacity to live its whole life in that kind of cold, winter after winter.

Edition Size: 300 signed and numbered
Release Date: 1980
Published from an original watercolor

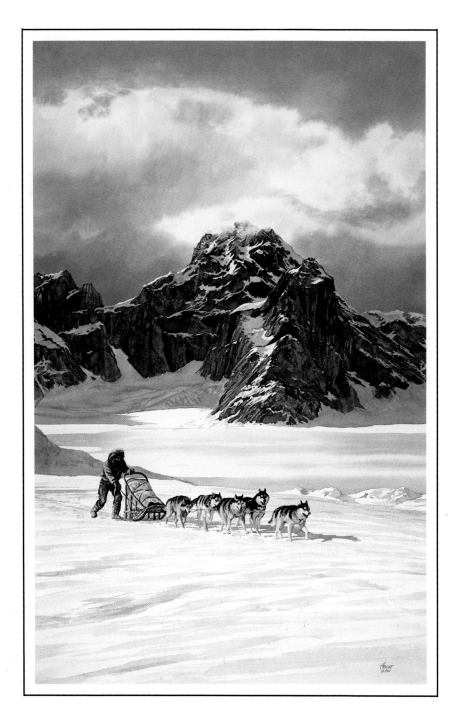

"Across the Pass"

Artist's Comments: This musher is just picking up his brake and urging his team to get under way to finish their trek through the mountains. The scene represents an actual spot in McKinley. The mountain peak seems to have a halo of light around it. To me, the mountains are as much a part of the picture as the man and his team.

Edition Size: 300 signed and numbered
Release Date: 1981
Published from an original watercolor

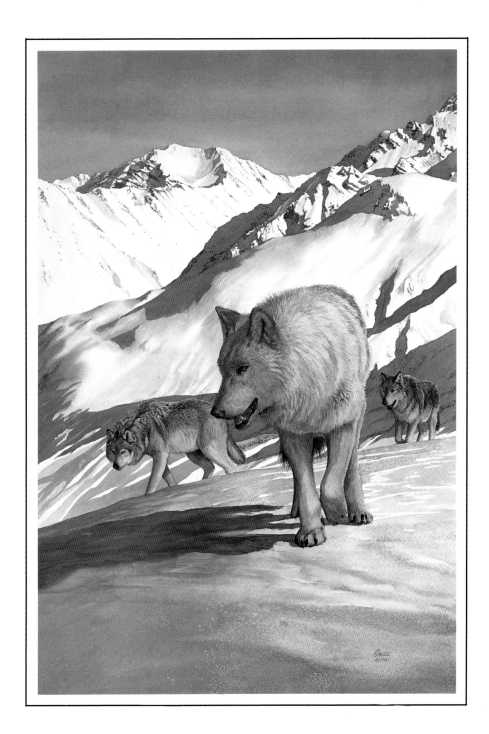

"A Meal in Sight"

Artist's Comments: This is a strong directional piece, with strong diagonal lines. Every line in it makes you look where the wolves are looking and you are imagining what it is that they are stalking. Sometimes as I work, I'm not explicitly aware of the final design, but I'm conscious of the line when I look back at it later.

Edition Size: 300 signed and numbered
Release Date: 1981
Published from an original watercolor

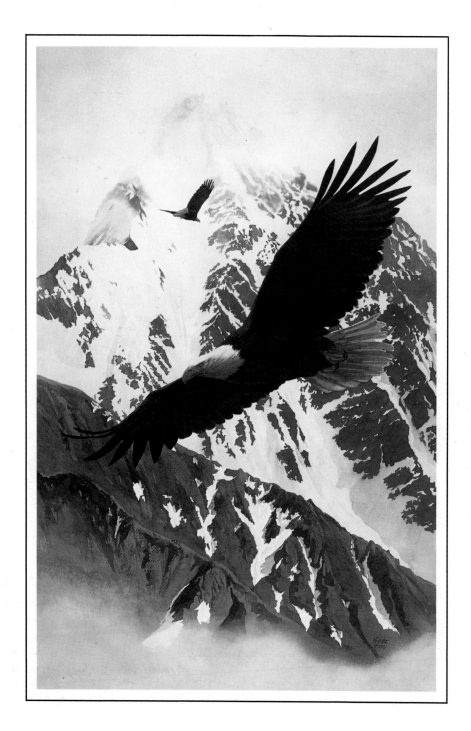

"Soaring"

Artist's Comments: The feeling in this painting is that of "hanging on air." There are clouds above and clouds below. The bird in the distance is showing us the probable path of the bird in the foreground — soaring higher and higher until they are lost in the mists.

Edition Size: 300 signed and numbered
Release Date: 1981
Published from an original watercolor

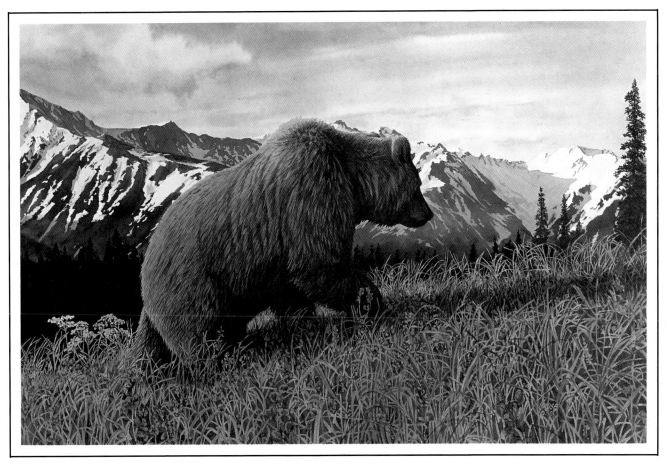

"Out in the Open"

Artist's Comments: I wanted to paint a bear in the very middle of summer in the high country, in a high meadow. In watercolor, bear fur is a real challenge. This was one of my earlier attempts and I'm still refining the process. The mountain range in the background is in Chugach State Park.

Edition Size: 300 signed and numbered
Release Date: 1981
Published from an original watercolor

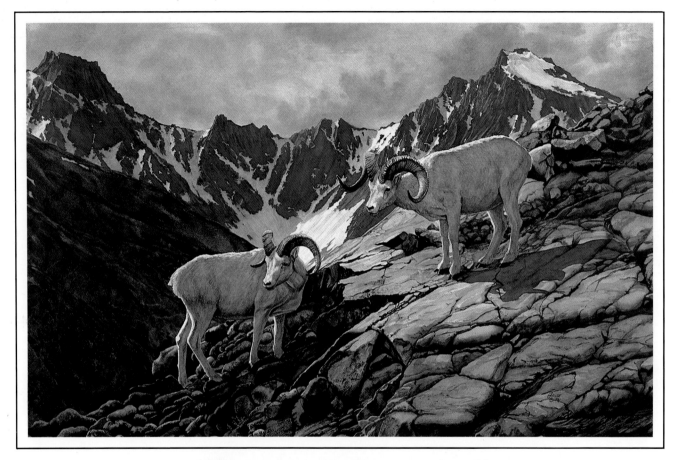

"Rugged Country"

Artist's Comments: The rocks are my favorite part of this painting. I was really struck by the rock formations when I was in this portion of McKinley Park. I photographed the rocks knowing that some day I was going to put some Dall sheep on them.

Edition Size: 300 signed and numbered
Release Date: 1981
Published from an original watercolor

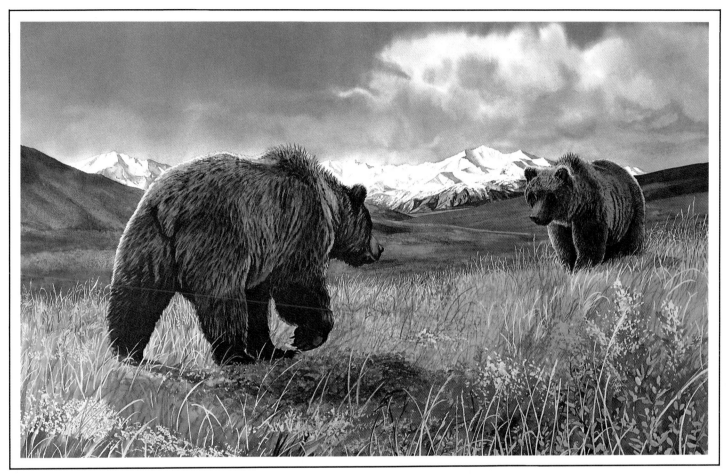

"Territorial Trouble"

Artist's Comments: I've returned to this theme twice for prints. This was the first one. I spent many hours in McKinley Park in the fall. I enjoy observing bear encounters and the different ways they handle them. One day I watched as a young bear chased an older bear out of his territory. The older bear ran straight up a hill with the younger one right behind him. The whole chase took about 30 seconds. Finally the older and larger bear just sat down, as if to say, "I'm not going any farther." The younger bear stood for a moment swaying his head, then went back down the hill. Apparently the other bear was larger than he had expected when he began his chase.

Edition Size: 300 signed and numbered
Release Date: 1981
Published from an original watercolor

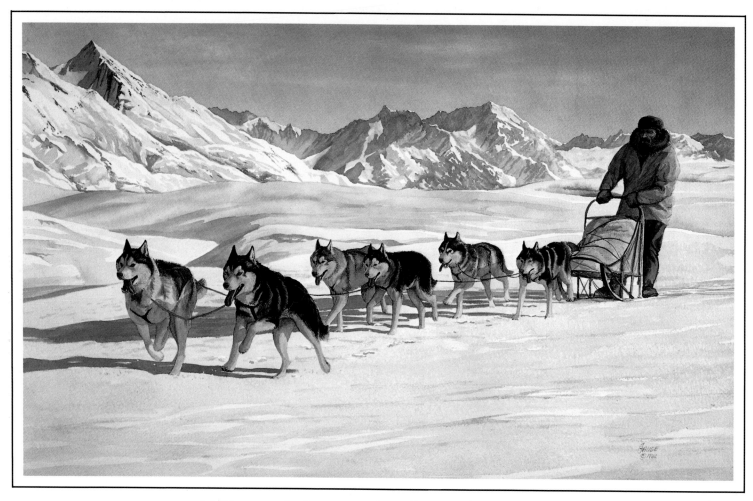

"Six Ahead, 6° Below"

Artist's Comments: The setting is Thompson Pass, in the springtime. The light up there was just blinding because of all the white snow. I wanted to represent the idea of teamwork — that the musher was confident that he could handle the 6° below because of the six he had ahead.

Edition Size: 300 signed and numbered
Release Date: 1982
Published from an original watercolor

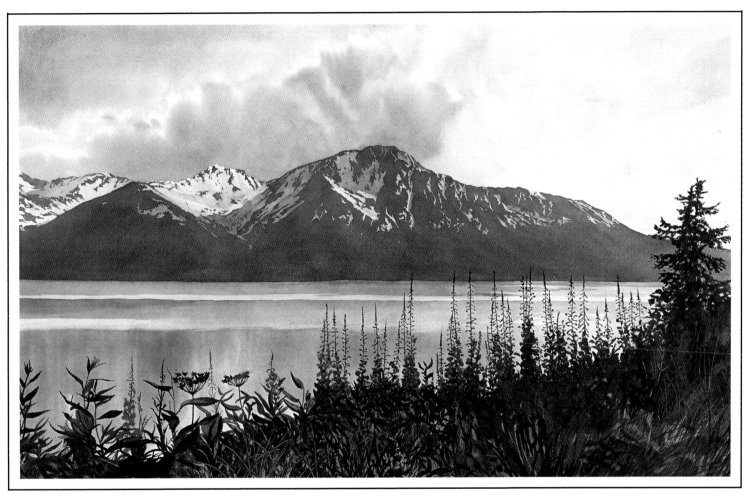

"Turnagain Tidelands"

Artist's Comments: This is a sunny afternoon on Turnagain Arm — summer, because the fireweed blossoms are lower down on the stems. I tried to capture the late summer haze, the opalescent light in the cloudy sky was a challenge. Part of what attracts me to watercolor is that it is a battle, a challenge, to control it. It's a little like my golf game. Some days every stroke goes where you want it to and other days it's a battle to keep it on course.

Edition Size: 300 signed and numbered
Release Date: 1982
Published from an original watercolor

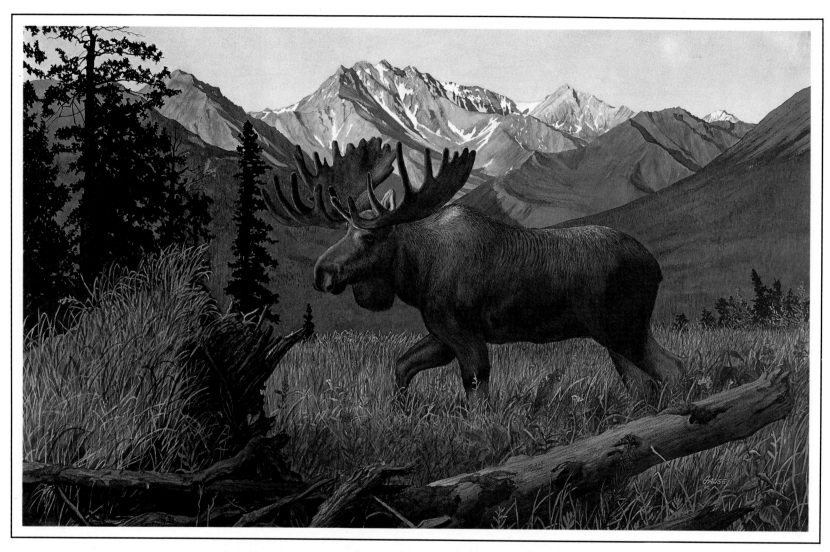

"Through the Meadows"

Artist's Comments: I was inspired by a mountain range just north of Palmer for the scene. Alaskans develop almost a ho-hum attitude about their moose, but I'm still moved when I see a large bull with a massive rack — the freight train of the wild.

Edition Size: 300 signed and numbered
Release Date: 1982
Published from an original watercolor

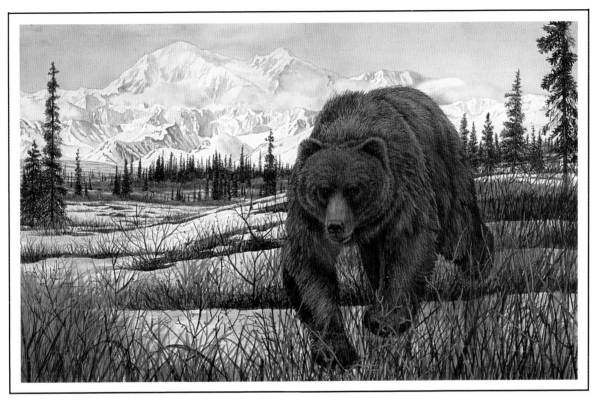

"Two Kings"

Artist's Comments: Mt. McKinley is the king mountain and the grizzly bear is the king of North American beasts. I got my inspiration for this while driving in McKinley Park. Sitting in the car early one fall morning, with the window down, I didn't see this bear until the great massive head came up the crest of the road. I was shocked. We saw each other at the same time; it seemed as though he hadn't been aware of me until then. I could see his breath in the air. Although it appears he's charging or moving toward the viewer, I have him looking past you, so you can imagine him pursuing something else. Bears are awkward running creatures. The challenge was to convey in a still image that this bear was running. Nearly every reference photo I've taken of bears running looks awkward. In movies, they look fluid, but only one out of fifty still shots looks natural. Sometimes I am frustrated by the limitations of the two-dimension image.

Edition Size: 300 signed and numbered
Release Date: 1982
Published from an original watercolor

31

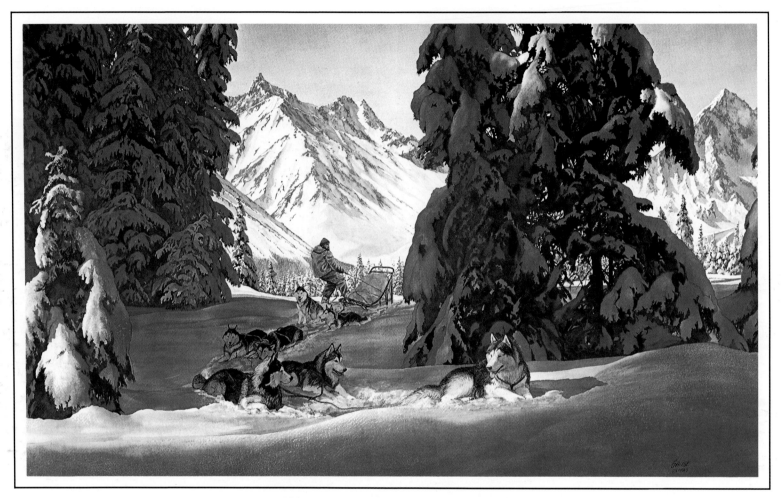

"Blue Shadows"

Artist's Comments: This musher has stopped to re-secure his provisions. The scene shows us that men are busy even at rest time. They don't often pause to reflect. The dogs are alert to what's happening around them, listening to the squirrels and noises in the forest. I like this painting. I kept it for a few years in my living room, and finally someone talked me out of it.

Edition Size: 300 signed and numbered
Release Date: 1983
Published from an original watercolor

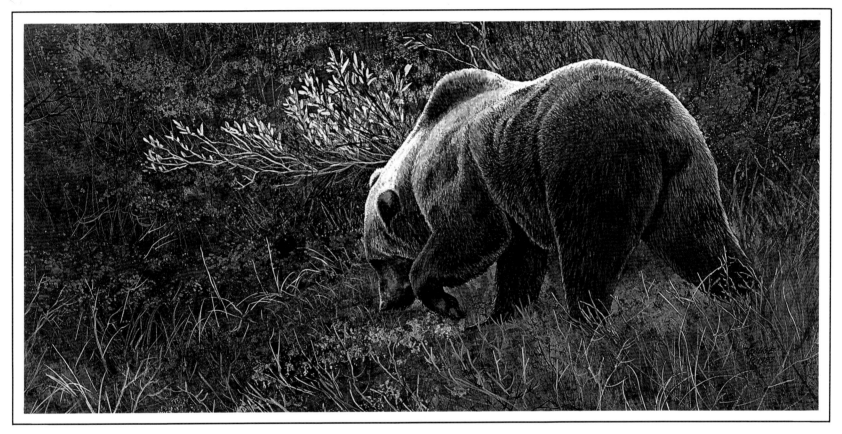

"Shades of September"

Artist's Comments: This is a study of harmony between the bear and his environment: the way he reflects the autumn colors of the tundra. I can almost see his fur rippling in the wind like the yellow grasses that he's walking over.

Edition Size: 750 signed and numbered
Release Date: 1983
Published from an original watercolor

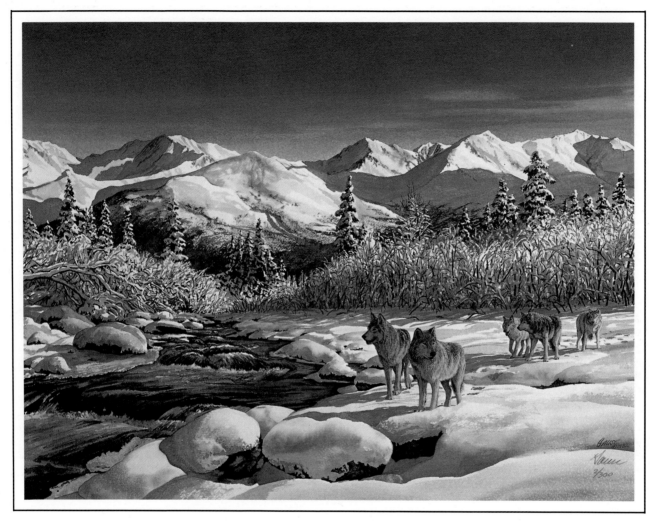

"The Wanderers"

Artist's Comments: This scene is the morning after the first or second heavy snowfall for the year; the sun is just breaking through. Into this setting, I have painted a pack of wolves wandering freely, even aimlessly. They may have spent the evening hunting and plan to "hang out" at the creek. The scenery is taken from the Gunsight Mountain area.

Edition Size: 300 signed and numbered
Release Date: 1983
Published from an original watercolor

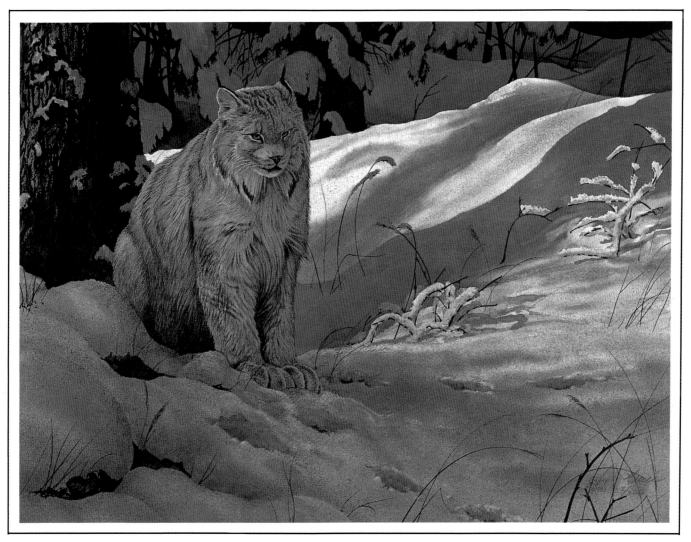

"The Silent One"

Artist's Comments: Lynx hunt all night. This is one of those moments in the day when he's resting. I found myself wondering what cats think about when they're not pursuing game. I thought the fresh snow balanced so delicately on the blades of grass and twigs was a nice parallel to the soft layers of fur.

Edition Size: 300 signed and numbered
Release Date: 1983
Published from an original watercolor

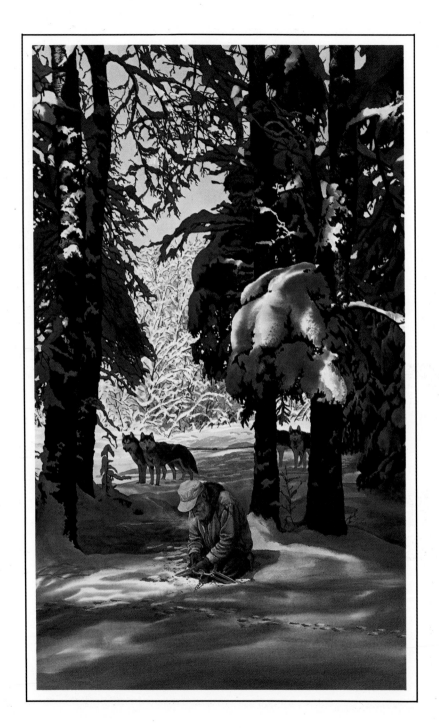

"North Country Trapper"

Artist's Comments: I was in my back yard one morning after a fresh snow, and my eye was caught by the strong contrast of the deep blue shadows in the foreground trees againt the ones in the back. The dog team is left largely out of the scene. It is almost as if the trapper has entered a holy place, and they must wait quietly for him until he finishes.

Edition Size: 300 signed and numbered
Release Date: 1984
Published from an original watercolor

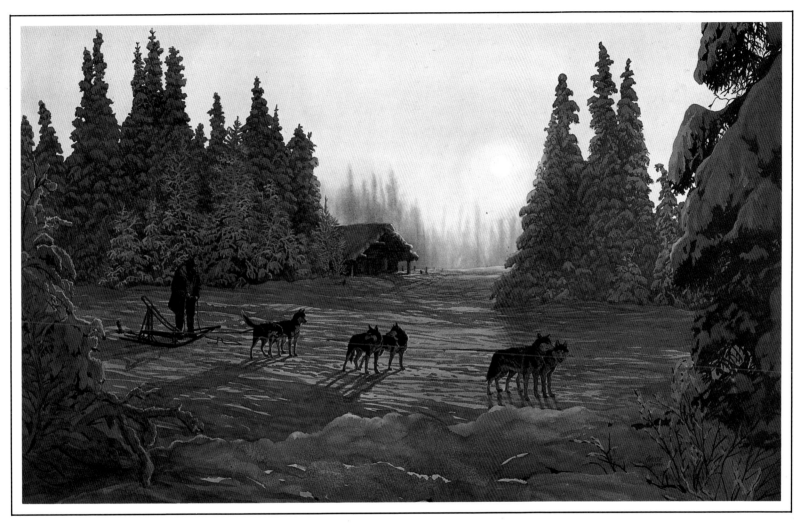

"Home by Sundown"

Artist's Comments: When I was in Fairbanks in the winter of 1975, I saw this kind or arctic light many times. It's a sun that doesn't give any warmth. Some viewers may enjoy it more if they don't know exactly where it is; they may feel they already know or they have been to a similar spot. I like to imagine it is possible for viewers to say, "Yes, I was there, but I forgot my camera."

Edition Size: 300 signed and numbered
Release Date: 1984
Published from an original watercolor

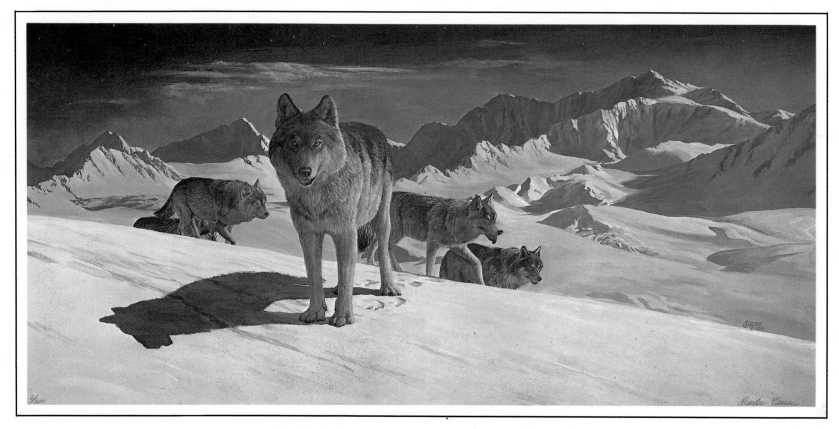

"Night Hunters"

Artist's Comments: When I first got to Alaska, I was working on the North Slope and came across a group of wolves much like this up in the Brooks Range. I was driving down the haul road at the time. I felt they were seeing men for the first time, and I was seeing wolves in the wild for the first time. I remember the leader of the pack standing much as this one is.

Edition Size: 300 signed and numbered
Release Date: 1984
Published from an original acrylic

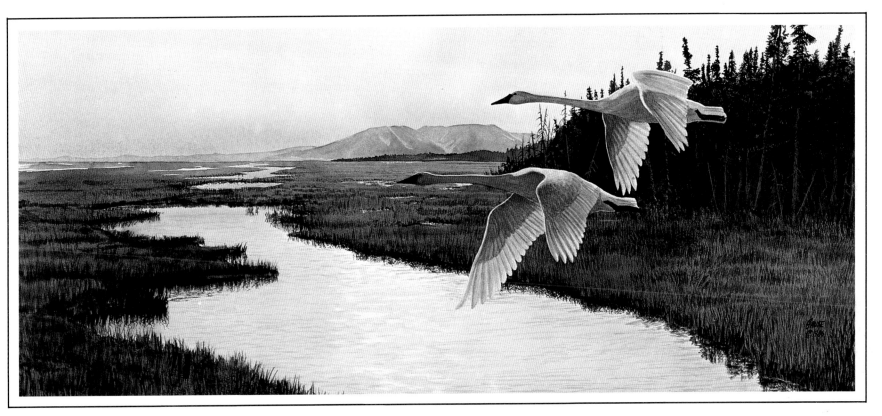

"Morning on the Marsh"

Artist's Comments: This is an area where I spend a lot of time in the fall during hunting season. One year, I made a swan decoy out of styrofoam, trying to get other swans closer for some good photos. One pair was especially concerned about my lone swan in the marsh. They flew circles around me, honking the whole time, and finally flew away. Ten minutes later, the same pair came back with another swan, as if they were matchmakers. In my romantic moments, that's how I like to think about it. Of course, they could have been completely different swans!

Edition Size: 300 signed and numbered
Release Date: 1986
Published from an original watercolor

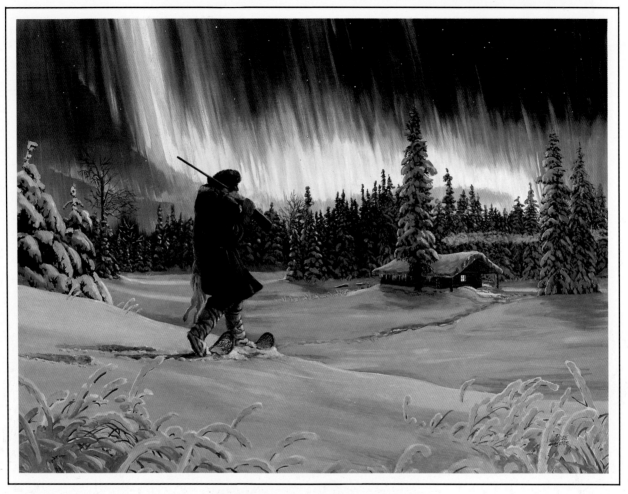

"High North"

Artist's Comments: This was the first alkyd painting I did for printing. I wanted to portray a feeling of the warmth and satisfaction of people living in the Bush. Even though this man lives in the remote wilderness and sometimes has to struggle (like going out when it's very cold to find fresh meat for an evening meal), he is rewarded on his way home by a spectacular light show which confirms why he has chosen this lifestyle. I wanted to share the inviting light of the cabin, and the smoke from the cozy fire in the wood stove, but also the extreme cold of the arctic night when the Northern Lights are at their best.

Edition Size: 300 signed and numbered
Release Date: 1986
Published from an alkyd painting

"Loafing in the Lupine"

Artist's Comments: While I was in McKinley Park one year, I spent a day watching a sow and her two cubs, rolling here and there, lounging around, just enjoying themselves. They stayed in the same area all day. Life in the wild is not always a matter of survival — bears enjoy themselves too.

Edition Size: 300 signed and numbered
Release Date: 1987
Published from an original watercolor

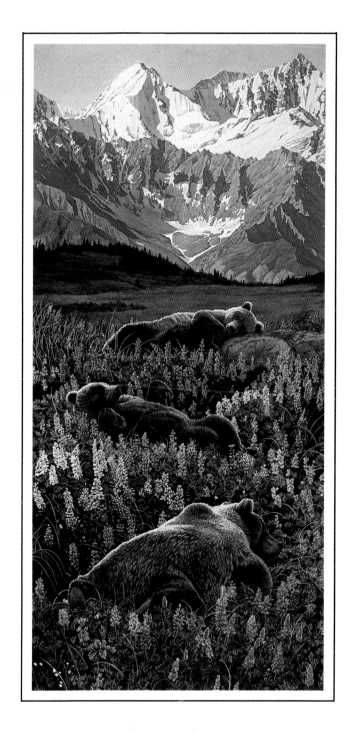

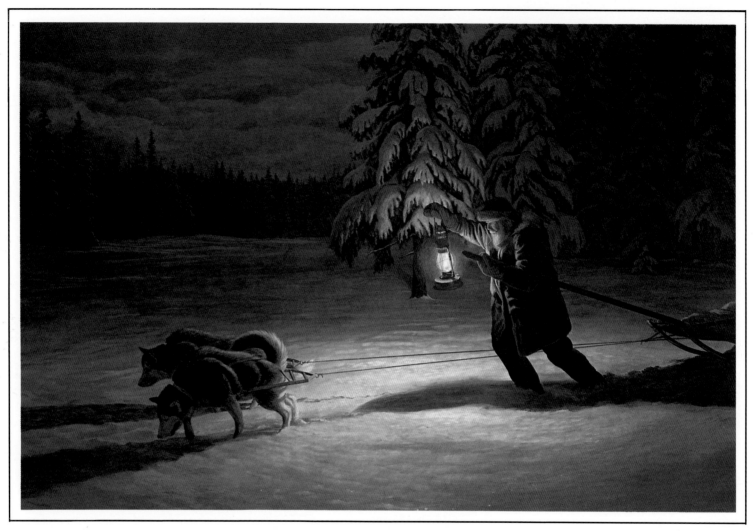

"Lost Trail"

Artist's Comments: This figure has been the recurring character in my vision of Alaska as it used to be. I first painted him when I was in high school. My best friend's mother bought that painting, and she said it made her feel cold on the hottest day of summer. We know the man's got a heavy load by the effort his freight dogs are putting out. Even the trees seem to hover around as silent observers to his plight.

Edition Size: 300 signed and numbered
Release Date: 1987
Published from an original acrylic

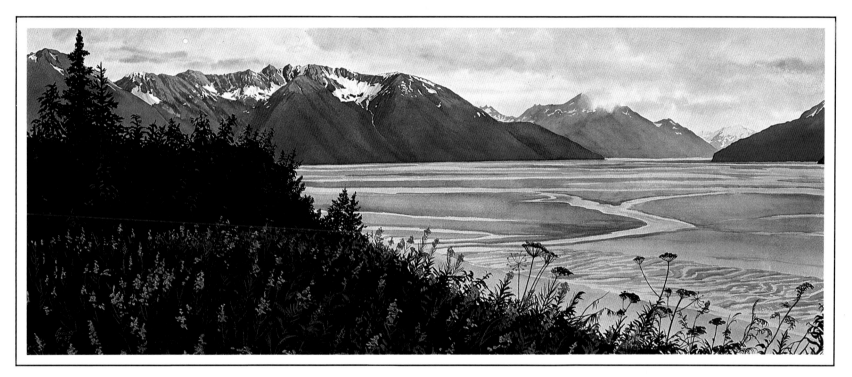

"Turnagain Summer"

Artist's Comments: This is the third print in the Turnagain set. After doing the first two Turnagain scenes almost in "window" shape (standard rectangle), I decided on more of a panoramic view to show the width of the inlet. I was trying to get across a mood of relaxation.

Edition Size: 300 signed and numbered
Release Date: 1987
Published from an original watercolor

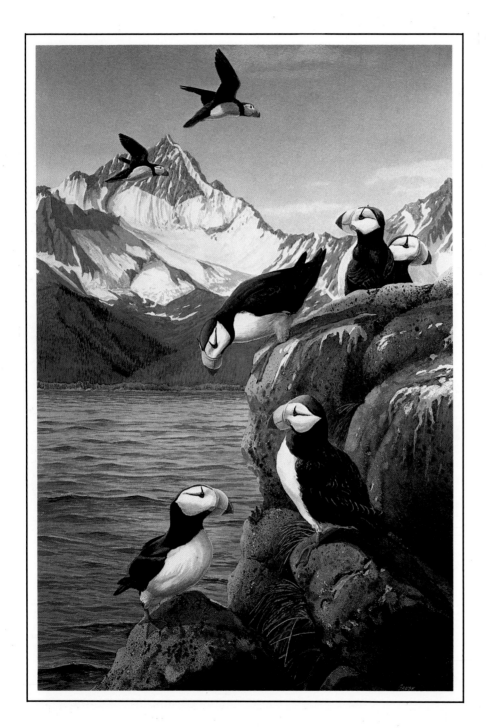

"Puffin Paradise"

Artist's Comments: This was a special commission painting for someone who really loved puffins and spent many hours in the Kenai Fjords area. Puffins are such exotic looking birds. Most everytime I have seen them they have been flying so I put a few in flight. The puffin population is quite healthy in the Kenai Fjords area and almost every trip you can see a rock that has a group of puffins on it.

Edition Size: 300 signed and numbered
Release Date: 1988
Published from an original watercolor

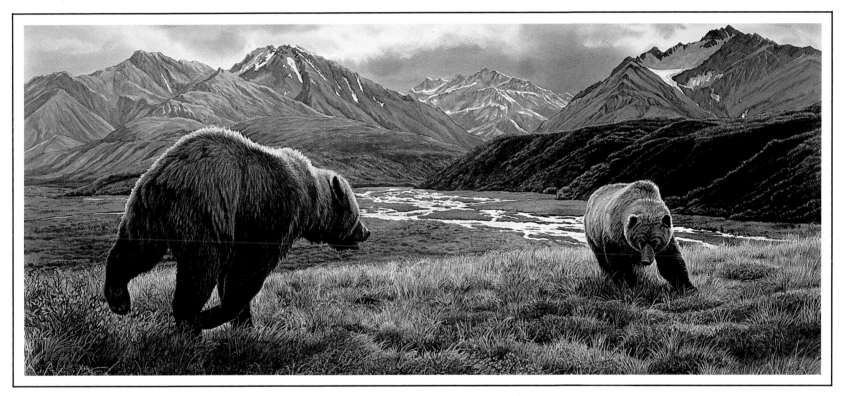

"Old Rivals"

Artist's Comments: Of all the bears I have painted, these two are the closest to actually getting into a tussle. I used the jagged, almost lightning bolt, shapes of the river to heighten the tension in the air.

Edition Size: 300 signed and numbered
Release Date: 1988
Published from an original watercolor

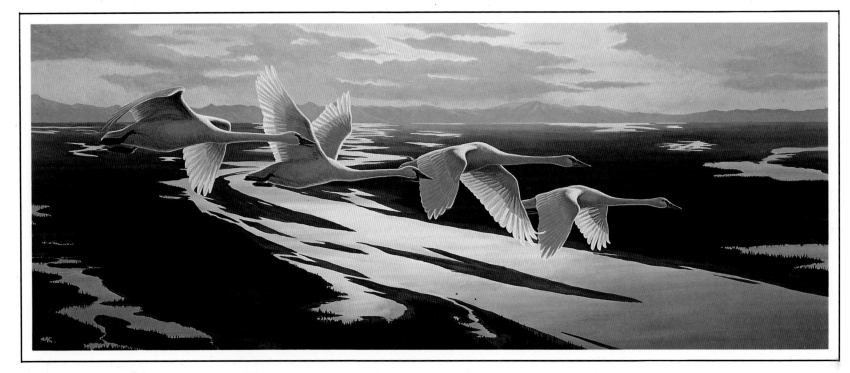

"Summer Evening Flight"

Artist's Comments: Anyone who has ever flown a small plane in Alaska on a summer evening enjoys the reflection of the sky in the many lakes and streams. I like to think that the birds enjoy flying and scenery as much as we do. These two mated pairs are out for an evening wing-stretch.

Edition Size: 300 signed and numbered
Release Date: 1988
Published from an original acrylic

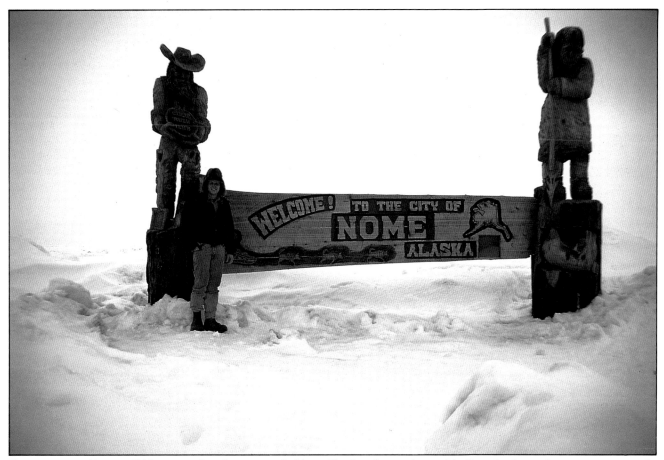

This was a visit to Nome in 1990 to research and experience the Iditarod finish and to get photos of the Nome landscape. I set up my camera and took my own photo.

About the Iditarod Fundraising Program

Stephan Fine Arts joined the Iditarod team of sponsors in 1987 with a unique way of combining the collectible artwork of Charles Gause with a generous contribution to "The Last Great Race." In collaboration with the Iditarod Trail Committee, it was decided that a terrific fundraising idea had come of age. Why not pay tribute to the mushers who have helped make Iditarod what it is today by having them sign the print also. The program has proved tremendously successful not only for Iditarod but for the collectors themselves. The first two prints sold out within a six week time period and have increased in value up to 700%! The official copyrighted number of prints authorized by the Iditarod Trail Committee is 1049 (one print for each mile of the Iditarod) thus making this the only official fundraising print. With the purchase of this print, a $100.00 donation is paid directly to the Iditarod. This print raises over $104,900.00, thus making it one of Iditarod's major fundraisers!!

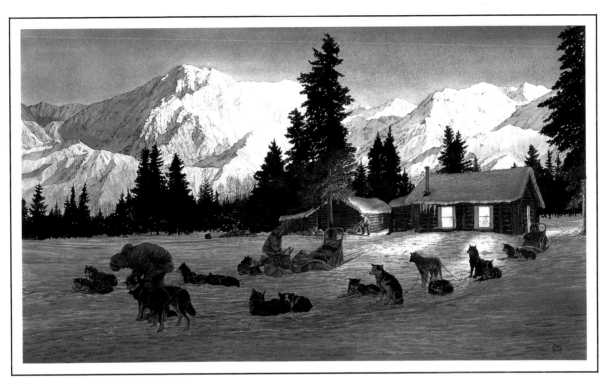

"A Welcome Rest"

(the first official fund-raising print for the Iditarod Trail Committee)
Each print is signed by the artist, along with Libby Riddles and Susan Butcher.

Artist's Comments: This piece was my first print done for the Iditarod Trail Committee as the official fund-raising print. When the Iditarod Committee first approached me I was thrilled, but then I wondered how to portray this great race in one painting. This was after Libby Riddles had made her place in history in 1985 as the first woman to win the Iditarod, and Susan had won the race the two years following. I thought Libby Riddles and Susan Butcher would be the ones to watch that year, so I approached the print from that angle. "Welcome Rest" portrays mountains similar to the Rainy Pass area and the cabin at the Ophir Checkpoint. Susan and Libby have arrived at the checkpoint to feed their dogs and give them a well-earned rest. The alpenglow on the mountains and the light coming from the cabin give a feeling of warmth in spite of the coldness and the competition on the trail.

Edition Size: 1,049 (one print for each mile of the Iditarod race)
Release Date: 1987
Published from an original watercolor

61

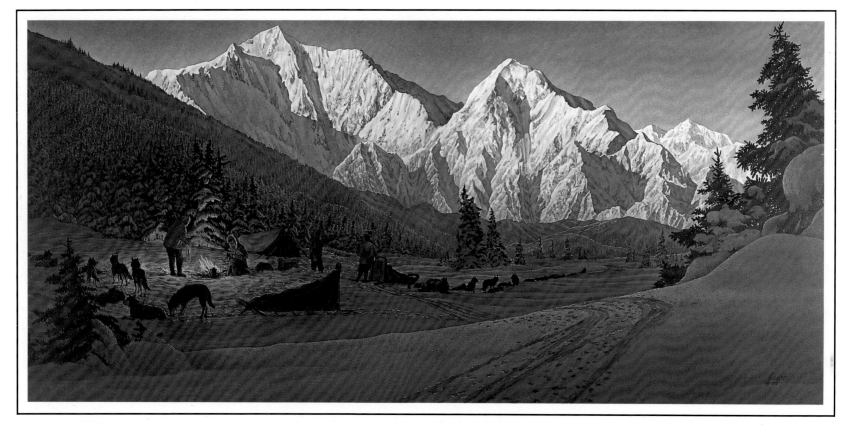

"Leading the Way"

Artist's Comments: This scene depicts an early morning as it might be on the Iditarod Trail with the mushers breaking camp and getting ready to head out, leading the way. They're enjoying the last few moments by the fire before they face the icy cold again. This was my second Iditarod print; it was signed by seven leading male mushers who made historical accomplishments. They were Edgar Nollner, Col. Norman Vaughan, Earl Norris, Dick Wilmarth, Sonny Lindner, Bob Buzby and Rick Swenson.

Edition Size: 1049
Release Date: 1988
Published from an original watercolor

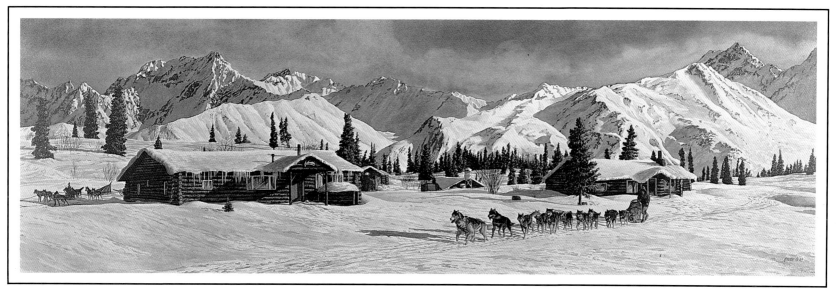

"*Coming into Rainy Pass*"

Artist's Comments: This is an actual scene in Rainy Pass. I flew up there in a small plane to get a feel for the place and tramped around in snow shoes for an afternoon. This was my third Iditarod print. It was signed by seven leading women mushers who are all champions in their own right. They are Dee Dee Jonrowe, Susan Butcher, Roxy Wright Champaine, Natalie Norris, Libby Riddles, Mary Shields and Kathy Swenson.

Edition Size: 1049 signed and numbered
Release Date: 1989
Published from an original watercolor

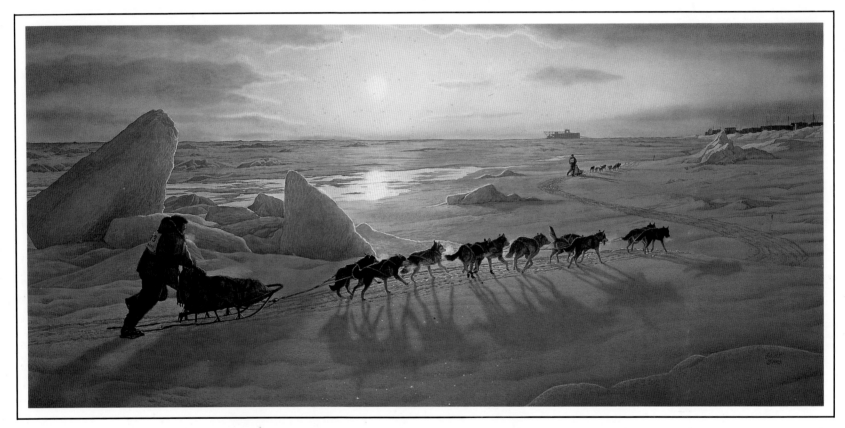

"The Race for the Record"

Artist's Comments: Although the mushers have raced over 1000 miles, sometimes the Iditarod finish can become a foot race down Front Street in Nome, with each musher shouting encouragement to the dogs. I sat out on the ice in Nome waiting for the sun to go down to get the inspiration for this painting. In the distant background is a sea mining dredge, anchored offshore of Nome in the winter. The buildings of Nome are visible on the far right.

Edition Size: 1049 signed and numbered
Also signed by Rick Swenson and Susan Butcher
Release Date: 1990
Published from an original watercolor

Posters

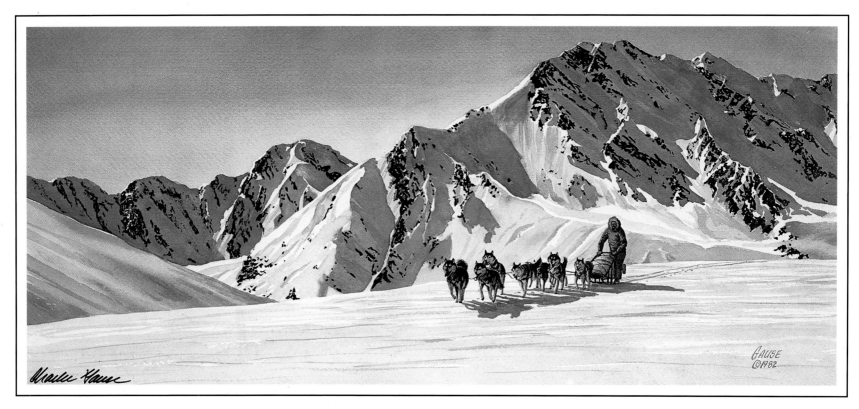

Commemorative Show Poster

Artist's Comments: This is a small piece. I tried to show the bright mid-day light of an Alaskan winter and a musher slowly crossing a mountain pass. Where he is going is left to the viewer's imagination.

Edition Size: 1000
Release Date: April 1982
Published from an original watercolor

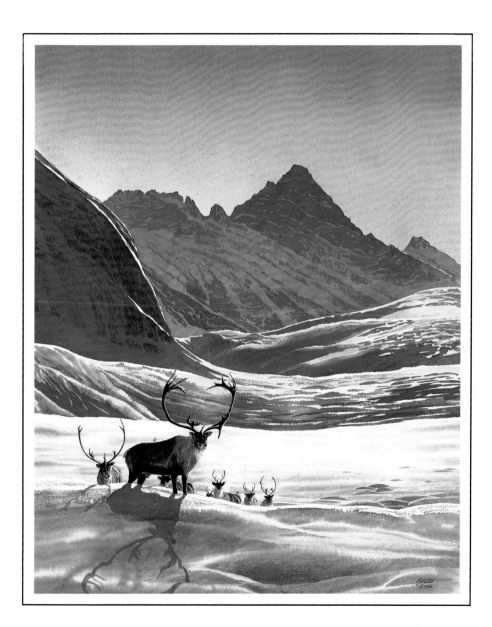

Brilliant Arctic
The 1986 Show Poster

Artist's Comments: My inspiration for this piece came from my time spent in the Brooks Range. The mid-day sun almost blinds you and creates bold shadows. There is also a healthy caribou population in this area. I can imagine someone on snowshoes just coming over a crest and there is this herd of caribou. They are curious and have a surprised look on their face.

Published from an original watercolor

67

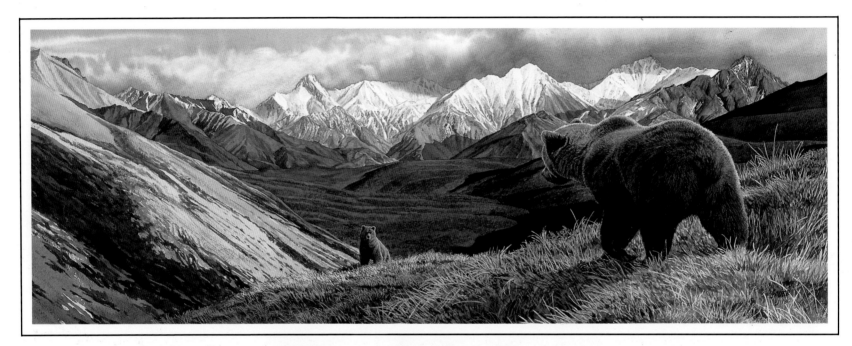

"Where Paths Cross"

Artist's Comments: The setting for this painting is Polychrome Pass. I observed a similar encounter as I was parked along the Savage River one evening. I was watching one bear when another entered its berry patch. The first bear rose up on his hind legs, and there was a moment of tenseness as he was trying to make an identification. Both bears broke into a gallop and the larger one chased the intruder from his territory. I wasn't able to take photos because of the low light, but the scene is forever logged in my memory. In the painting, I tried to capture the moment of tension before the charge.

Poster Release: Official Sportsman Show Poster (1000 posters)
Second release as a Denali National Park poster
Published from an original watercolor

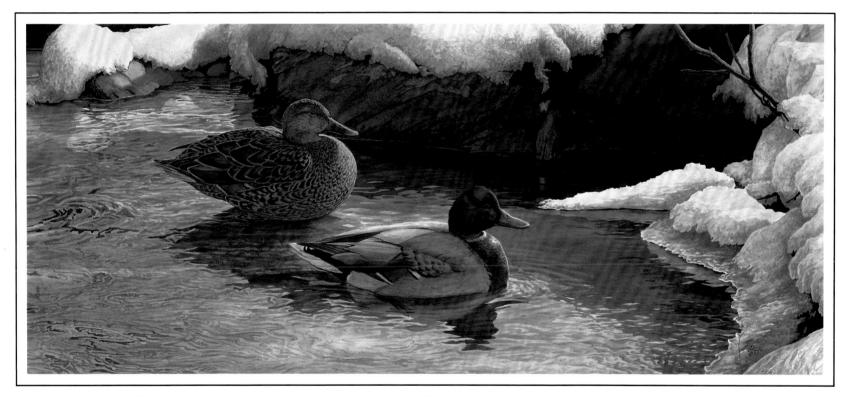

Official Sportsman Show Poster for 1989

Artist's Comments: Anchorage has a somewhat temperate climate which supports a strong population of mallard ducks. I found this pair on a hillside creek in winter and couldn't resist painting them. Because mallards are the most popular species of water-fowl, this piece was selected as the Official Sportsman Show poster for 1989.

Original painting medium: Watercolor

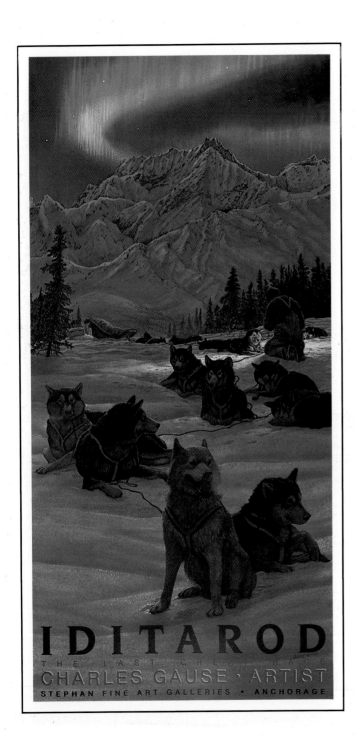

"Night on the Iditarod Trail"

1990 Iditarod Fund Raising Poster

Artist's Comments: This painting was also inspired by my trip to Rainy Pass. I began to think, "What would these mountains look like under the glow of Northern Lights." The scene became a fund raising poster for the Iditarod.

Published from an original watercolor
Release Date: 1989

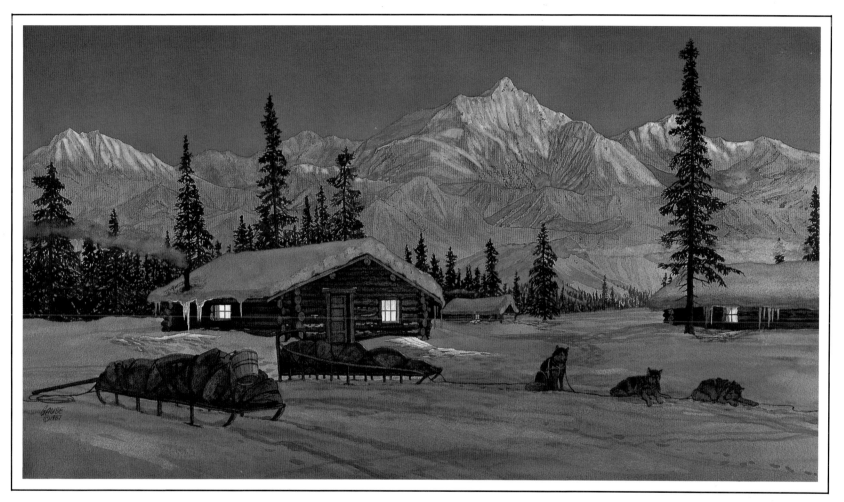

"Alpenglow Iditarod"
Iditarod Sponsor Poster 1991

Artist's Comments: This Iditarod poster shows a roadhouse and its cabins in the early days of Alaska mushing. Perhaps Leonard Seppala encountered a scene similar to this in the original serum run to Nome.

Published from an original watercolor
Release Date: 1990

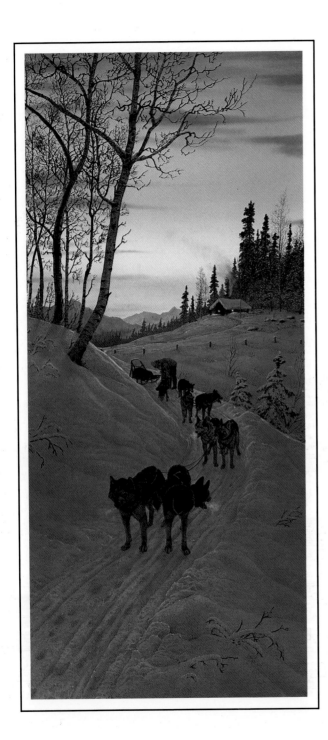

"The Training Run"
The 1991 Official Fur Rendezvous Poster

Artist's Comments: One of the most exciting highlights of the Fur Rendezvous activities is the World Championship Sled Dog race. Alaskans and visitors turn out in full force to cheer on their favorite mushers. Many hours of training are needed to build champions. This musher lives in the bush where he has wide open space to train his dogs. He gets an early start every morning and his dogs are eager to run. A quick untangle and they are off. The world championship races are just a few weeks away. So every training run counts.

Published from an original watercolor
Release Date: 1990

Originals

Artist with one of his favorite paintings!

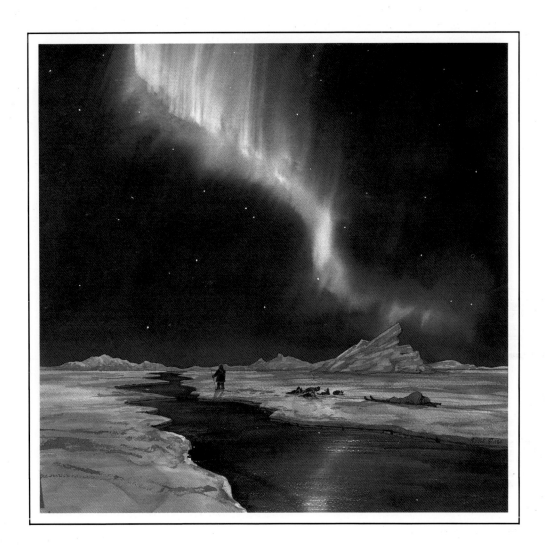

"On the Ice Pack"

Artist's Comments: This is a seal hunter traveling home. The ice has separated from shore preventing him from crossing. His dogs take it all in stride and lay down to sleep. He is wondering how he will get across and what he should do now. Maybe by morning the wind will change and close the gap. He knows it's a cold swim and still a long way home.

Original Watercolor
Private Collection

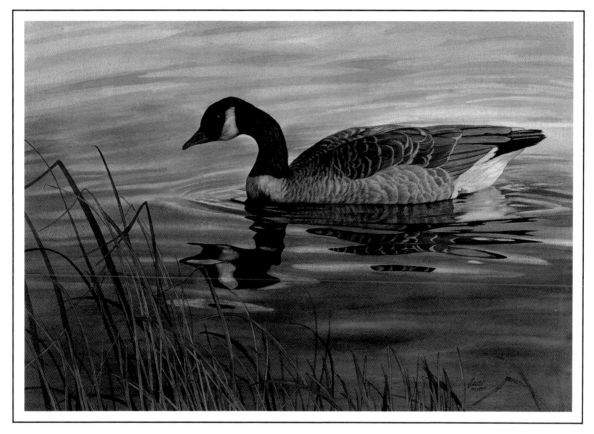

"Grey Dawn—Canada Goose"

Artist's Comments: I enjoy painting reflections on water. It's a challenge to make paint on paper look liquid. When you are successful, there is a real sense of accomplishment. The Canada Goose is a longtime favorite bird for me.

Original Watercolor
Private Collection

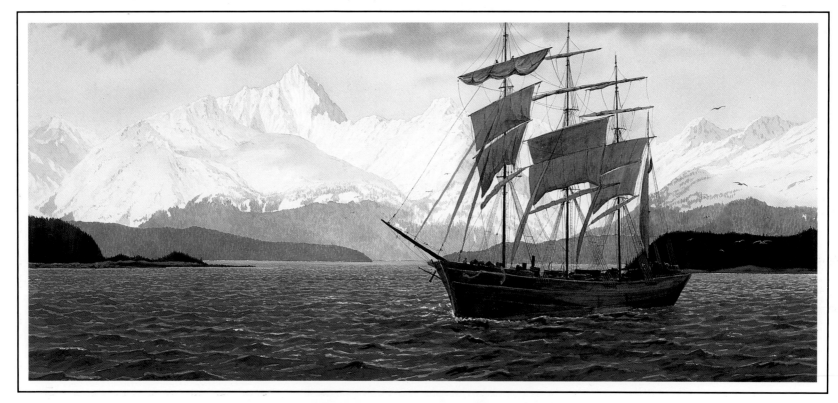

"Taking in Sail"

Artist's Comments: I like tall ships. This is a painting of a cannery vessel in the early years of Alaska, sailing the Inside Passage in the early spring to bring home a cargo of Alaska salmon. I had two uncles in the navy when I was a boy, and I used to draw ships all the time. This particular scene was inspired by a ferry trip from Juneau to Haines during March one year.

Original Watercolor
Private Collection

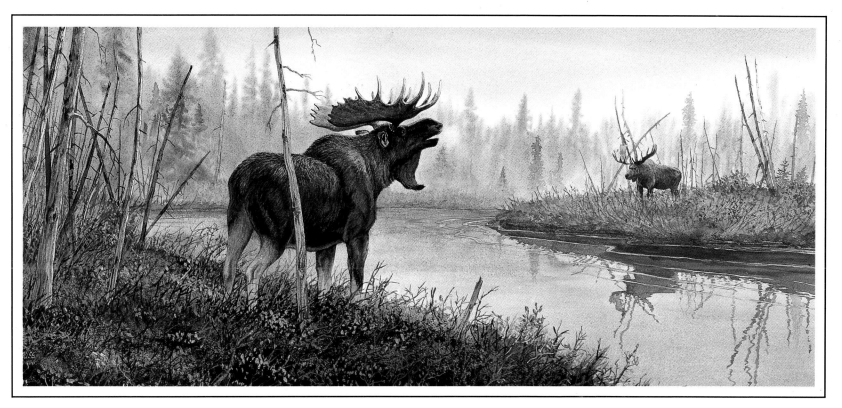

"Call to Battle"

Artist's Comments: This is an early morning scene along the banks of one of the many slow meandering streams in Alaska's interior. The rut has begun and this bull is issuing his challenge to the invader across the stream.

Original Watercolor
Private Collection

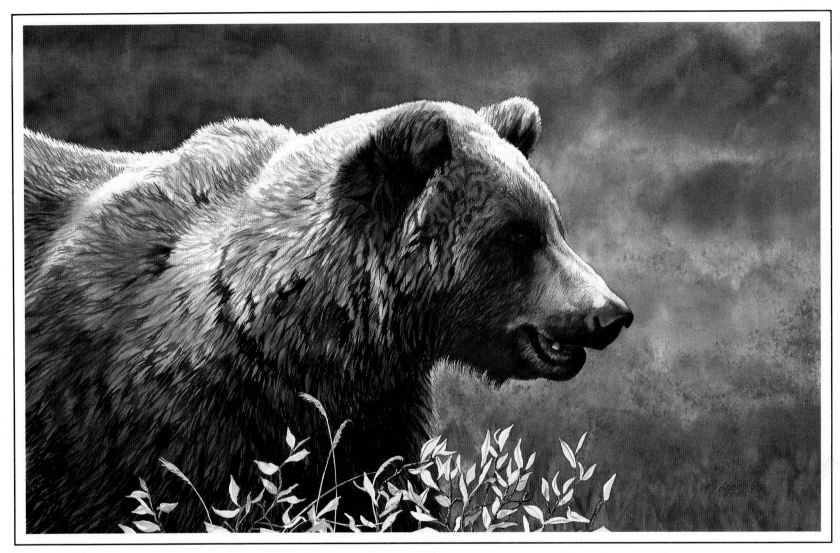

"Grizzly Portrait"

Artist's Comments: This is a painting of an autumn grizzly. He's taking a brief pause from gorging himself on blueberries — his lips are stained purple. He seems to be almost smiling at having found such a good berry patch.

Original Watercolor
Private Collection

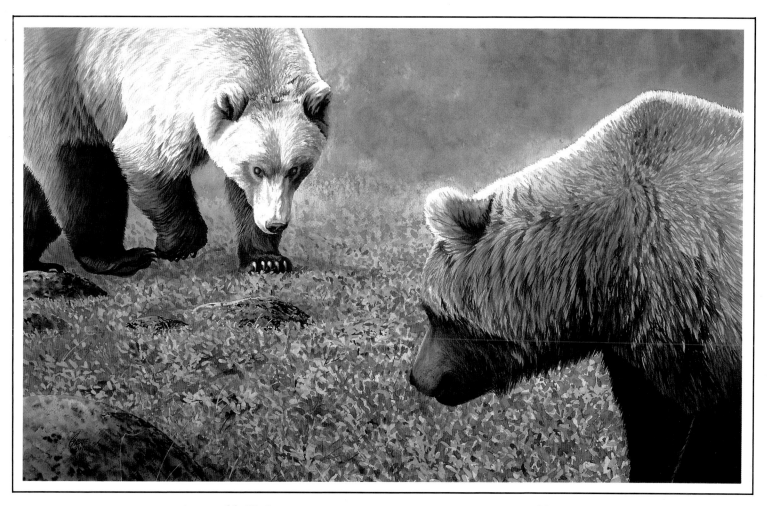

"Chance Encounter"

Artist's Comments: This portrays another face-to-face encounter — perhaps a fight, perhaps a standoff. I used some Impressionistic techniques in the background, fading it out to rivet attention on the two circling opponents. The instinct to defend territory is implicit here. These are Toklat grizzlies, which is shown by their straw-blond fur and dark legs. A grizzly bear's eye and a shark's eye have a lot in common; it is impossible to read either one.

Original Watercolor
Private Collection

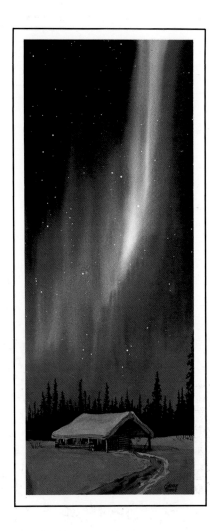

"Arctic Solitude"

Artist's Comments: This painting makes me feel alone — not always a bad feeling. Sometimes we do our best thinking and meditating when we are gazing at a star-filled sky, particularly when there is also the fascination of the aurora. The brilliant vertical line draws the eyes heavenward.

Original Watercolor
Private Collection

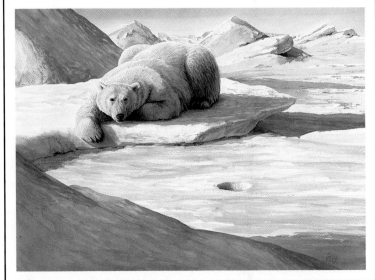

"Watching and Waiting"

Artist's Comments: I like the dynamics of this painting. I want the viewer to wonder how long the bear is going to wait for the seal to come up through the breathing hole. The bear has to remain motionless for hours because otherwise the seal will feel the vibrations of his body on the ice and won't come out. The diagonal line of the ice follows the bear's line of vision to the hole.

Original Watercolor
Private Collection

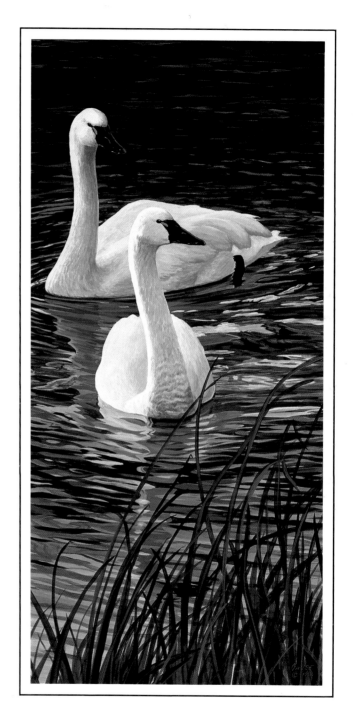

"*Ripples*"

Artist's Comments: These are Whistler Swans — restful, rhythmic. Their necks seem almost to sway like the reeds on the water's edge. Their feet moving under the surface of the water create ripples that keep time to some silent swan song. I was on the banks of Watson Lake with my scottish terrier running and barking. The swans had never seen anything like her. They were so curious that they swam over for a look, seeming completely unconcerned about her yapping.

Original Acrylic
Private Collection

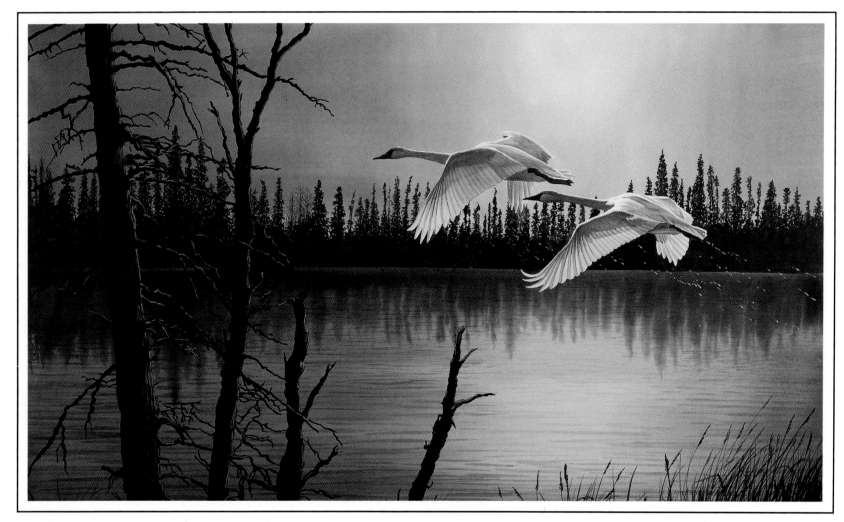

"Take Off"

Artist's Comments: The elegance of Trumpeter Swans inspires me. When they fly by, it's like music, measured and lilting. The movement of their brilliant white wings seems effortless, in the way that ballet looks effortless to the observer when it is done well. In this painting, I included harsh dead spruce trees rising up to accentuate the swan's softness.

Original Watercolor
Private Collection

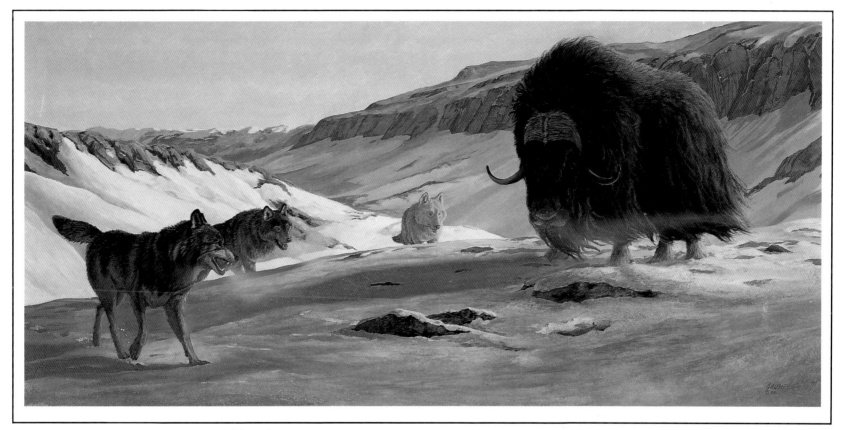

"It's Tough Being Single"

Artist's Comments: This is a survival scene. Sometimes I like paintings that have tension. You can sense a chess game going on between these figures — move and countermove. Old bull musk oxen are known to leave the herd, perhaps driven out by younger bulls. This painting portrays the encounter of a pack of wolves with such a bull. In chess, the movements are patterned and ritualistic. Similarly, bulls learn traditional defense postures, and wolves have patterned plans of attack. One holds the attention of the intended prey, while the others sneak in from behind. This is part of the everyday struggle of life and death in the far reaches of the North.

Original Alkyd
Private Collection

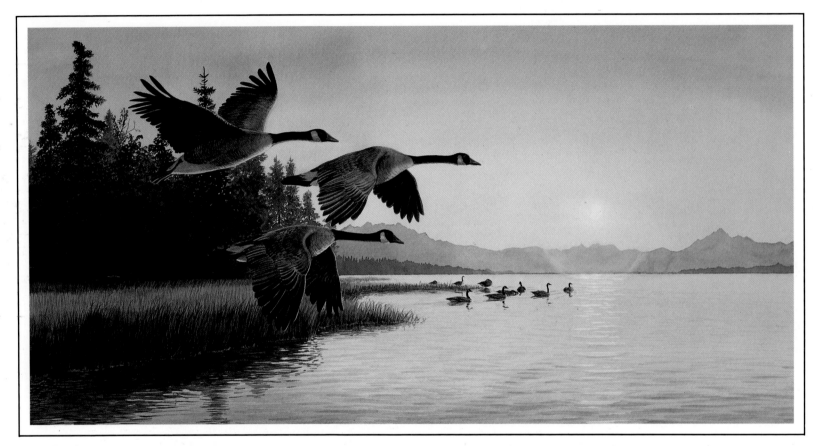

Morning Light – Canada Geese

Artist's Comments: This trio of Canada Geese is doing a "fly-by" in their typical weary fashion before they decide to land among the group on the lake shore. I enjoyed the challenge of catching the sun breaking over the mountains. Mornings are one of the best times to observe waterfowl in flight.

Original Watercolor
Private Collection

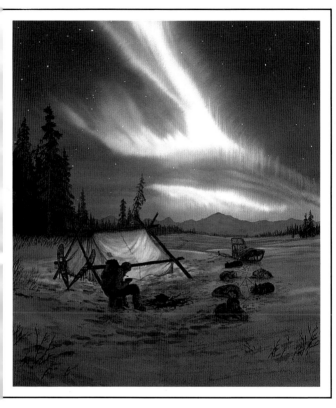

"The Last
One to Eat"

Artist's Comments: This trapper has set up his
camp, fed the dogs, taken care of the day's catch.
Finally, he gets to sit down on an empty can of lard
to have some grub. He eats alone, but enjoys the
inviting glow of the lantern in the tent and the light
of the aurora.

Original Watercolor
Private Collection

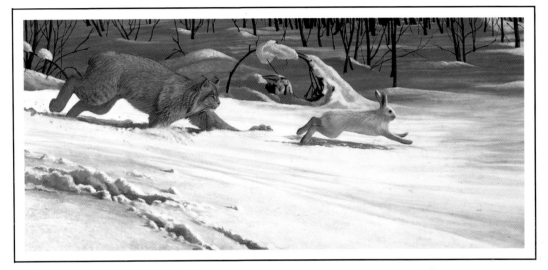

"The Chase"

Artist's Comments: I was visiting the Alaska zoo one day, standing watching the
lynx, feeling sorry for him that he was stuck in there unable to hunt any more. He
was lying outside on the snow; I thought he was asleep. Suddenly, like the snap of
the fingers, he was hanging from the top of his cage, and he had captured a bird
that had been unfortunate enough to land on top of the chain link cage. In the
wild, however, the rabbit is very elusive quarry, even with all the lynx's ability. Far
more encounters result in the rabbit's escape.

Original Acrylic
Private Collection

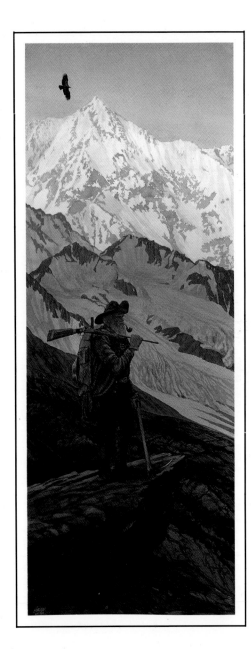

"First Trip of Spring"

Artist's Comments: This prospector is on his way back out to his digs in the spring. He has stopped to survey the landscape. His gun is tied together with string when he dropped it on the climb up. The golden eagle high overhead symbolizes the freedom he feels in his heart.

Original Watercolor
Private Collection

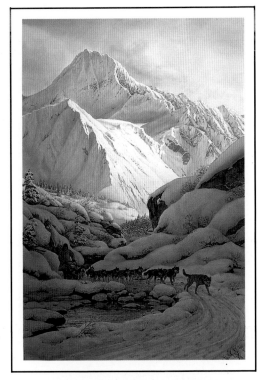

"Down the Gorge"

Artist's Comments: This is an afternoon scene; the faint pink alpenglow is already starting to show. A musher is traveling along a creek bed in a canyon far below the towering mountains. He may be in training for a big race or just heading to town to get his mail.

Original Watercolor
Private Collection

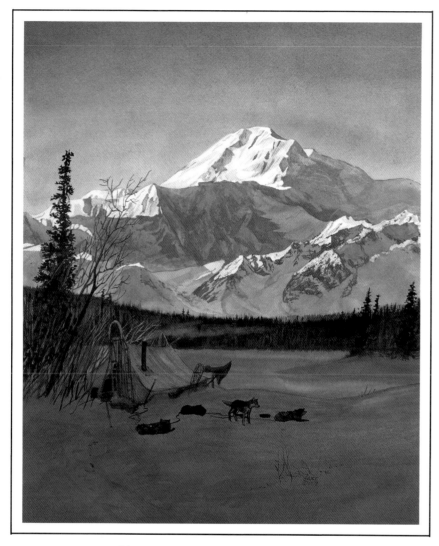

"Winter Rest"

Artist's Comments: This is a trapper's wall tent. His team is resting. Perhaps he's inside enjoying a well-deserved meal. Or maybe he's watching the last rays of the sun on Mt. McKinley through the door of his tent.

Original Watercolor
Private Collection

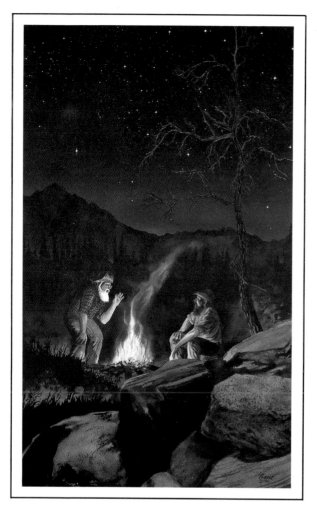

"The Nugget"

Artist's Comments: A good friend posed for both of these old sourdoughs. I had the hardest time getting him to make the facial expressions I was looking for. The prospector in the red shirt is no doubt spinning some tall tale about acquiring the nugget in his hand.

Original Watercolor
Private Collection

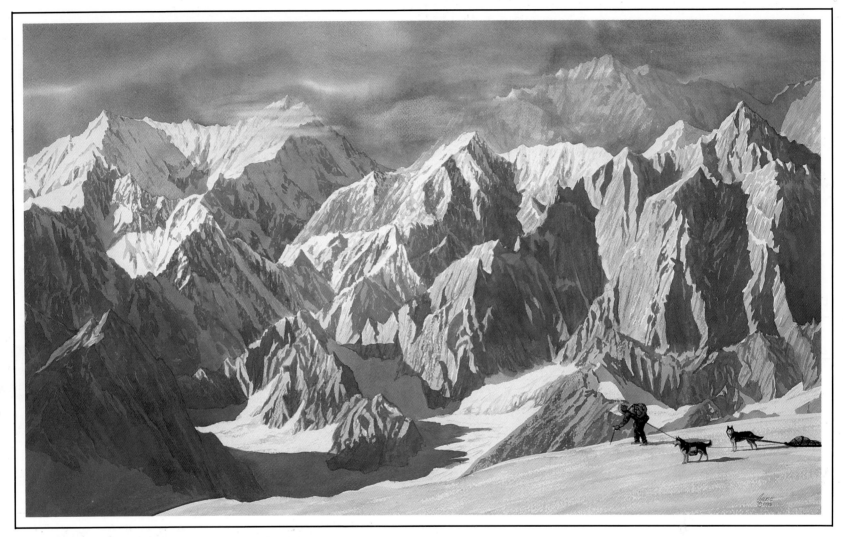

"Testing the Snow"

Artist's Comments: In this scene, the immensity of the Alaskan wild is contrasted with the size of the man and his team. He's probing a snow cornice with his ice ax, unsure whether the snow will collapse under him at the next step. But the mountains will still be there as silent watchmen — without comment on whatever occurs.

Original Watercolor
Private Collection

88

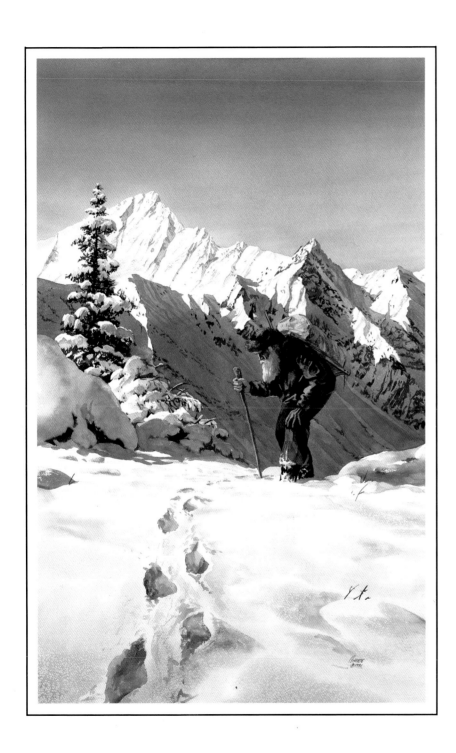

"Tracking the Devil"

Artist's Comments: This old sourdough has been tracking game through the high country. He bends low to examine the snow, looking for tell-tale signs that his last shot has hit the mark.

Original Watercolor
Private Collection

"Second Look"

Artist's Comments: I came across this scene of two young Dall sheep one day when I was out looking for animals. They blended in with the melting snow so well that I almost missed them. I liked the contrast between the ground cover and the dead patch of grass, the different pattern it makes.

Original Watercolor
Private Collection

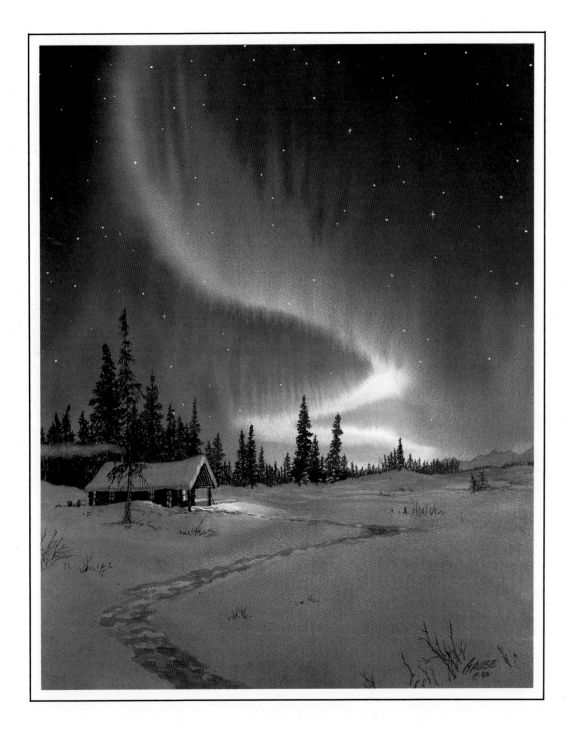

"The Glowing Sky"

Artist's Comments: The Northern Lights are a challenge to paint in watercolor and I like challenges. Trying to control the pigment while it's wet and still end up with realistic-looking Northern Lights always puts sweat on my brow. I've come to think of the Northern Lights as the Lord's compensation for enduring such long winters.

Original Watercolor
Private Collection

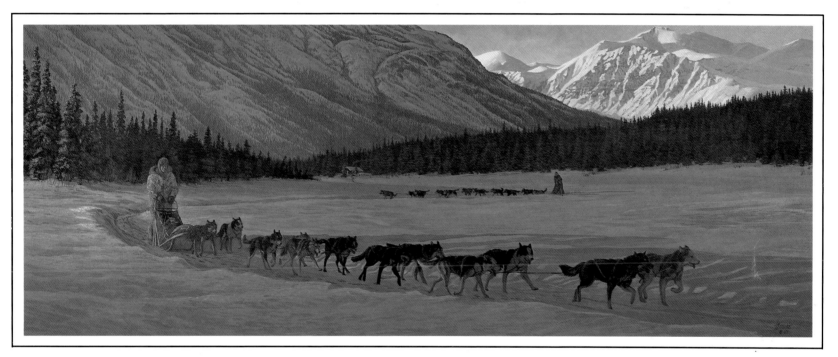

"Leaving the Rhone Check Point"
(Iditarod Trail)

Artist's Comments: This is a painting of Susan Butcher's team coming out of the Rhone River Check Point, with another musher not far behind. Like many Alaskans, I am fascinated by the Iditarod — the last great race — which is partly a celebration of the past and partly an expression of the competitiveness and independent spirit which still characterizes Alaskans.

Original Acrylic
Private Collection

"Above the Matanuska River"

Artist's Comments: While driving back from Sheep Mountain Lodge in the dead of winter, I came to this spot overlooking the Matanuska River. I thought, "What a view! What a spot for a cabin." And since I'm an artist — presto! A cabin appeared.

Original Watercolor
Private Collection

DON HENLEY INSIDE JOB

MW01259707

Project Manager: Sy Feldman
Book Art Layout: Rama Hughes
Album Art Direction: Stephen Walker
Front Cover Photography: Dennis Keeley
Additional Photography: Dennis Keeley and Matt Welch
Management: Irving Azoff
All Art © 2000 Warner Bros. Records Inc.

WARNER BROS. PUBLICATIONS - THE GLOBAL LEADER IN PRINT
USA: 15800 NW 48th Avenue, Miami, FL 33014

WARNER/CHAPPELL MUSIC

CANADA: 15800 N.W. 48th AVENUE
MIAMI, FLORIDA 33014
SCANDINAVIA: P.O. BOX 533, VENDEVAGEN 85 B
S-182 15, DANDERYD, SWEDEN
AUSTRALIA: P.O. BOX 353
3 TALAVERA ROAD, NORTH RYDE N.S.W. 2113
ASIA: UNIT 901 - LIPPO SUN PLAZA
28 CANTON ROAD
TSIM SHA TSUI, KOWLOON, HONG KONG

NUOVA CARISCH

ITALY: VIA CAMPANIA, 12
20098 S. GIULIANO MILANESE (MI)
ZONA INDUSTRIALE SESTO ULTERIANO
SPAIN: MAGALLANES, 25
28015 MADRID
FRANCE: 20, RUE DE LA VILLE-L'EVEQUE, 75008 PARIS

INTERNATIONAL MUSIC PUBLICATIONS LIMITED

ENGLAND: GRIFFIN HOUSE,
161 HAMMERSMITH ROAD, LONDON W6 8BS
GERMANY: MARSTALLSTR. 8, D-80539 MUNCHEN
DENMARK: DANMUSIK, VOGNMAGERGADE 7
DK 1120 KOBENHAVNK

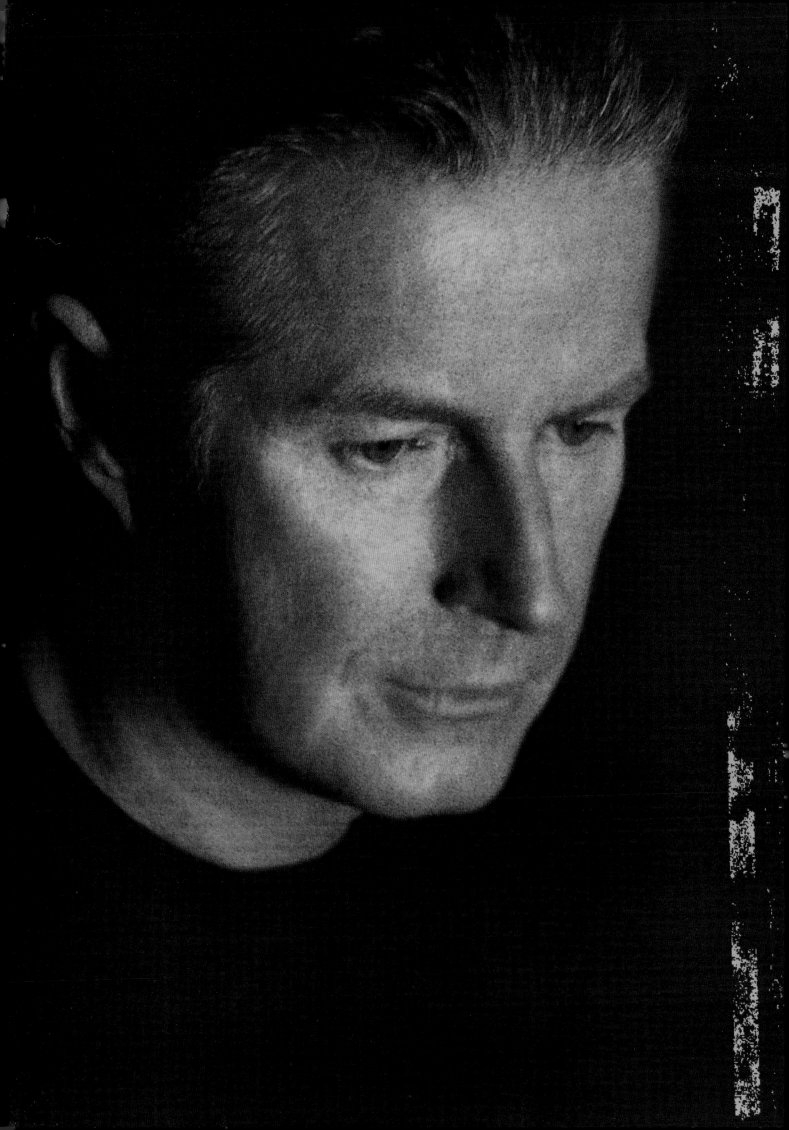

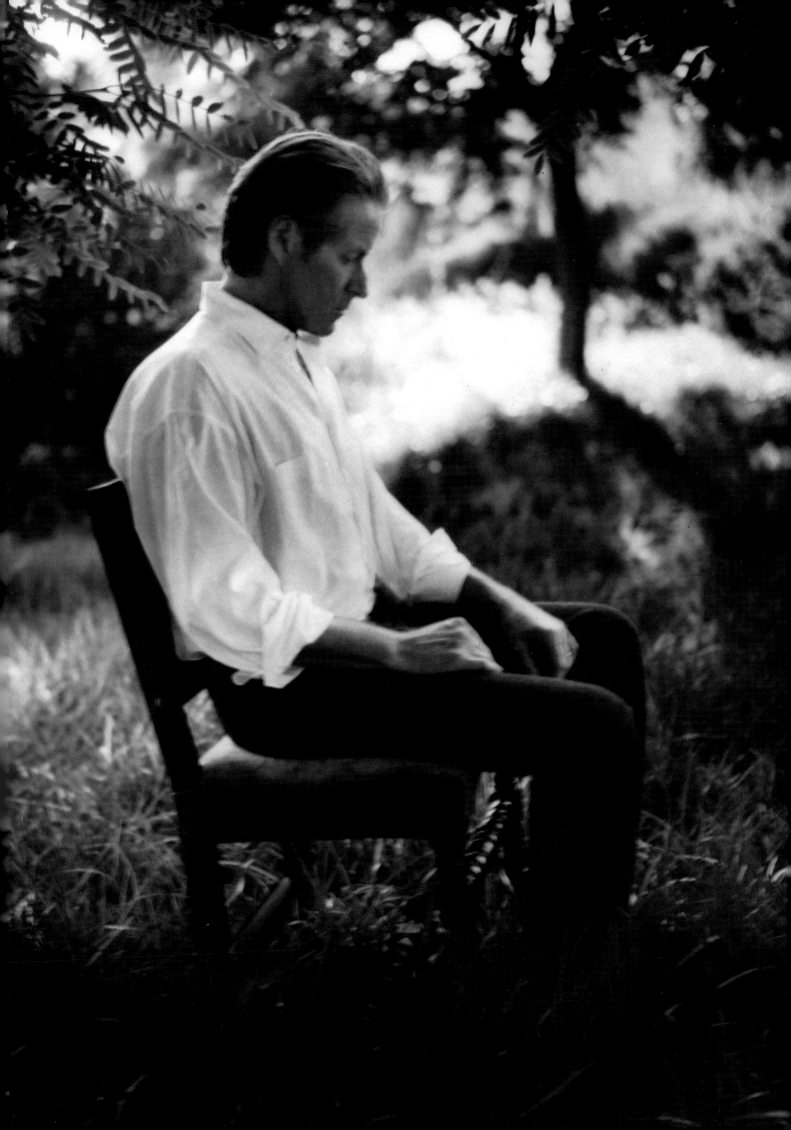

NOBODY ELSE IN THE WORLD BUT YOU

Words and Music by
DON HENLEY,
JAI WINDING and STAN LYNCH

Moderately ♩ = 108

Nobody Else In the World But You - 7 - 1
0448B

6

... end solo)

Chorus:

too.___ No-bod-y else in the world but you.___ No-bod-y else in the

world. No-bod-y else in the world but you.___ In

Verse 2:
Hey now, did your momma teach you anything?
Some things still got to be respected.
Is it a sign of the times, or is it just your callous heart?
How did you get so disconnected?
The way you push,
The way you shove,
The way you hate,
The way you love.
The lies you spin,
The scenes you make,
The grief you give,
The space you take,
It's like there's …
(To Chorus:)

TAKING YOU HOME

Words and Music by
DON HENLEY,
STAN LYNCH and STUART BRAWLEY

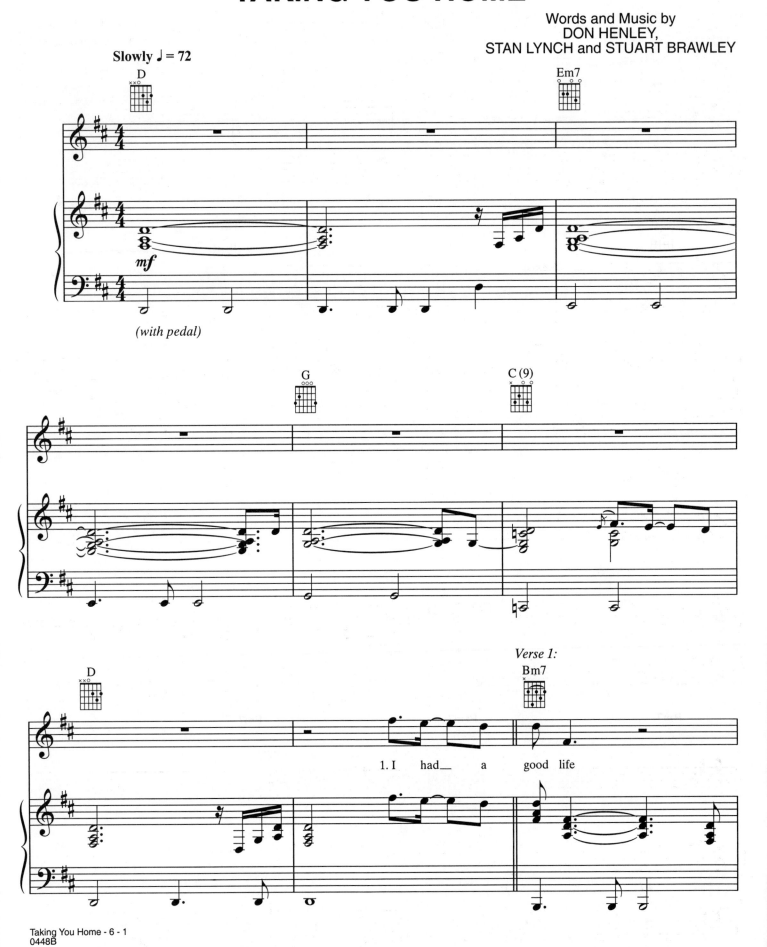

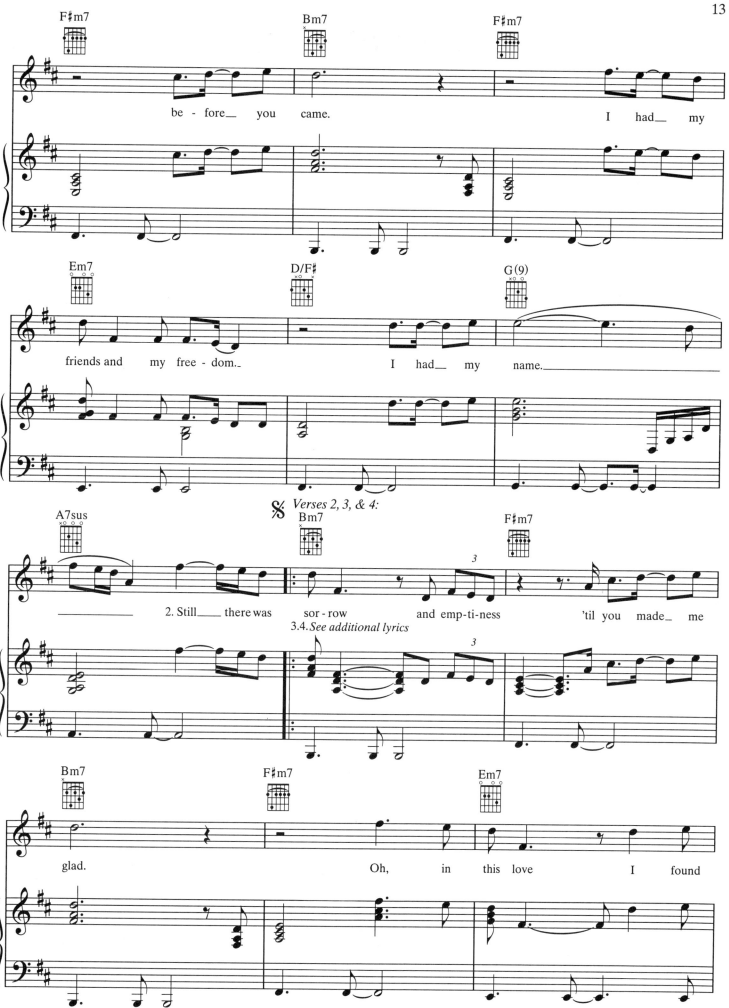

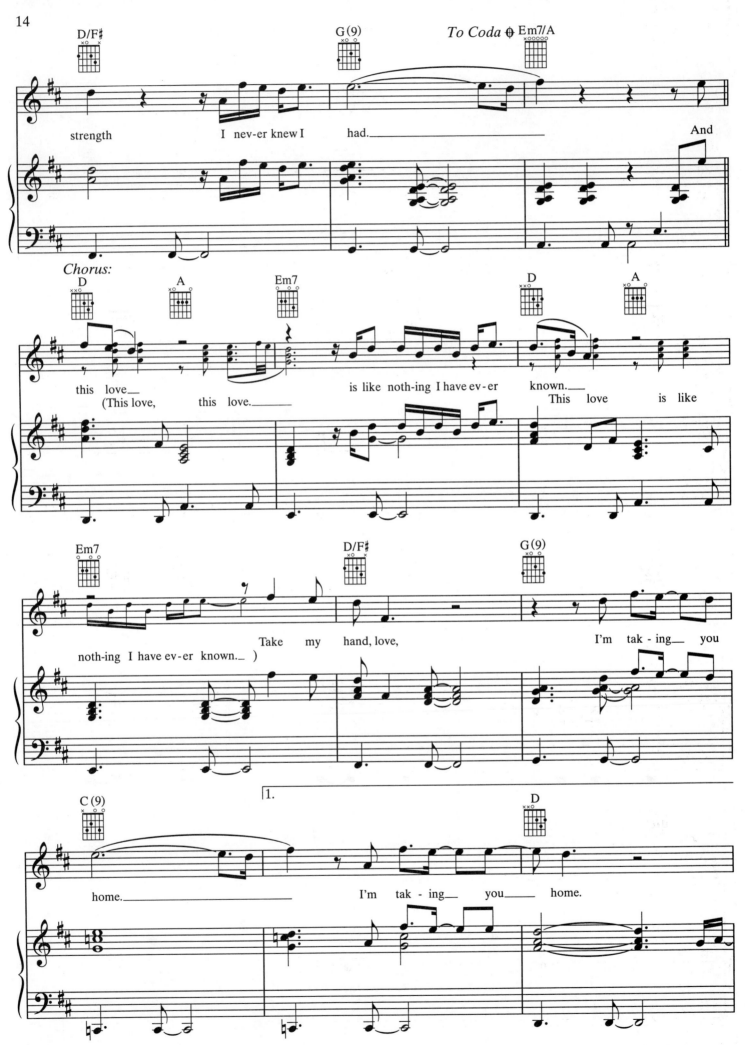

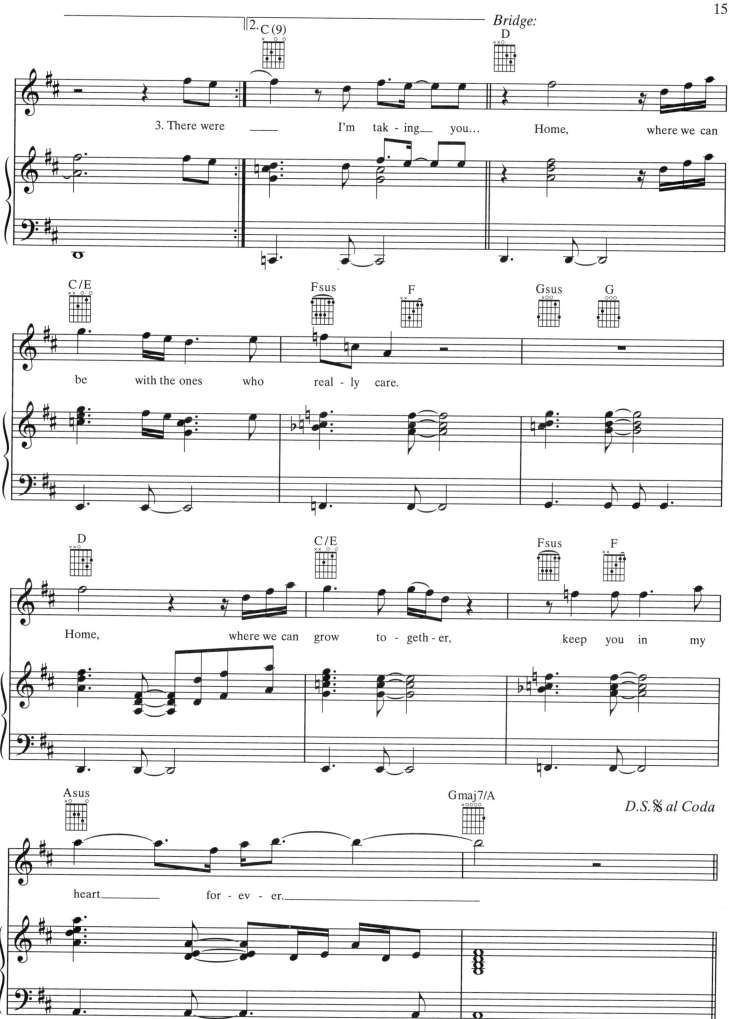

16

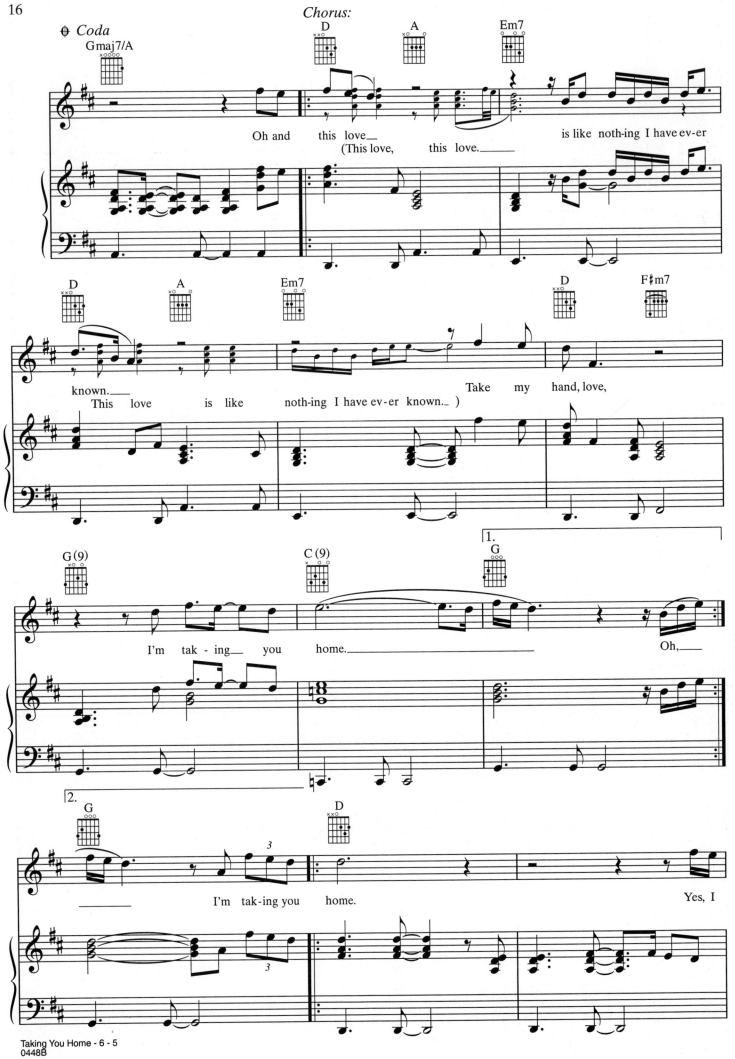

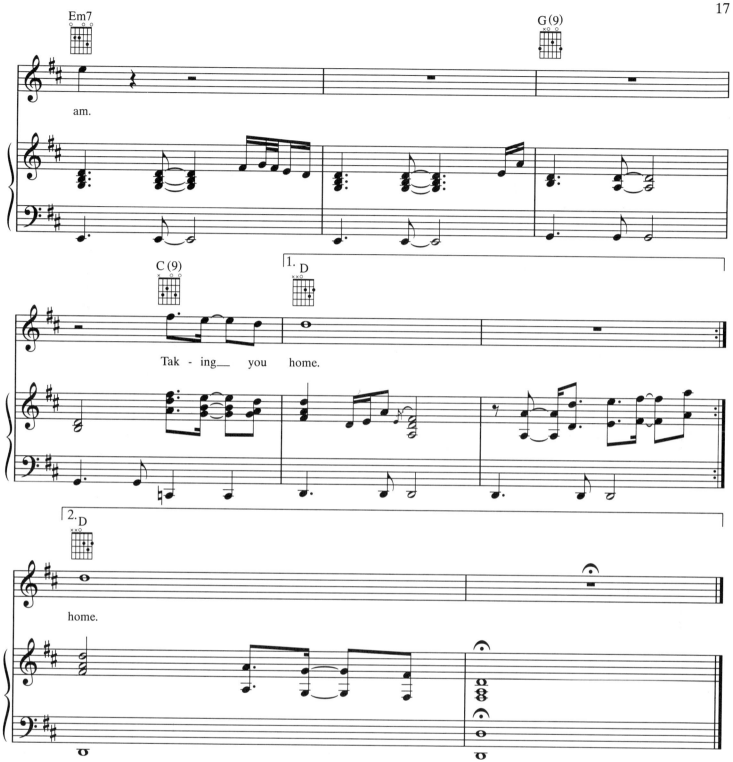

Verse 3:
There were days, lonely days
When the world wouldn't throw me a crumb.
But I kept on believing that this day would come.
(To Chorus:)

Verse 4:
(Instrumental solo ad lib.)
(To Chorus:)

FOR MY WEDDING

Words and Music by
LARRY JOHN McNALLY

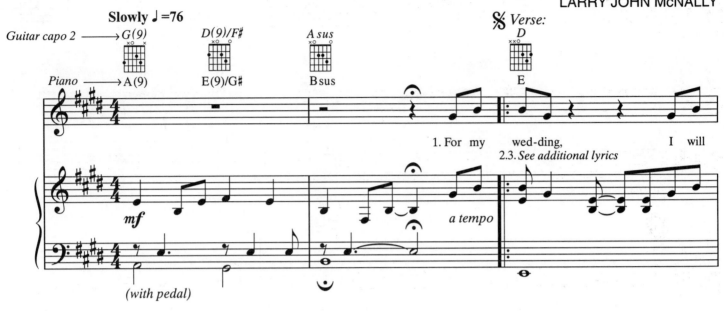

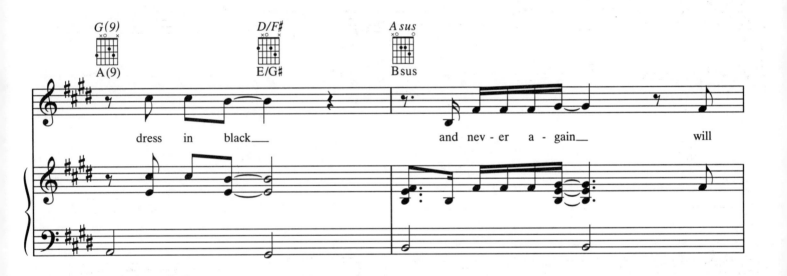

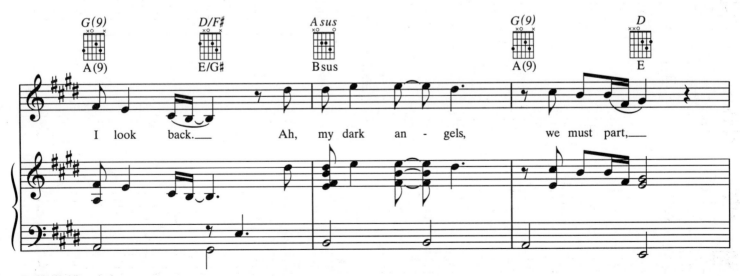

For My Wedding - 4 - 1
0448B

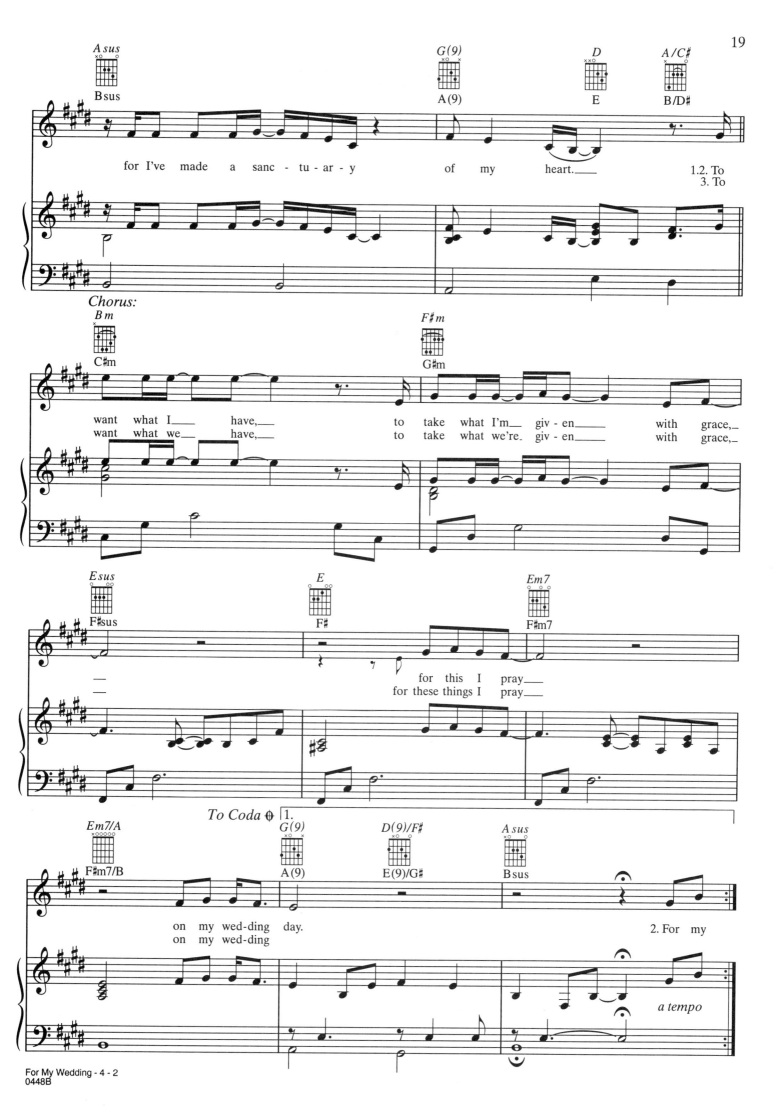

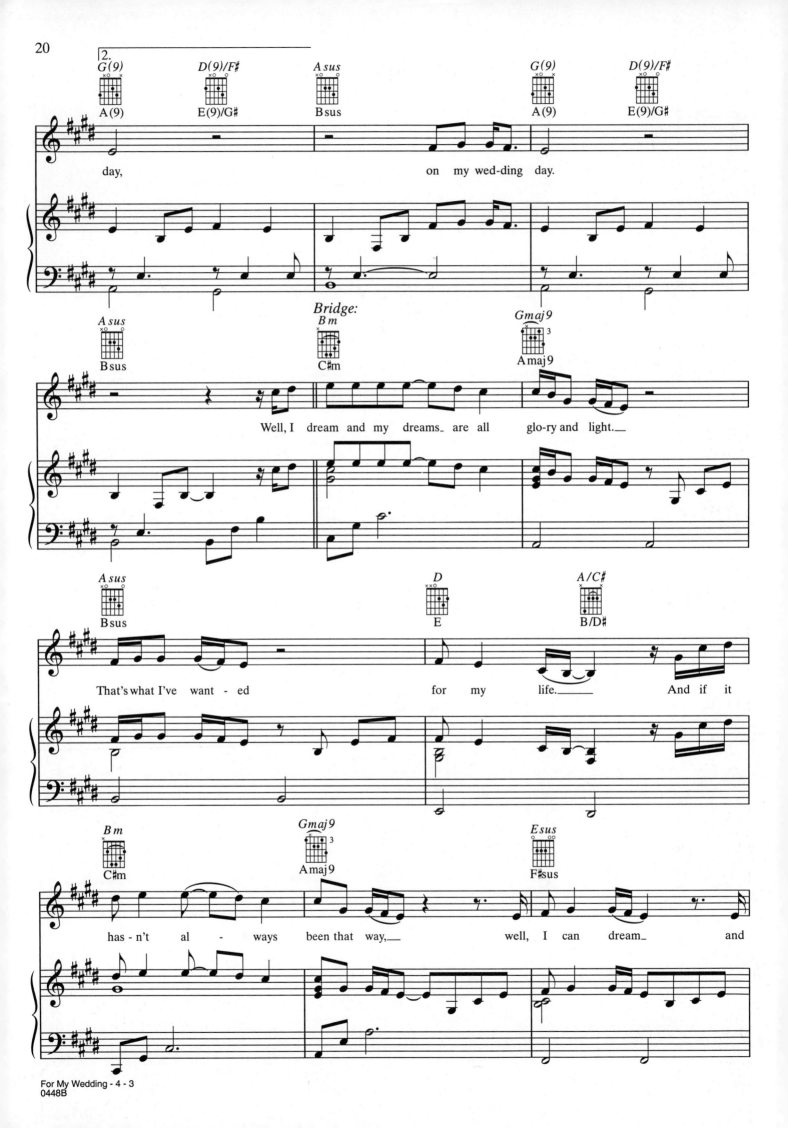

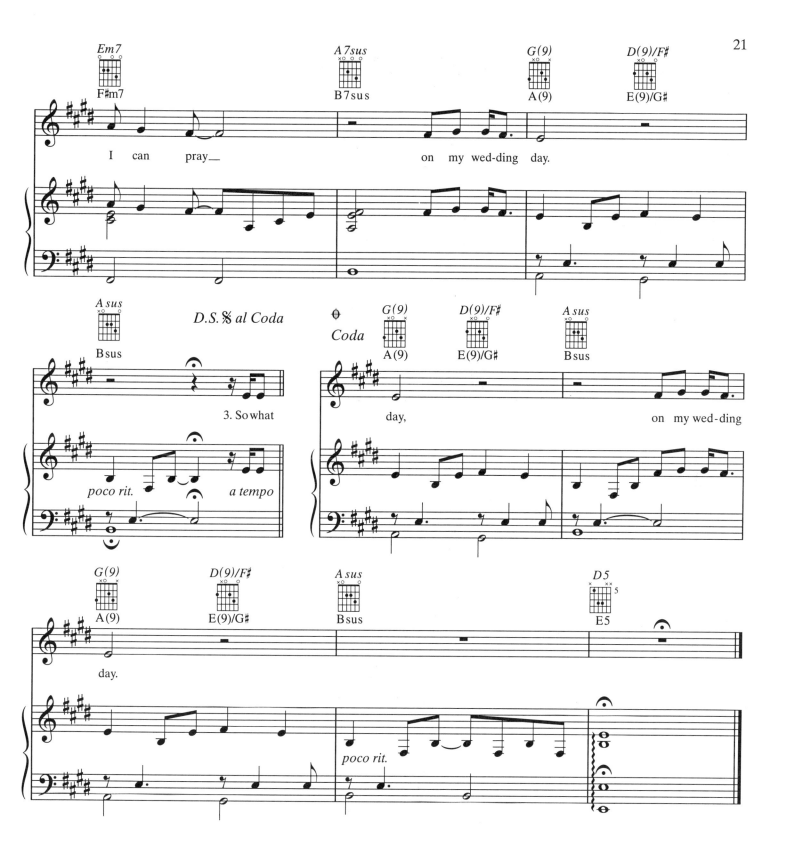

Verse 2:
For my wedding, I don't want violins
Or sentimental songs about thick and thin.
I want a moment of silence and a moment of prayer
For the love we'll need to make it in the world out there.
(To Chorus:)

Verse 3:
So what makes us any different from all the others
Who have tried and failed before us?
Maybe nothing, maybe nothing at all.
But I pray we're the lucky ones; I pray we'll never fall.
(To Chorus:)

EVERYTHING IS DIFFERENT NOW

Words and Music by
DON HENLEY,
SCOTT F. CRAGO and TIMOTHY DRURY

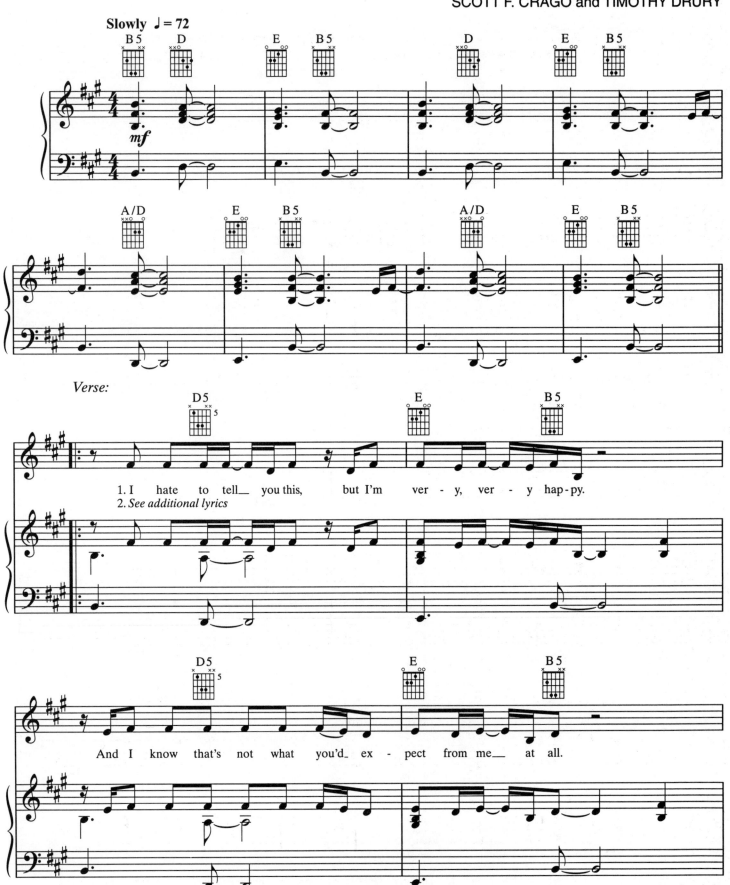

Verse:

1. I hate to tell_ you this, but I'm ver - y, ver - y hap - py.
2. *See additional lyrics*

And I know that's not what you'd_ ex - pect from me_ at all.

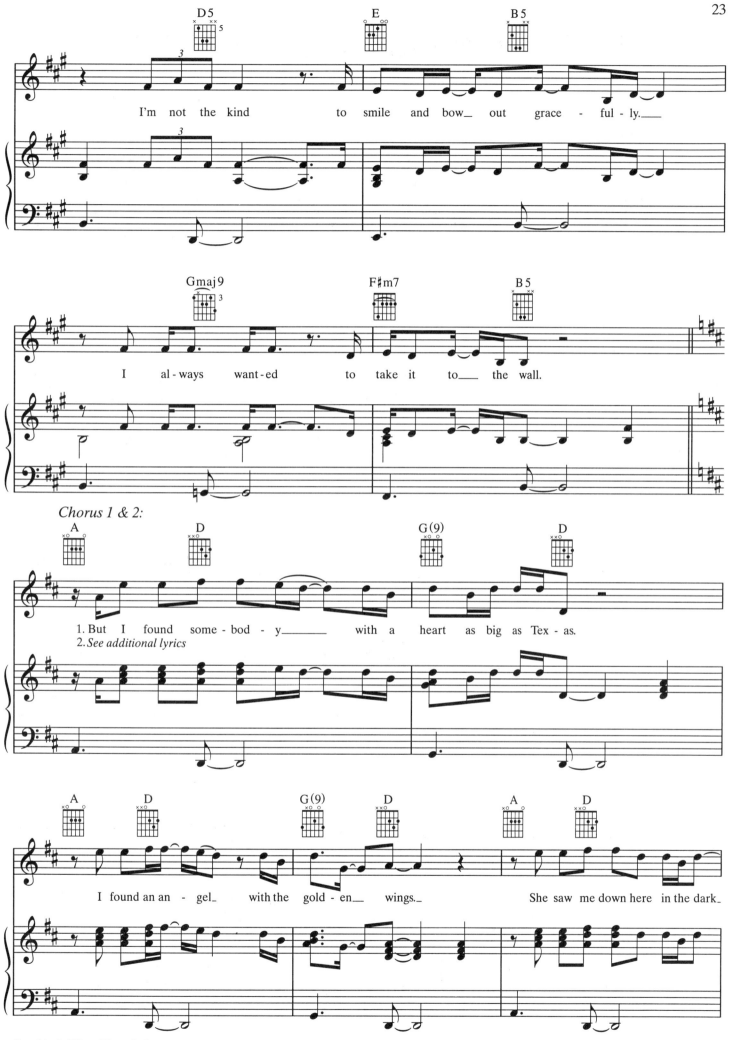

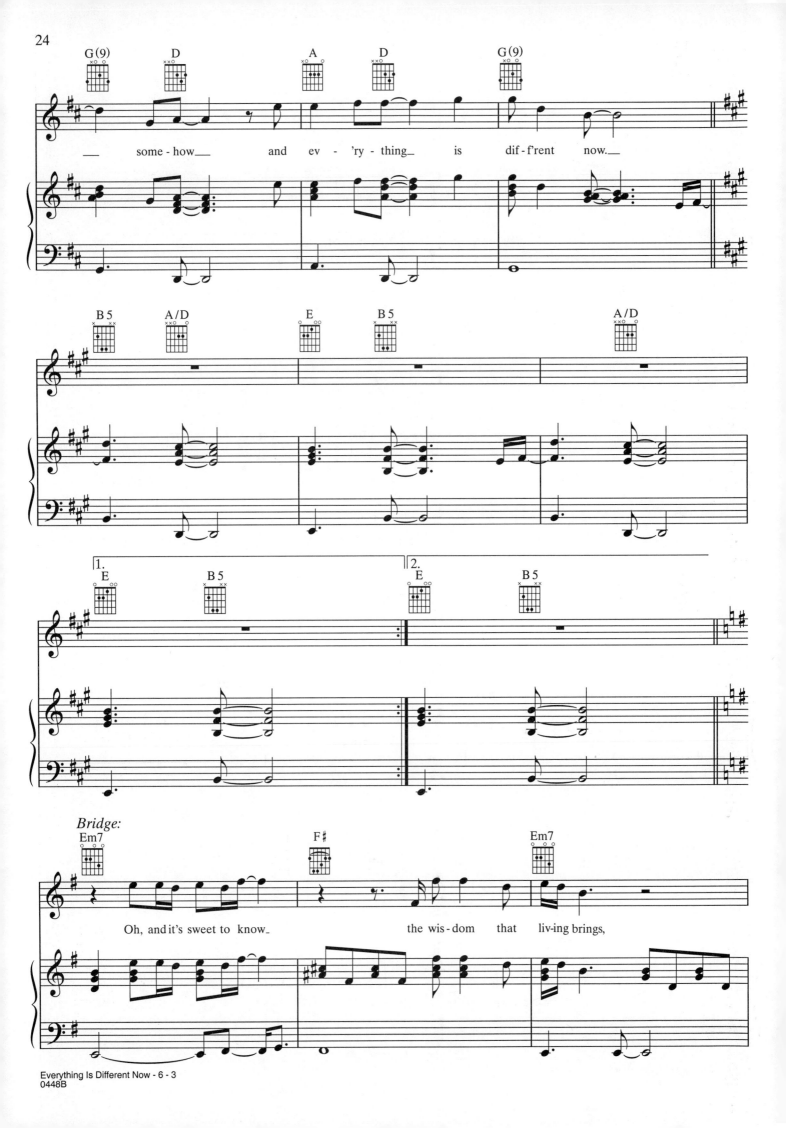

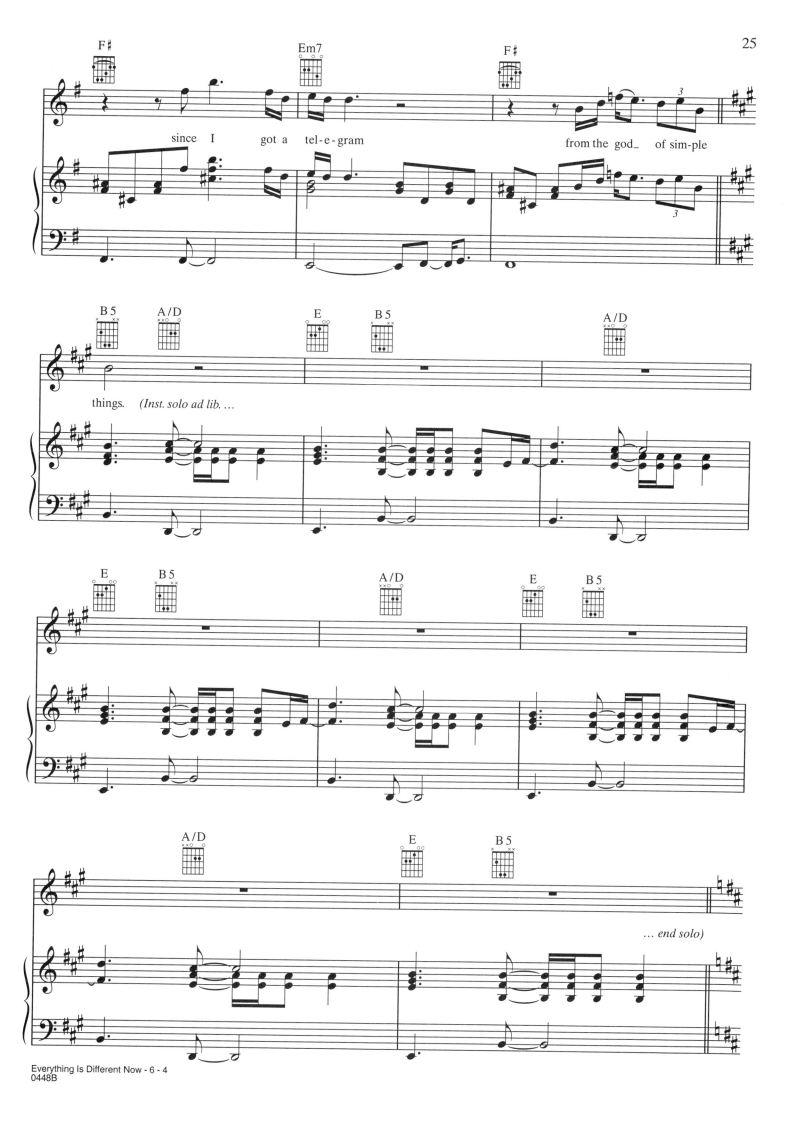

26

Chorus 3:

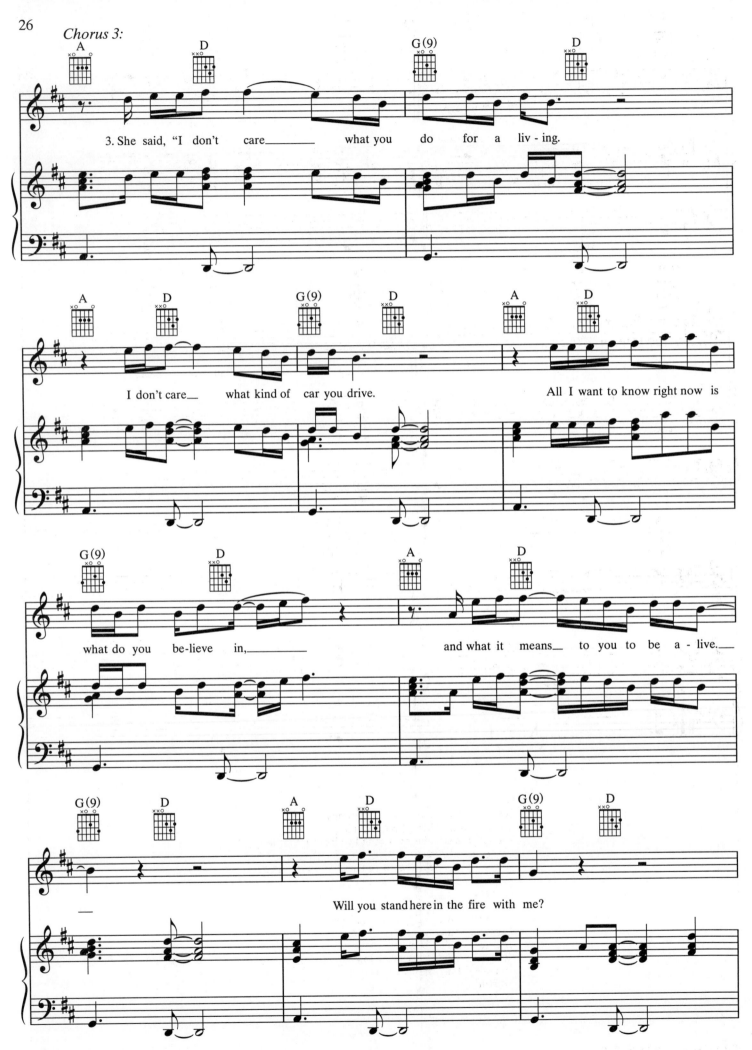

3. She said, "I don't care_____ what you do for a liv - ing.

I don't care___ what kind of car you drive. All I want to know right now is

what do you be-lieve in,_____ and what it means___ to you to be a - live.___

___ Will you stand here in the fire with me?

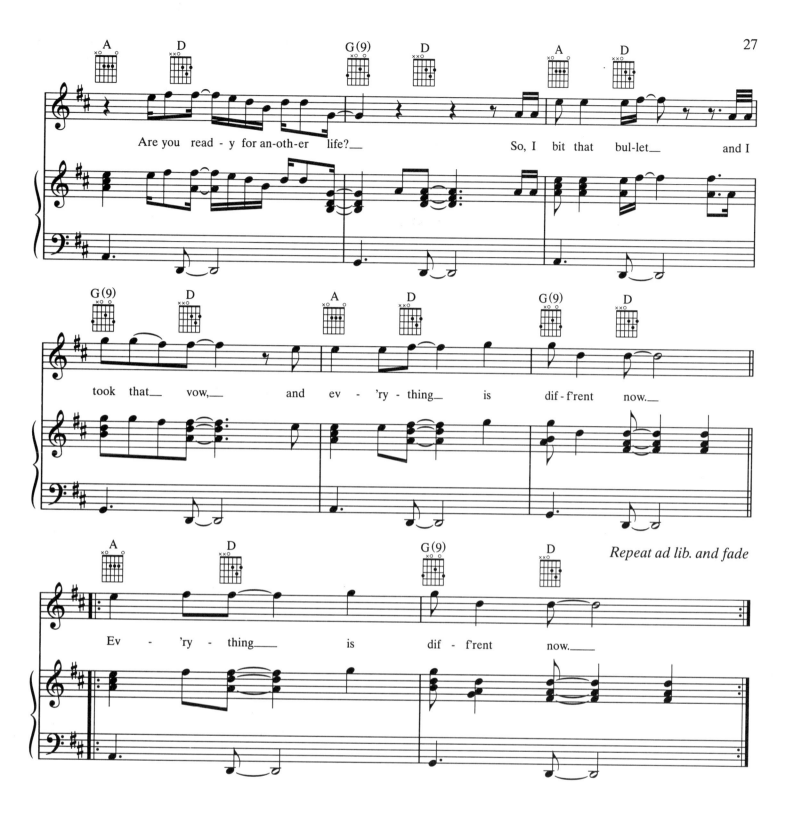

Verse 2:
Yeah, I miss the old crowd sometimes
And the wild, wild nights of running.
You know, a starving soul can't live like that for long.
You go around in circles that just keep getting smaller.
You wake up one morning and half your life is gone.

Chorus 2:
I got so tired of that; I got so lonely.
I dropped down and I called out to heaven,
"Send me someone to love."
And heaven shot back,
"You get the love that you allow."
And everything is different now.
(To Bridge:)

WORKIN' IT

Words and Music by
DON HENLEY,
FRANK SIMES and STAN LYNCH

Moderately slow ♩ = 86

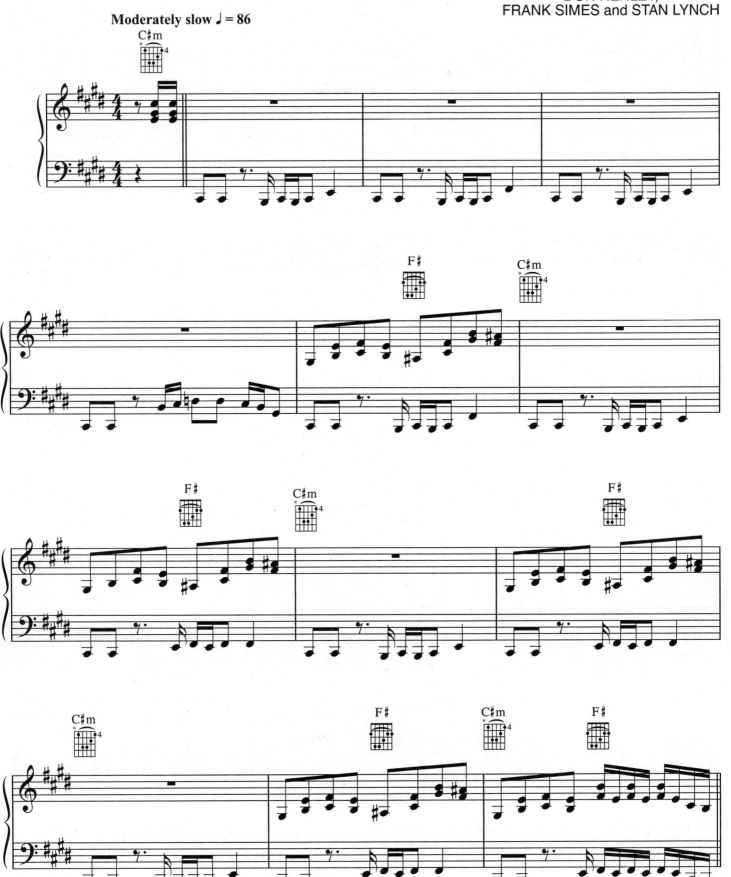

Workin' It - 10 - 1
0448B

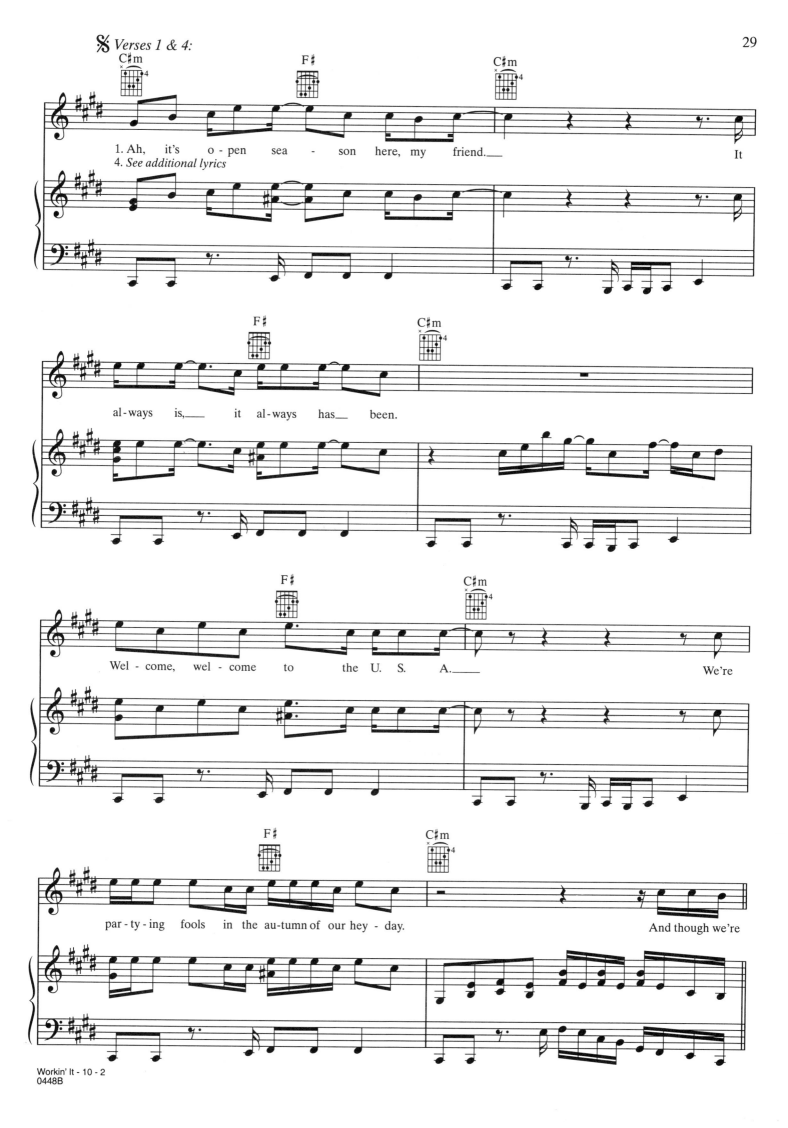

Verses 1 & 4:

1. Ah, it's o-pen sea-son here, my friend.___ It
4. *See additional lyrics*

al-ways is,___ it al-ways has___ been.

Wel-come, wel-come to the U. S. A.___ We're

par-ty-ing fools in the au-tumn of our hey-day. And though we're

30

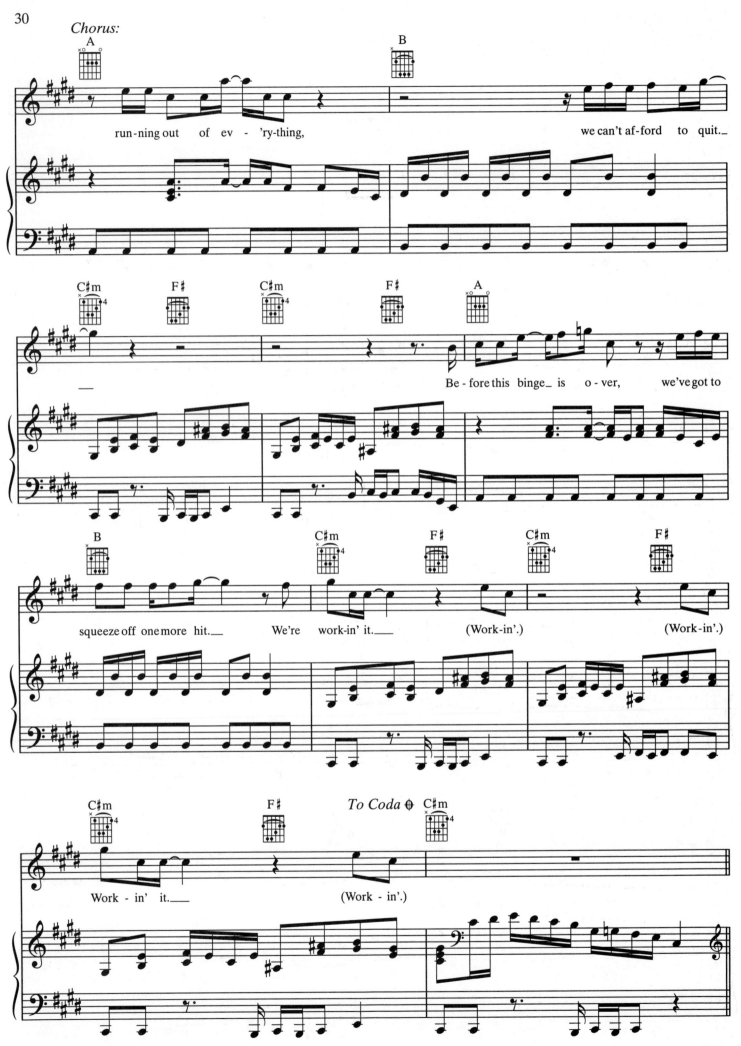

Verse 2:

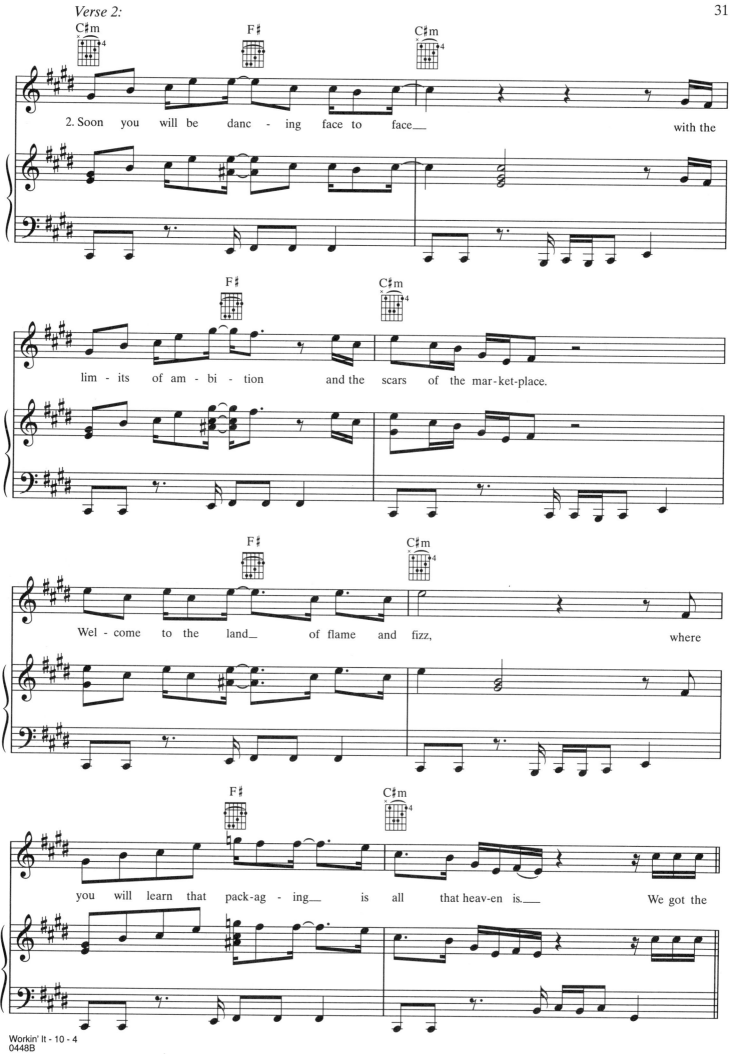

2. Soon you will be danc - ing face to face__ with the

lim - its of am - bi - tion and the scars of the mar-ket-place.

Wel - come to the land__ of flame and fizz, where

you will learn that pack-ag - ing__ is all that heav-en is.__ We got the

Verse 3:

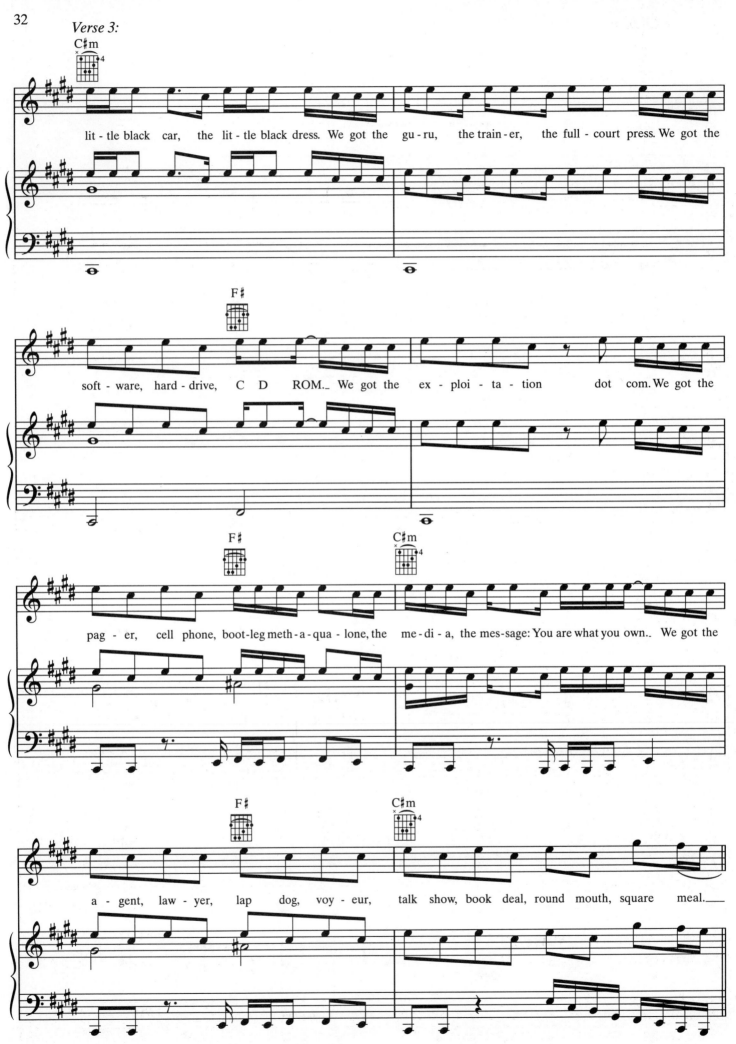

lit - tle black car, the lit - tle black dress. We got the gu - ru, the train - er, the full - court press. We got the

soft - ware, hard - drive, C D ROM._ We got the ex - ploi - ta - tion dot com. We got the

pag - er, cell phone, boot-leg meth - a - qua - lone, the me - di - a, the mes-sage: You are what you own._ We got the

a - gent, law - yer, lap dog, voy - eur, talk show, book deal, round mouth, square meal.___

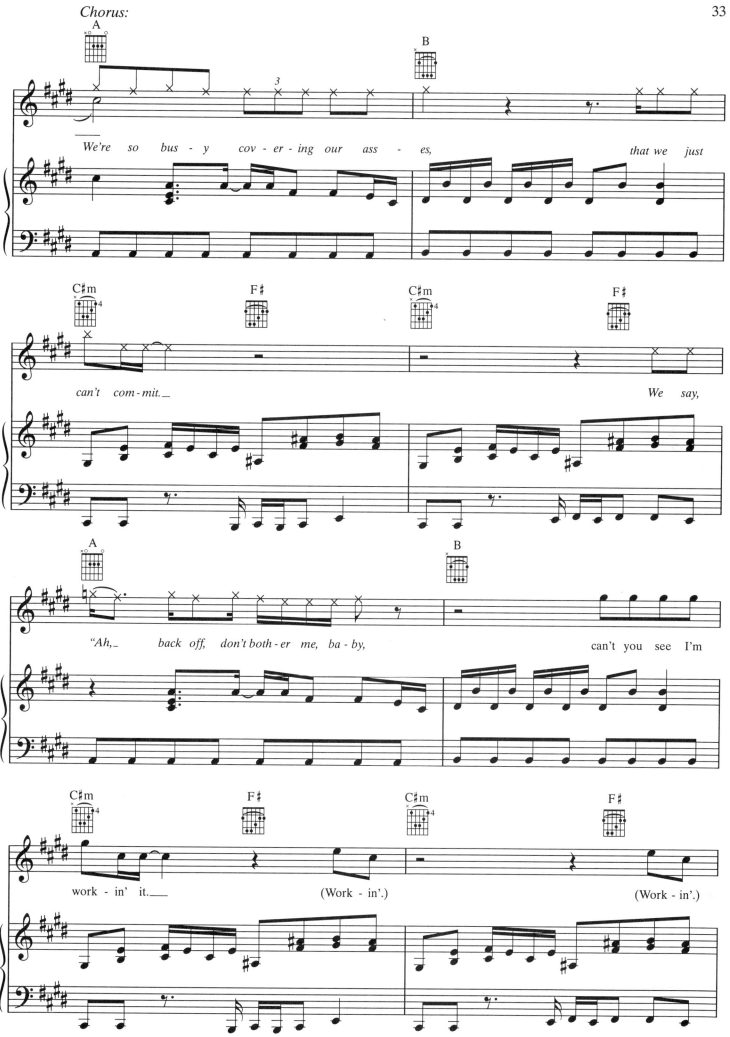

Chorus:

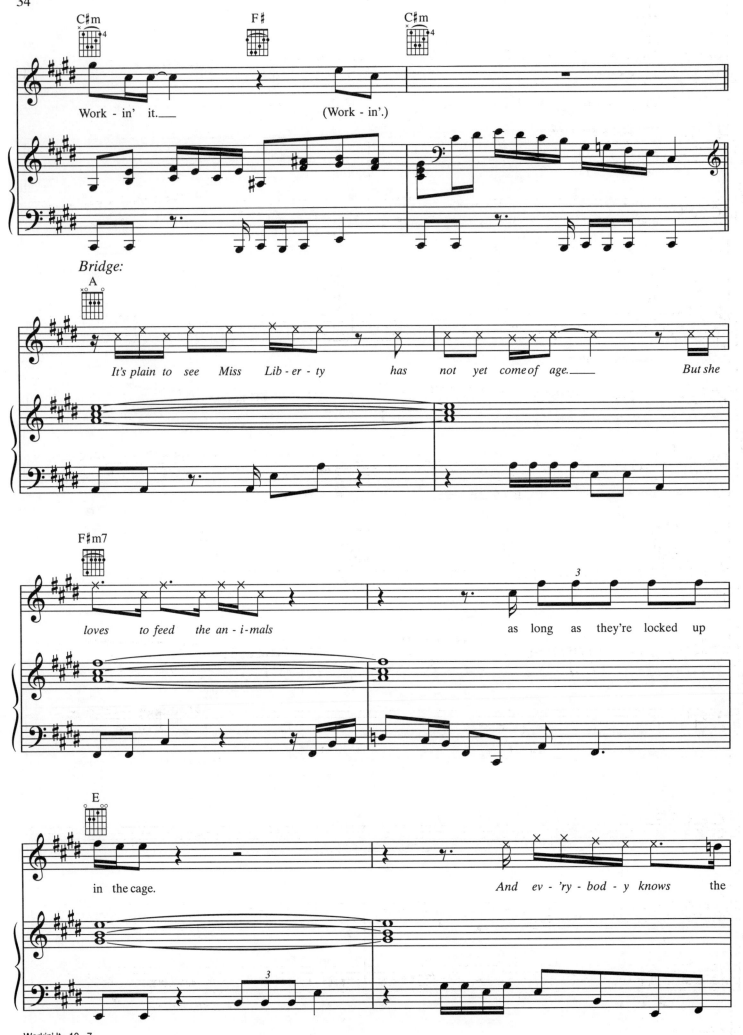

Work - in' it.___ (Work - in'.)

Bridge:

It's plain to see Miss Lib - er - ty has not yet come of age.___ But she

loves to feed the an - i - mals as long as they're locked up

in the cage. And ev - 'ry - bod - y knows the

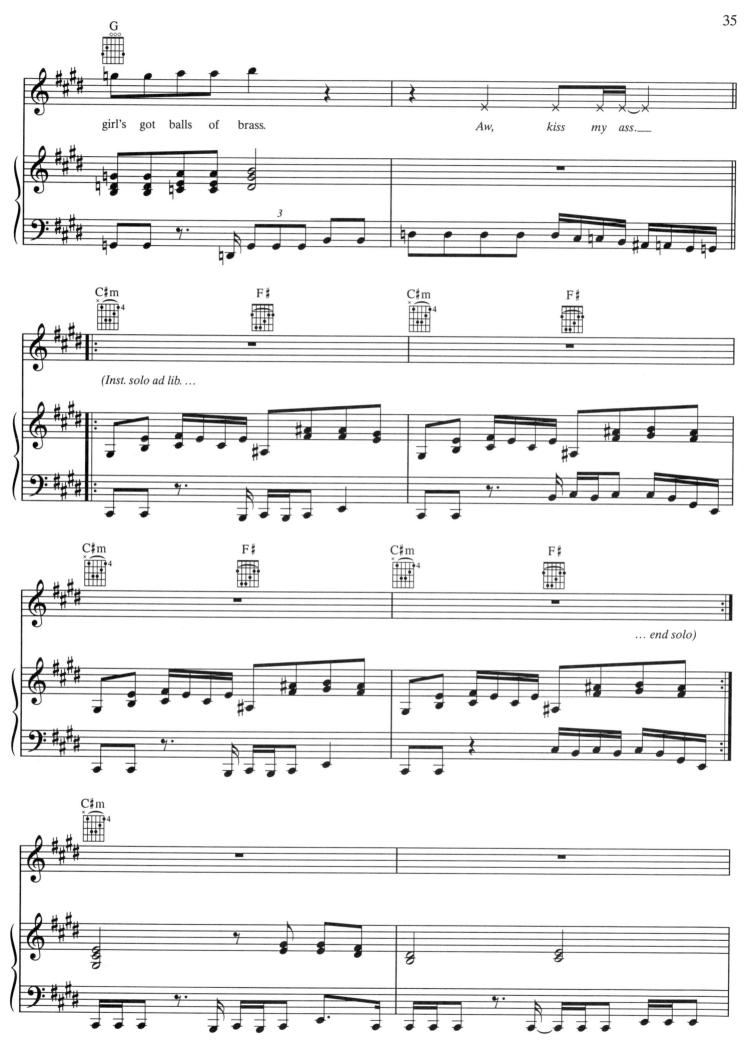

(Inst. solo ad lib. ...

... end solo)

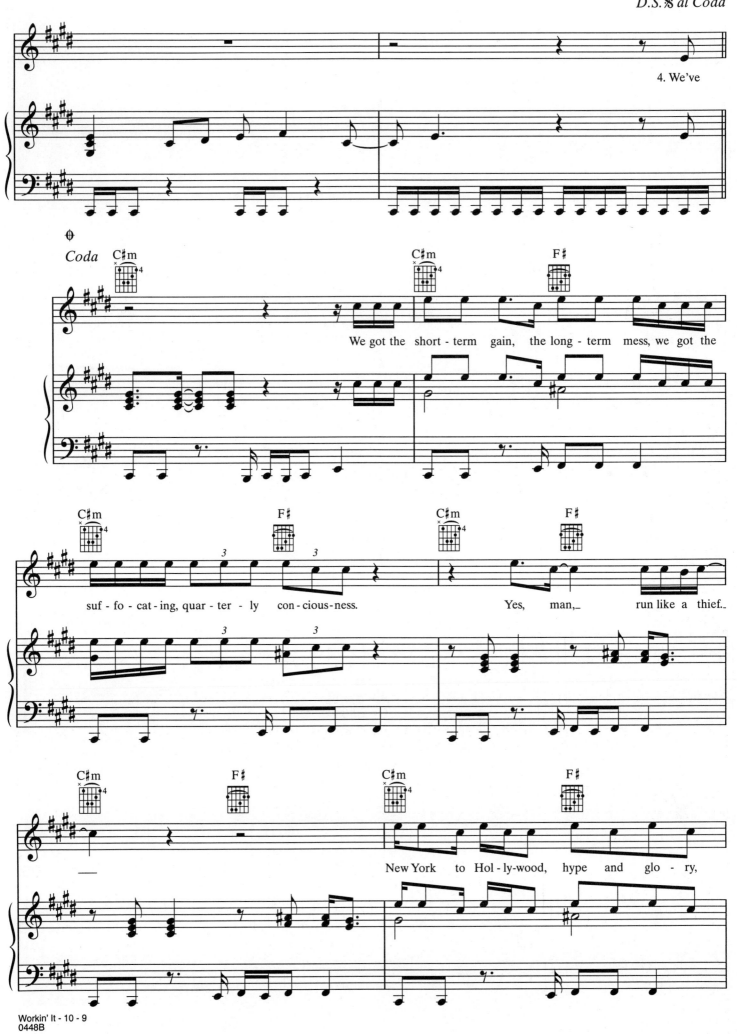

4. We've

Coda

We got the short - term gain, the long - term mess, we got the

suf - fo - cat - ing, quar - ter - ly con - cious-ness. Yes, man,_ run like a thief._

_ New York to Hol - ly-wood, hype and glo - ry,

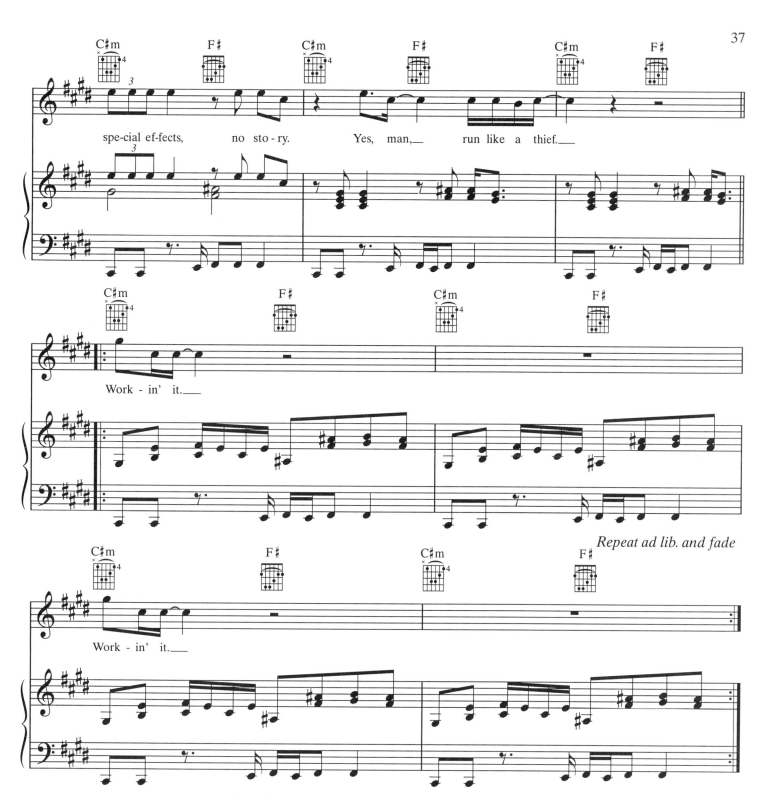

Verse 4:
We've got a whole new class of opiates
To blunt the stench of discontent,
In these corporation nation-states
Where the loudest live to trample on the least.
They say it's just the predatory nature of the beast.

Chorus 3:
But the barons in the balcony are laughing
And pointing to the pit.
They say, "Aw look, they've grown accustomed to the smell.
Now people love that shit and we're workin' it."

Ad lib. lyrics for repeat and fade:
Well, you don't know who the enemy is.
You don't know,
You don't know who the enemy is.
Company man.
"Eight for me, one for you."
"Very fair."
Business as usual,
Business as usual.

GOODBYE TO A RIVER

Words and Music by
DON HENLEY, STAN LYNCH,
JAI WINDING and FRANK SIMES

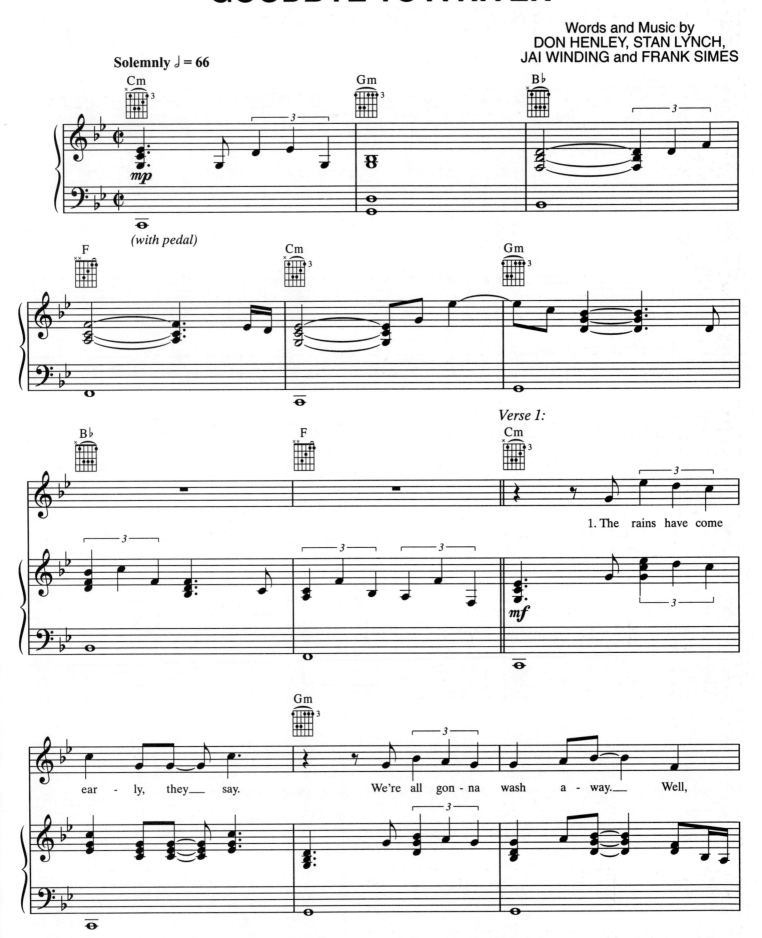

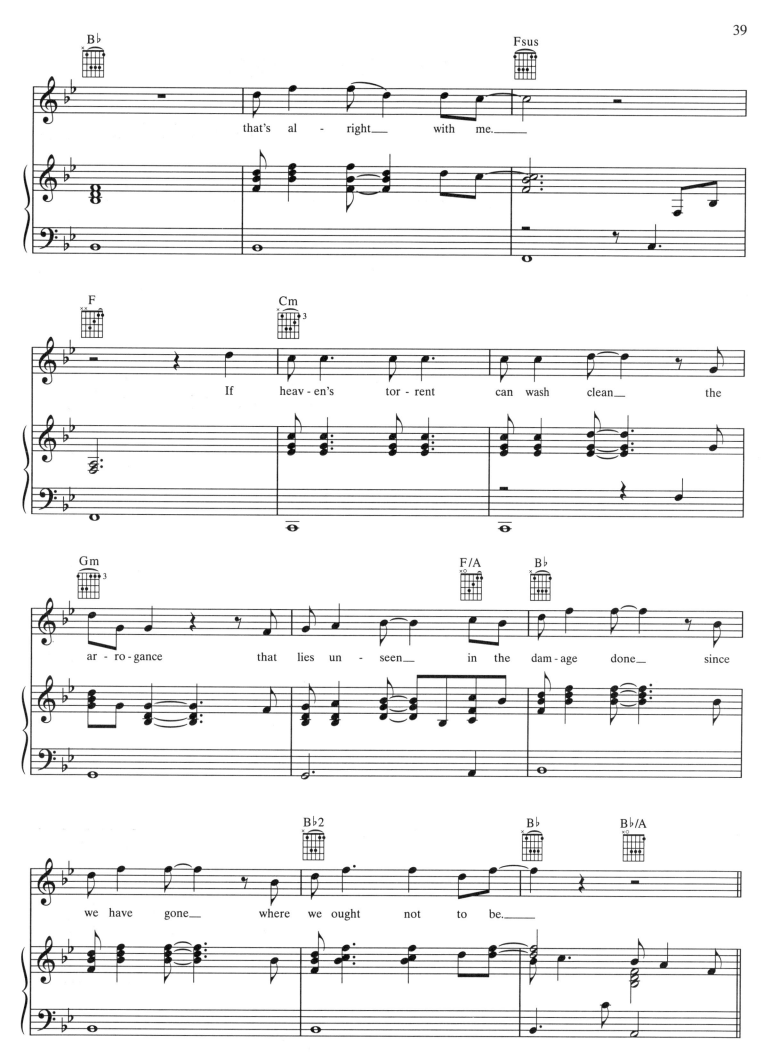

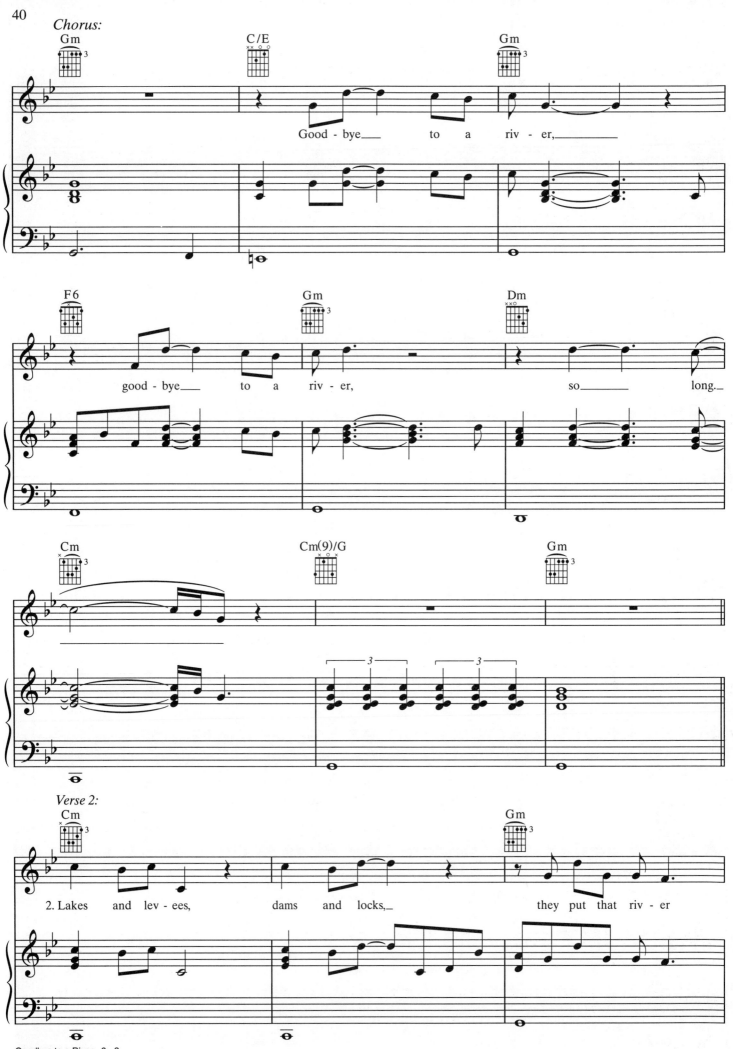

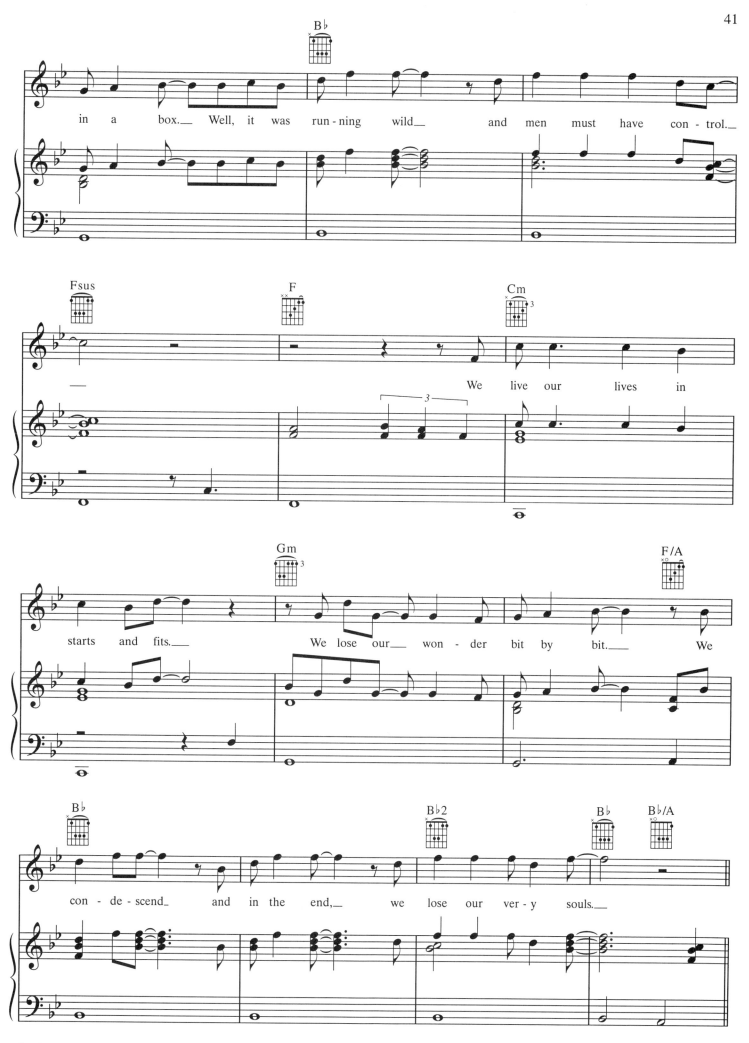

42

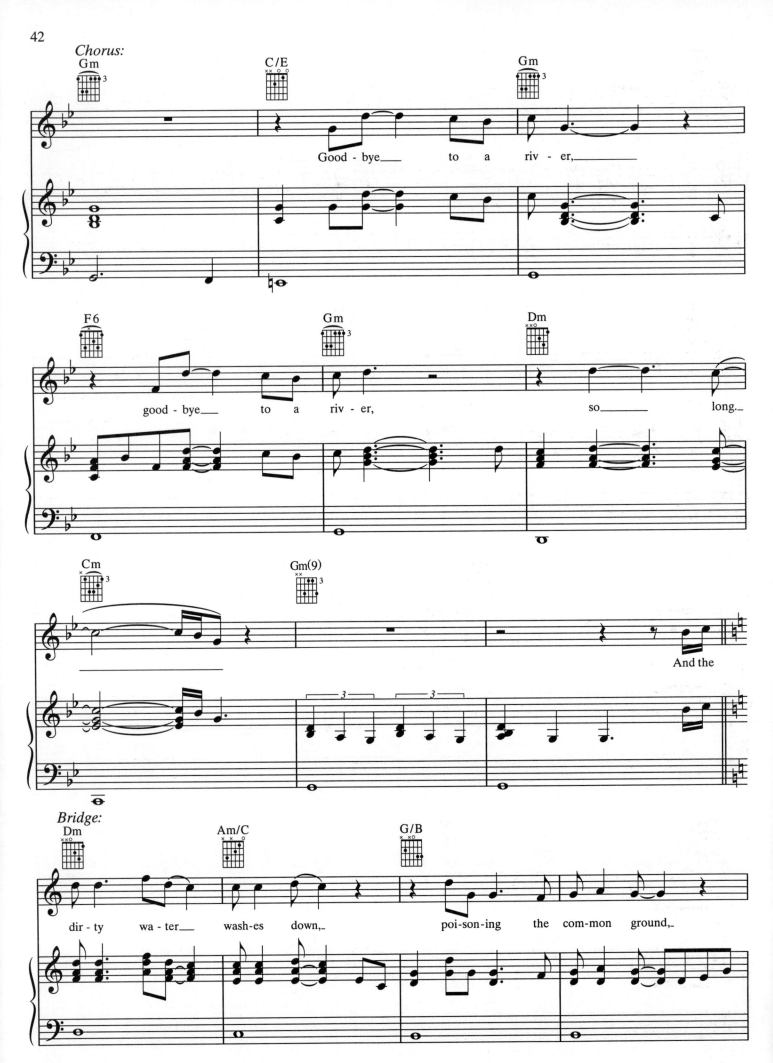

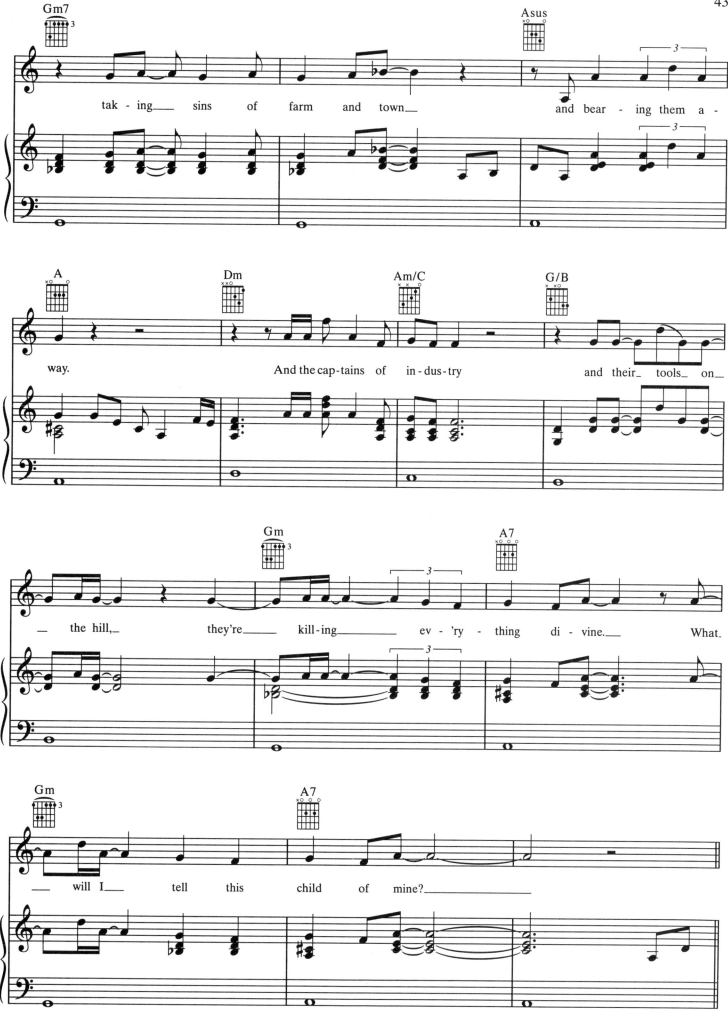

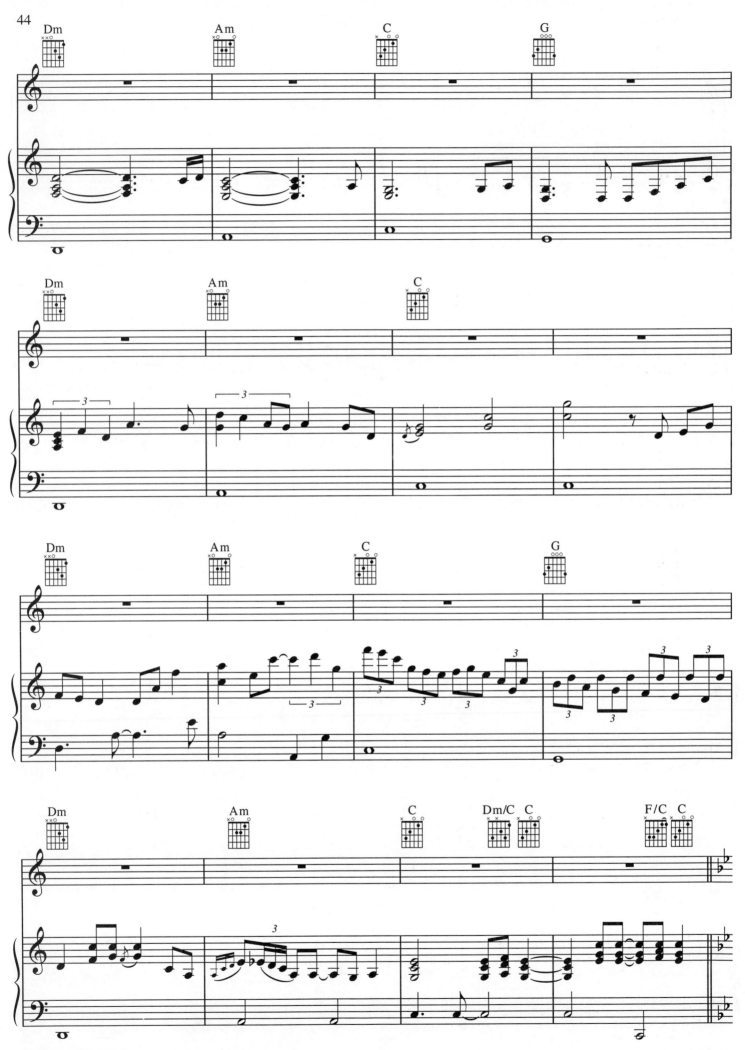

44

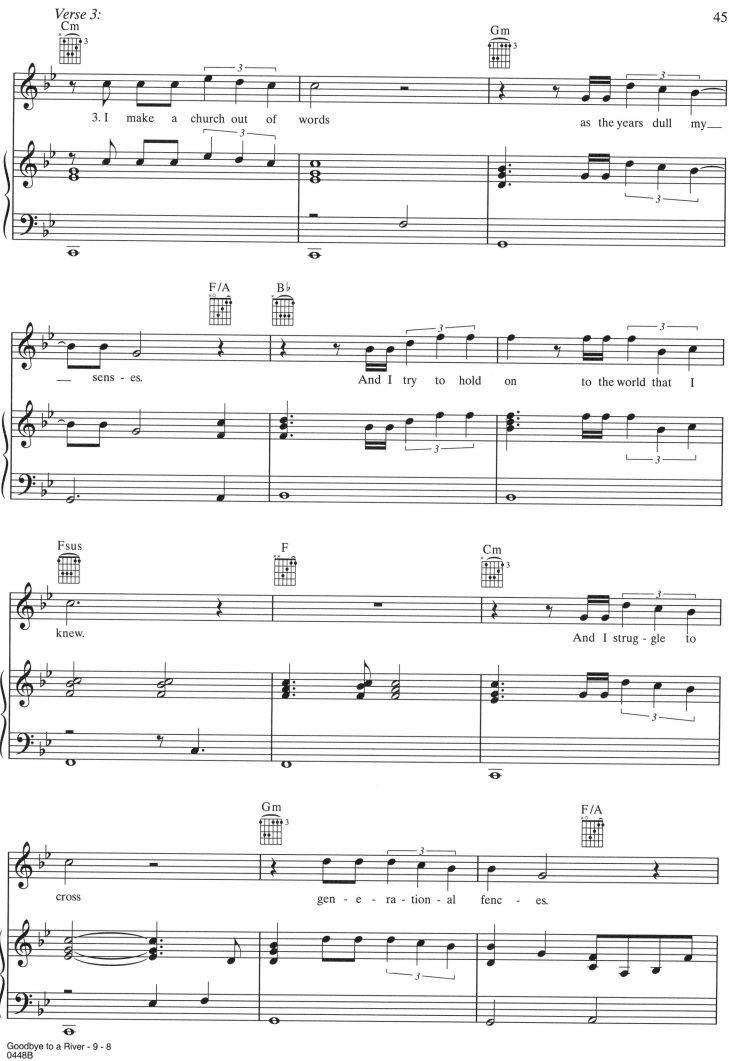

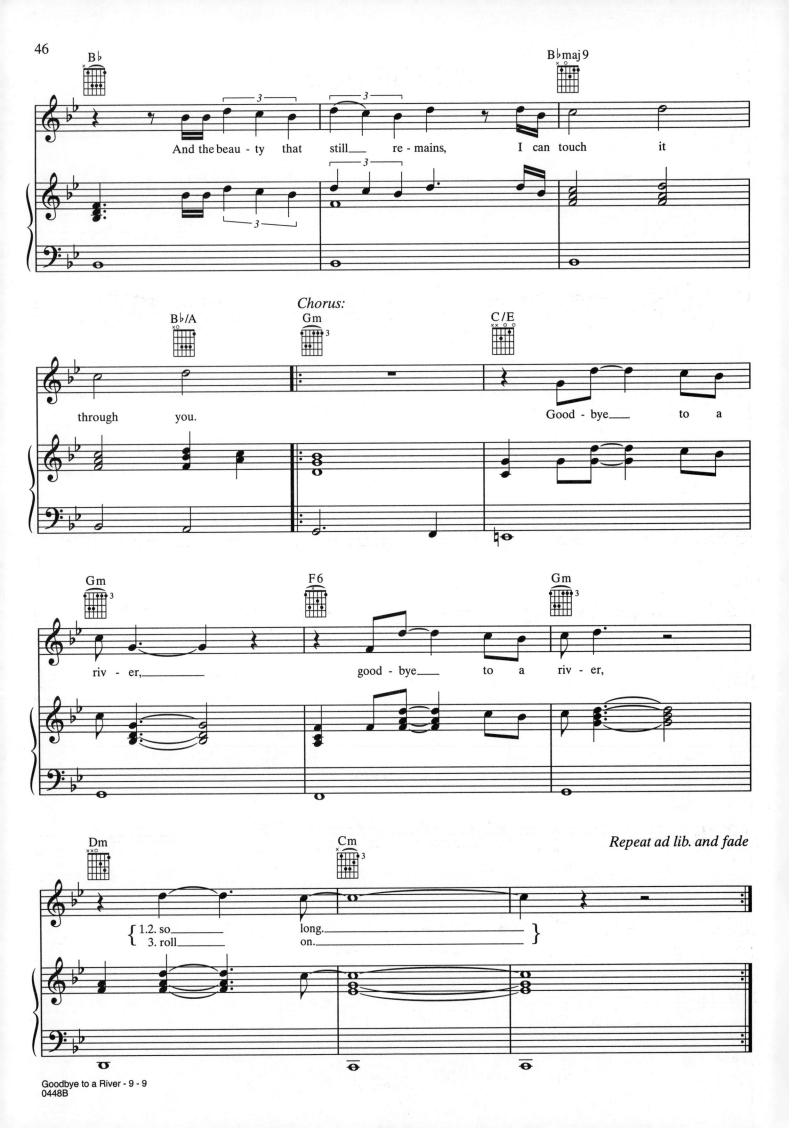

INSIDE JOB

Words and Music by
DON HENLEY and MIKE CAMPBELL

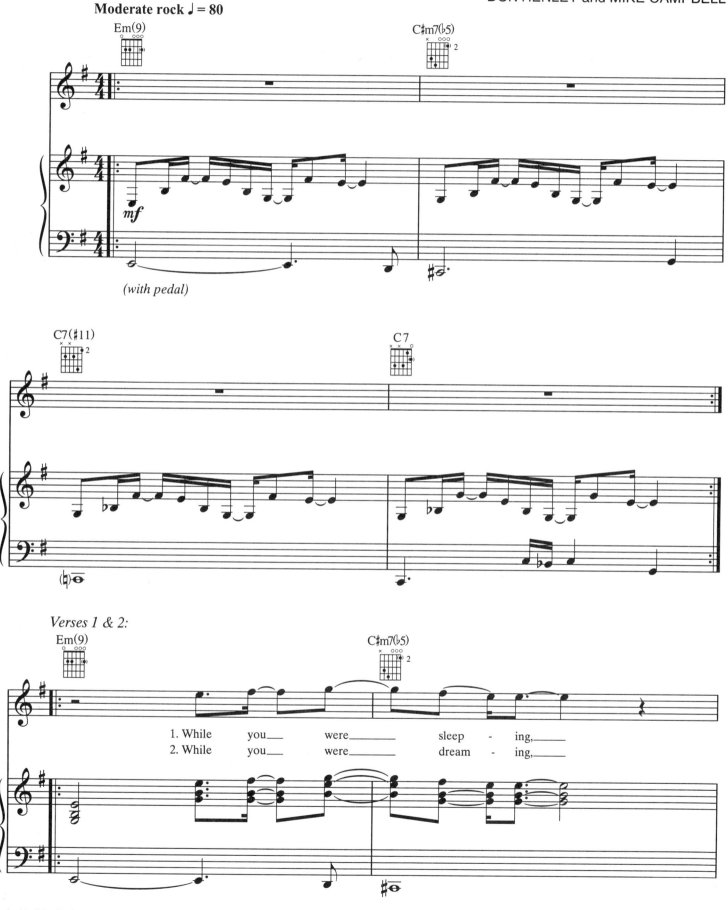

Verses 1 & 2:

1. While you___ were___ sleep - ing,___
2. While you___ were___ dream - ing,___

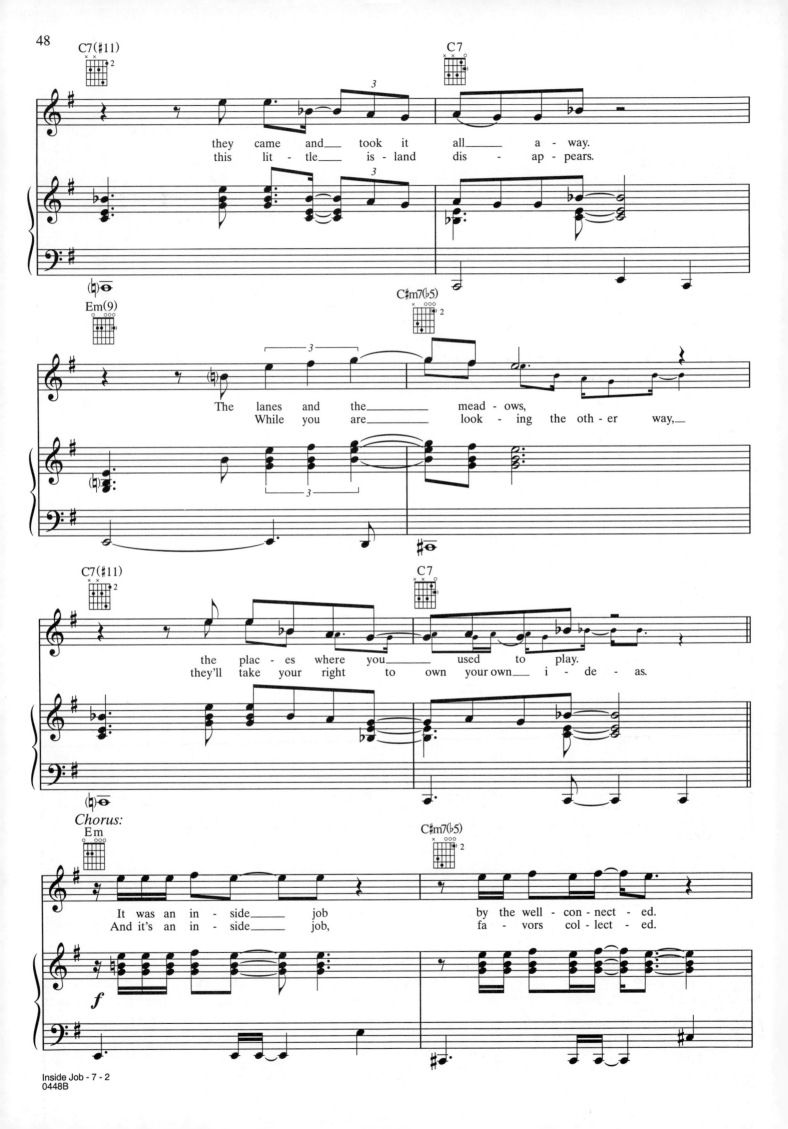

Inside Job - 7 - 2
0448B

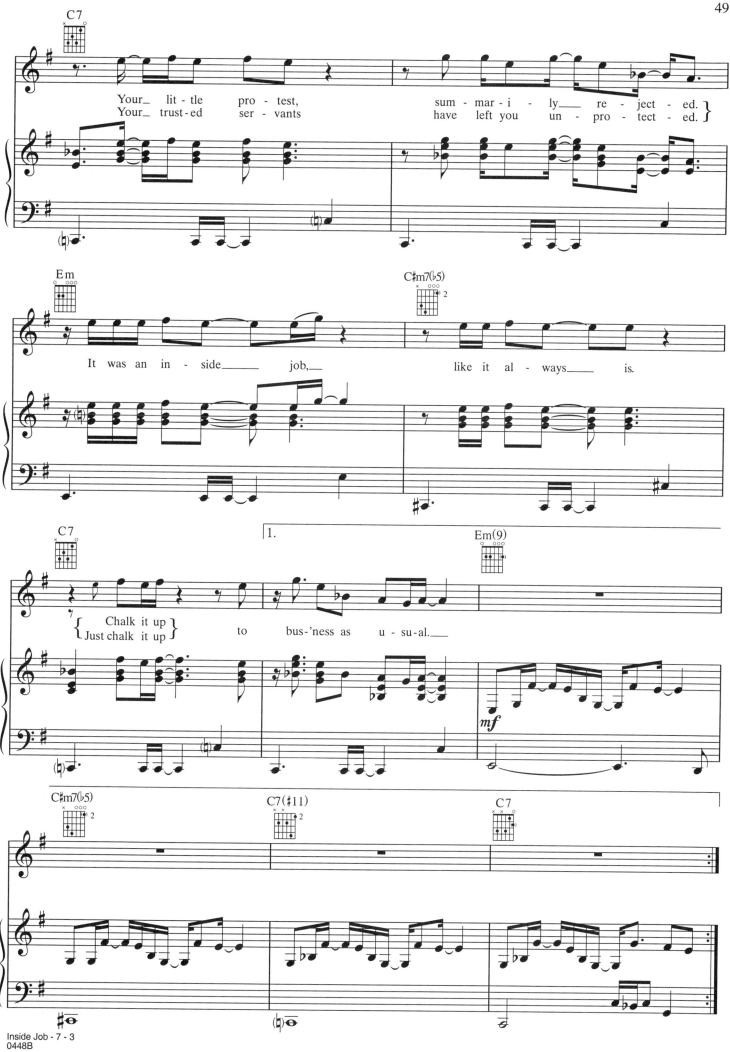

50

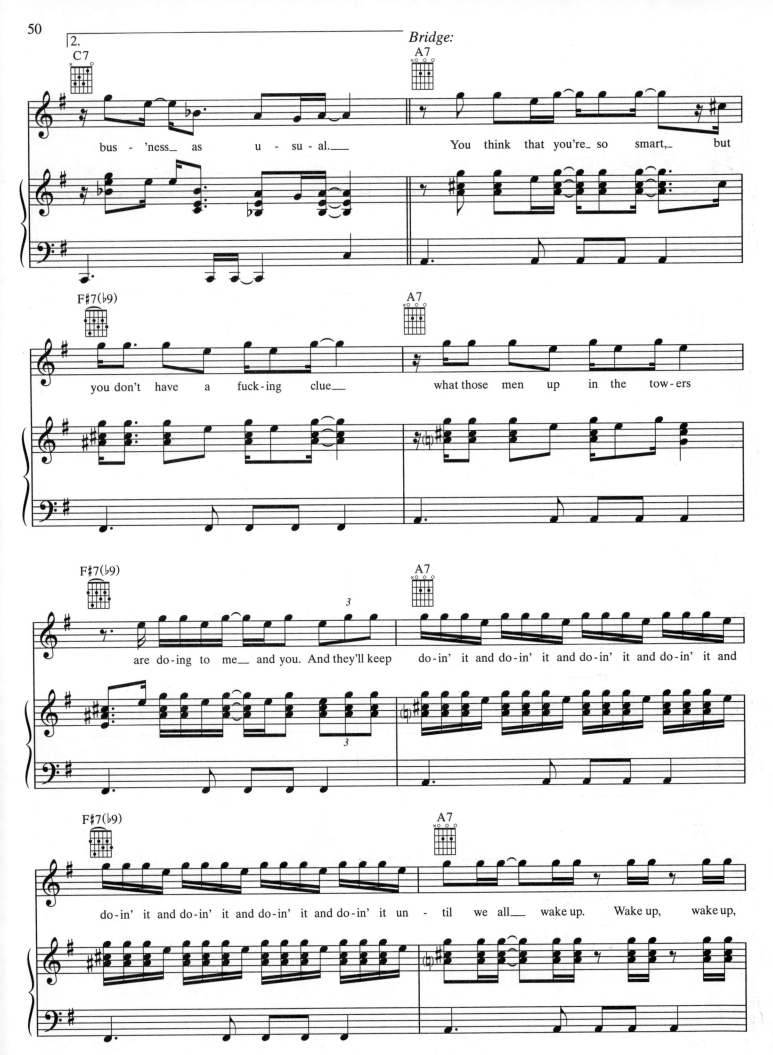

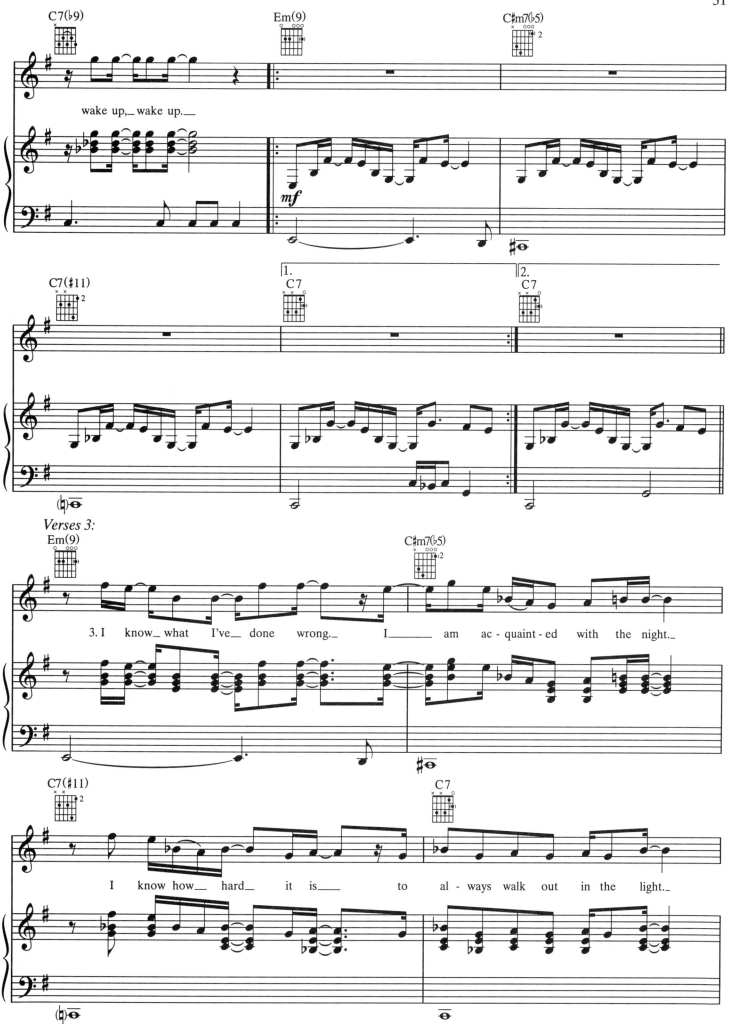

52

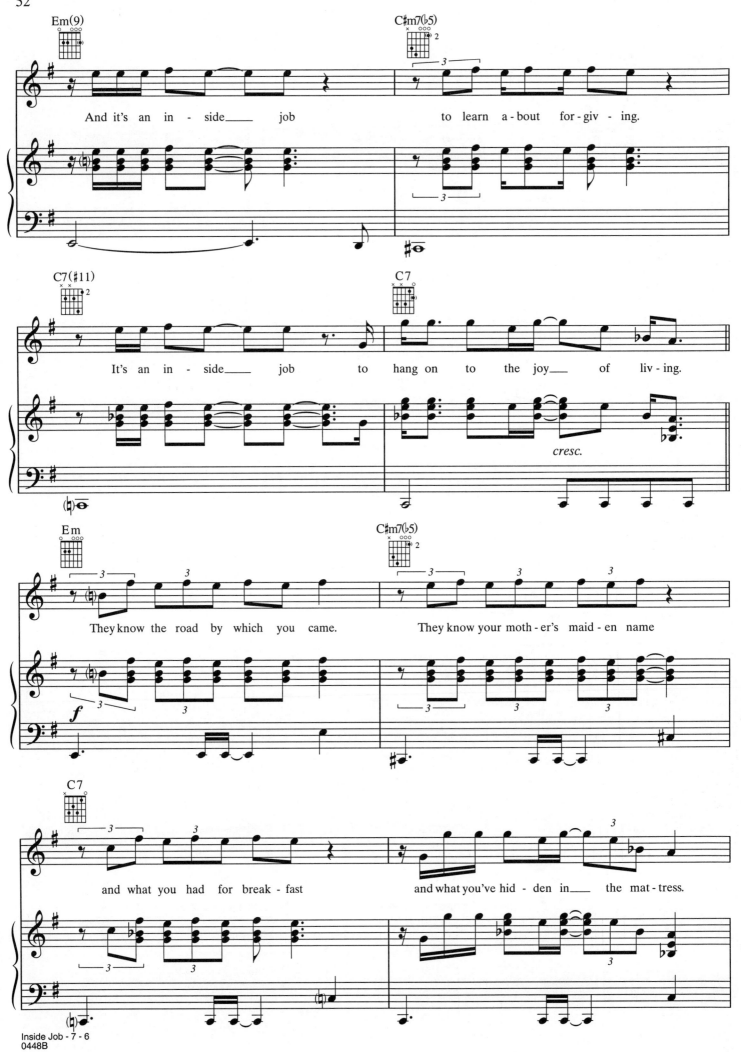

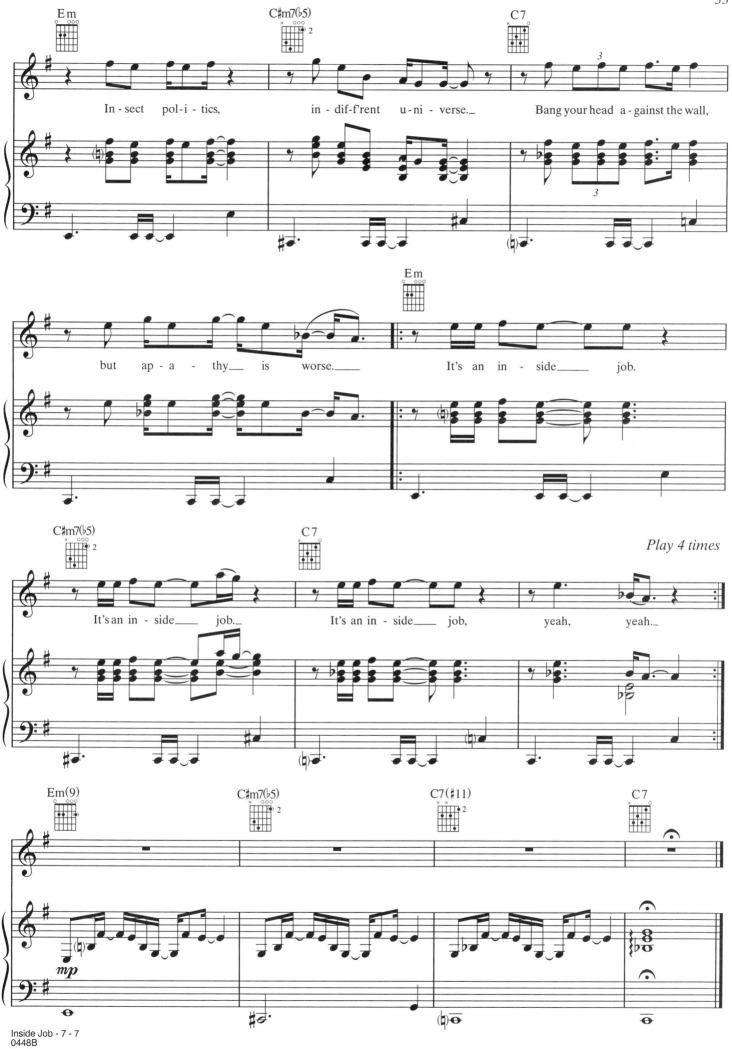

THEY'RE NOT HERE, THEY'RE NOT COMING

Words and Music by
DON HENLEY and STAN LYNCH

1.(Spoken:) From the

Arizona Desert to the Salisbury Plain, lights on the horizon,

They're Not Here, They're Not Coming - 9 - 1
0448B

56

F/C · C · F/C · C7sus · F/C · Gm

splat-tered down from heav-en.
just to get McNuggets?
Gov-ern-ment con-
Well, I don't think so,

spir-a-cy,
I don't think so, it's much too dangerous, it's much too strange.
cov-er-ups and lies,

hid-den in the des-ert,
Here in a world that won't give Oprah no
un-der end-less
home on the range.

skies.
Well, it's a cold, cold, cold, cold, cold, cold, cold, cold,

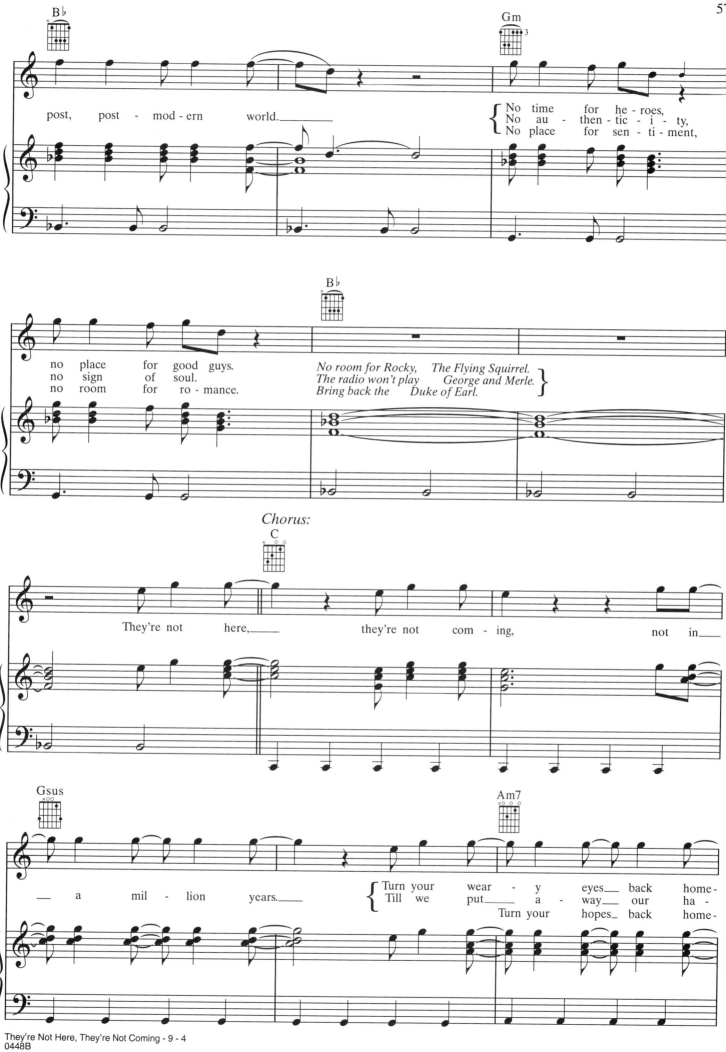

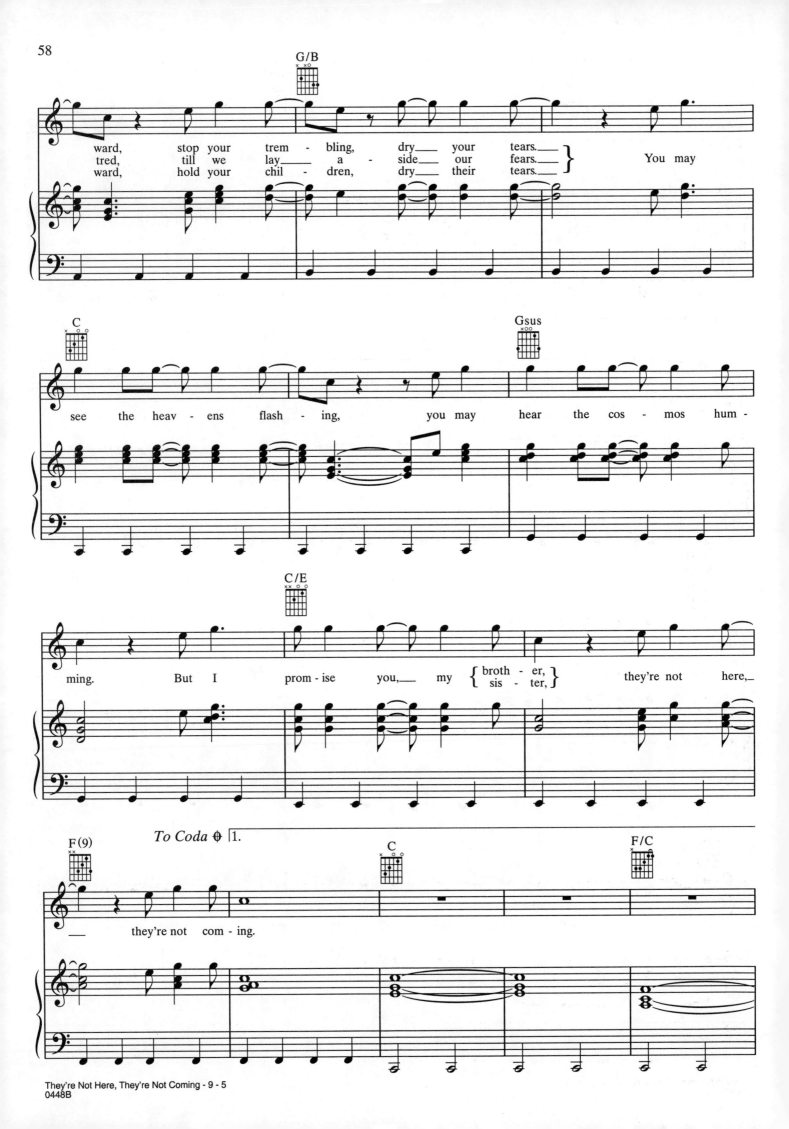

58

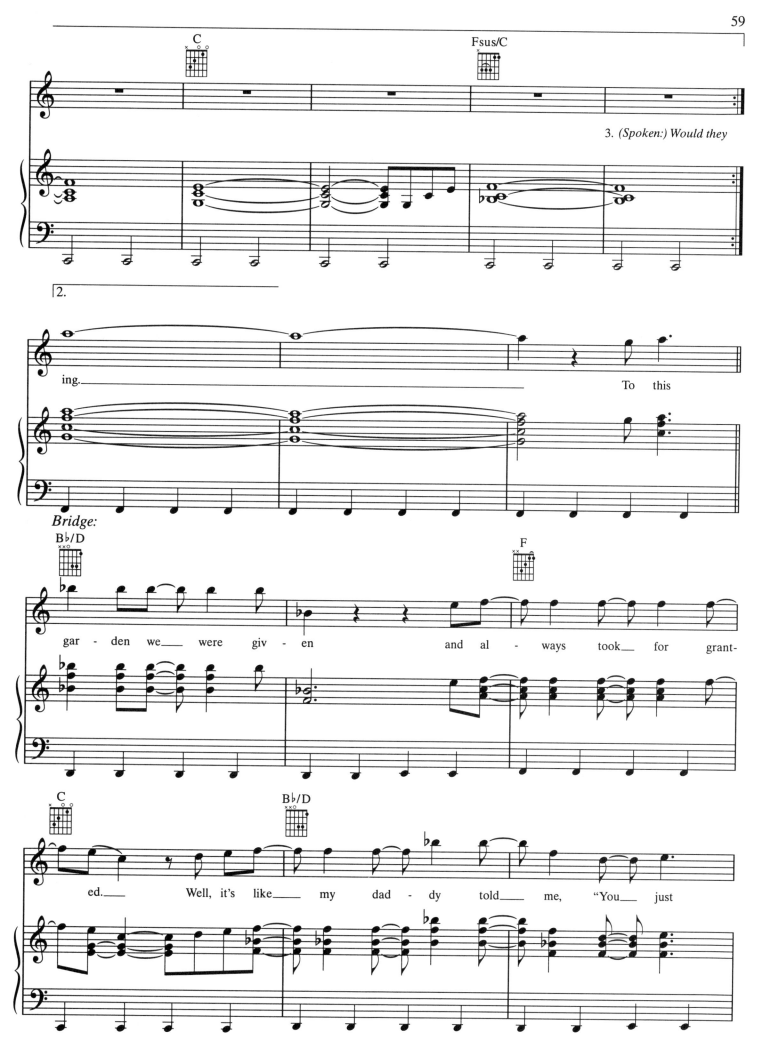

C

Fsus/C

3. (Spoken:) Would they

2.

ing._____ To this

Bridge:

B♭/D

F

gar - den we__ were giv - en and al - ways took__ for grant-

C

B♭/D

ed.__ Well, it's like__ my dad - dy told__ me, "You__ just

They're Not Here, They're Not Coming - 9 - 6
0448B

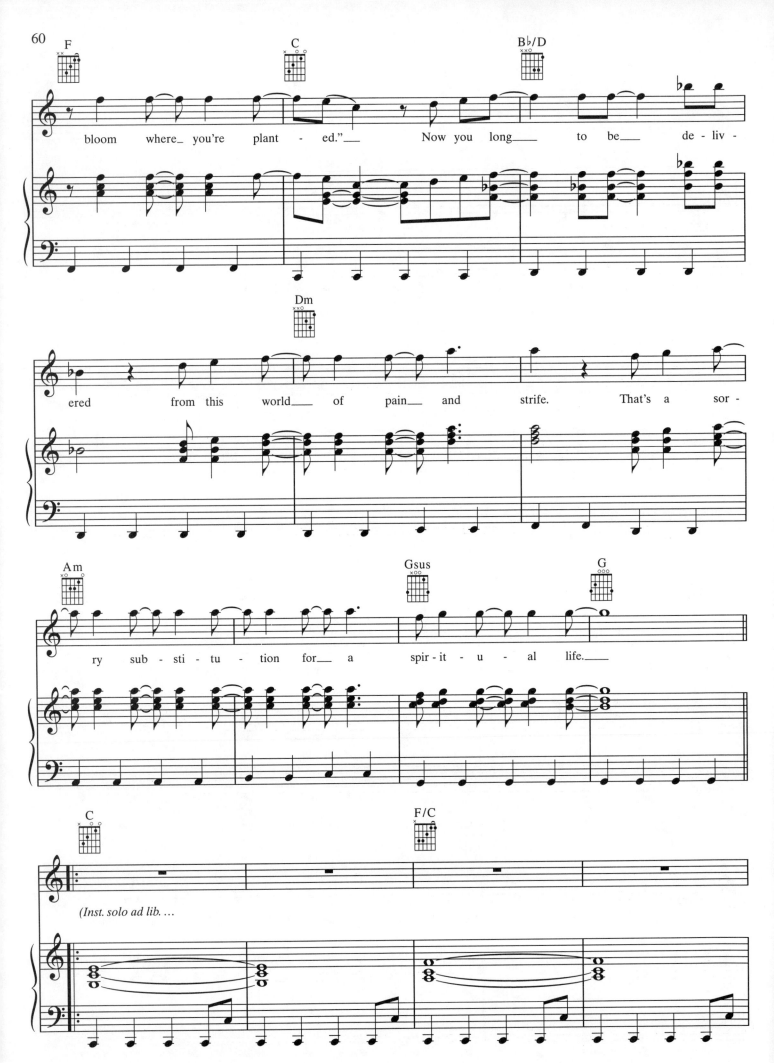

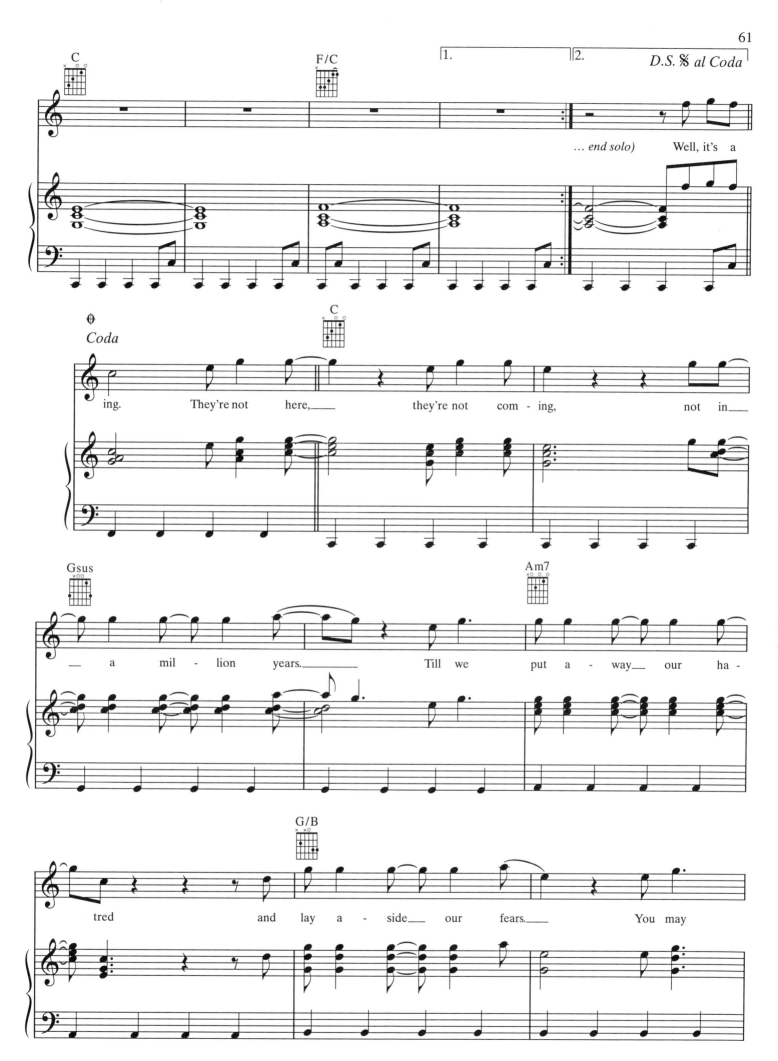

62

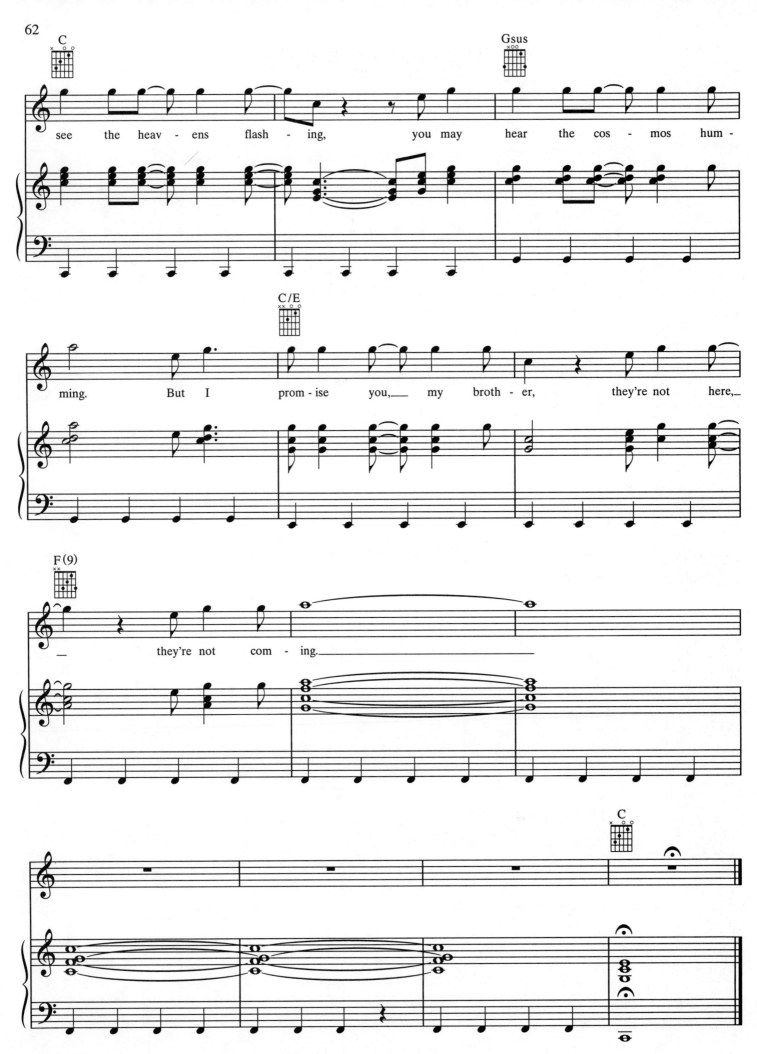

DAMN IT, ROSE

Words and Music by
DON HENLEY and STAN LYNCH

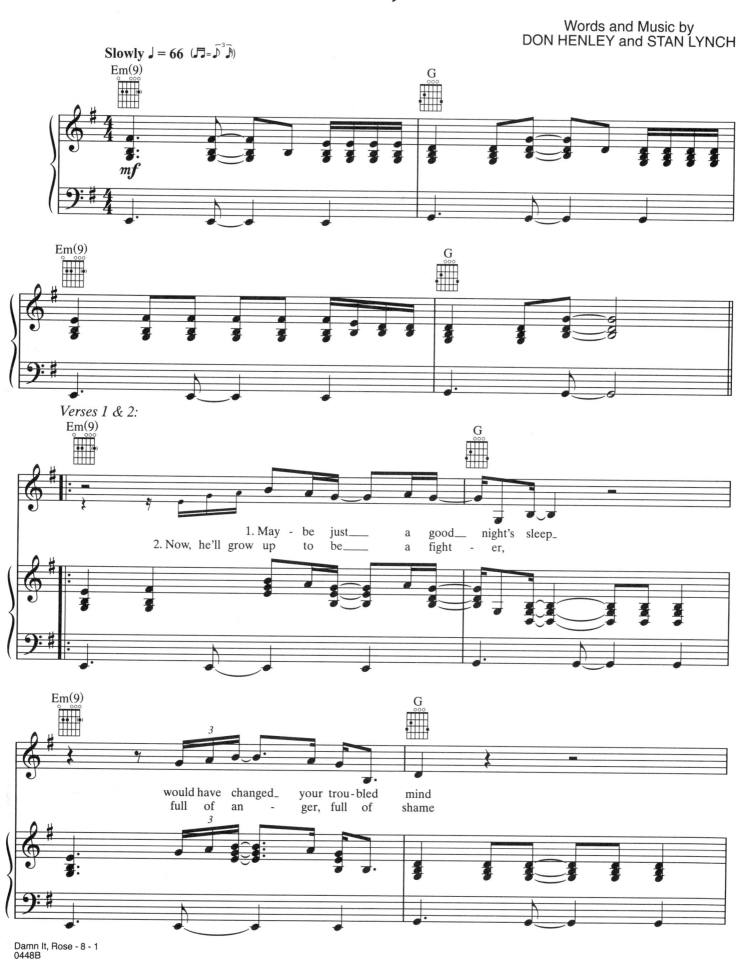

Verses 1 & 2:

1. May - be just____ a good____ night's sleep____
2. Now, he'll grow up to be____ a fight - er,

would have changed____ your trou-bled mind
full of an - ger, full of shame

Damn It, Rose - 8 - 1
0448B

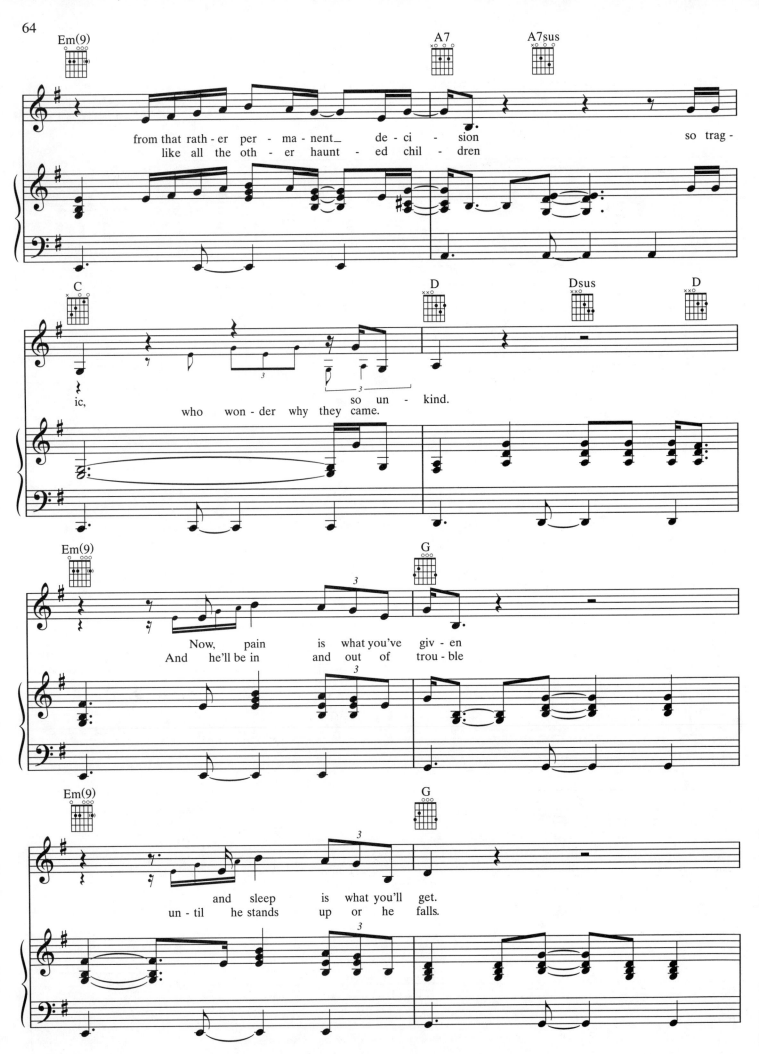

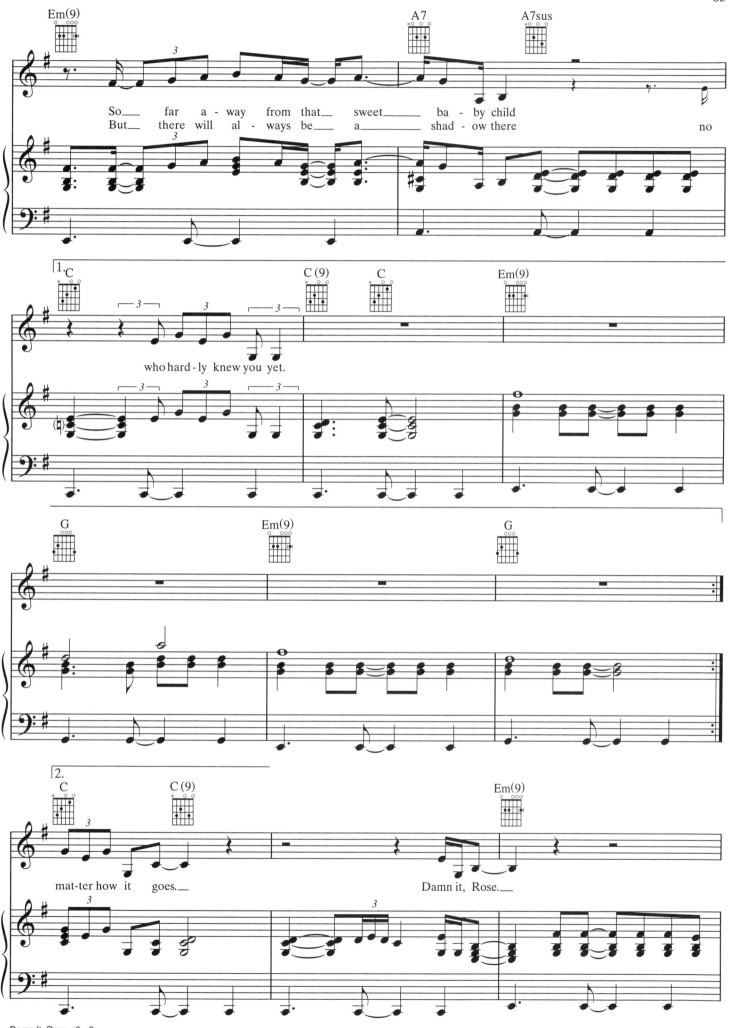

66

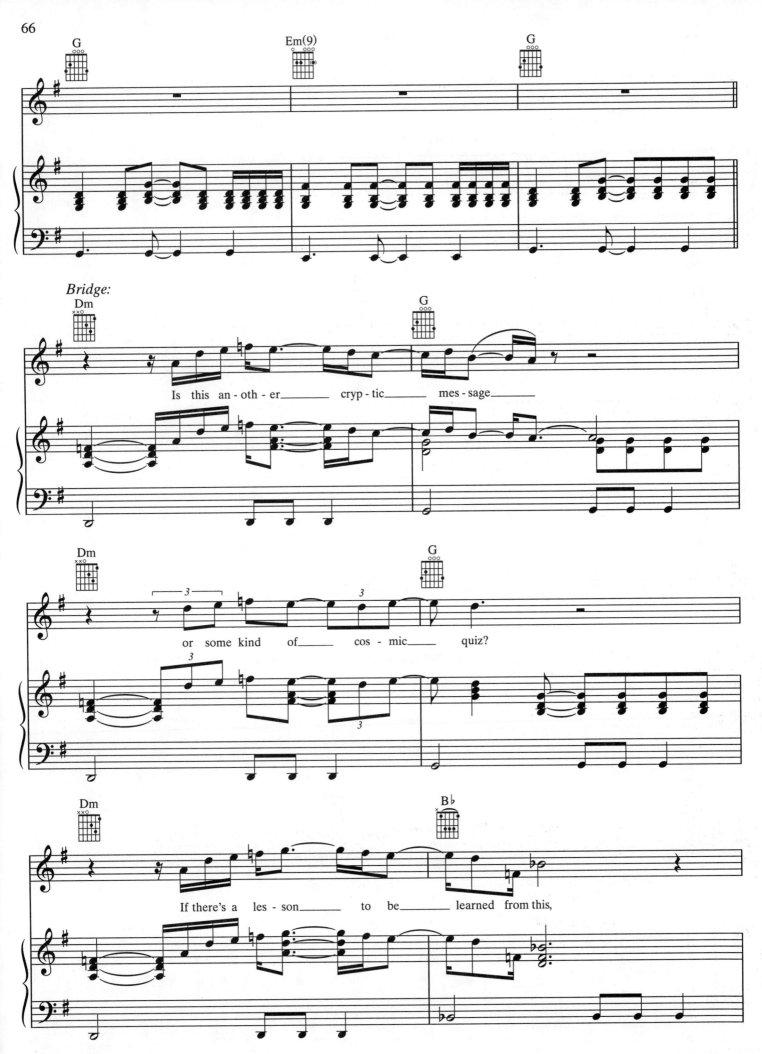

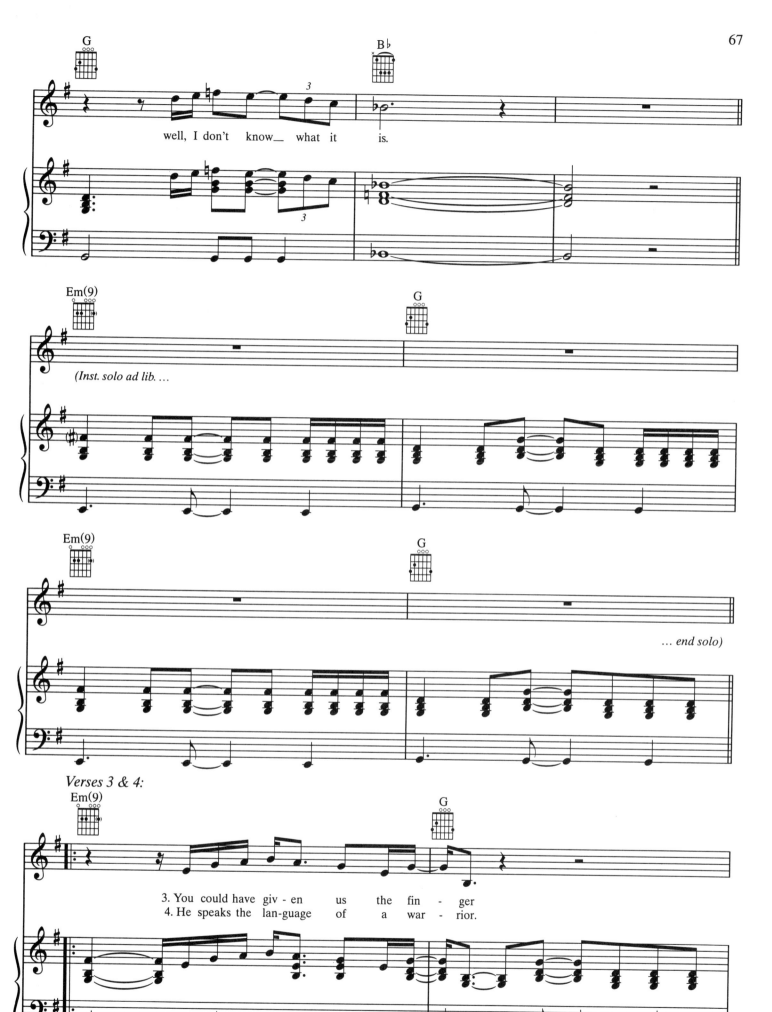

well, I don't know__ what it is.

(Inst. solo ad lib. ...

... end solo)

Verses 3 & 4:

3. You could have giv-en us the fin-ger
4. He speaks the lan-guage of a war-rior.

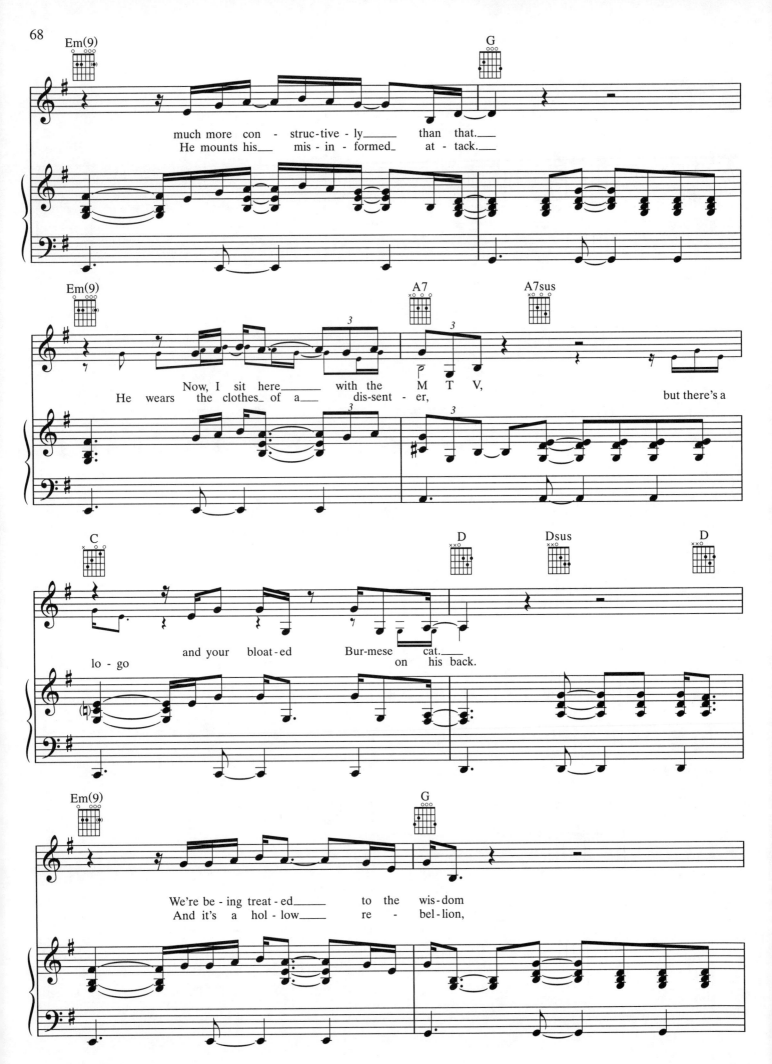

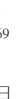

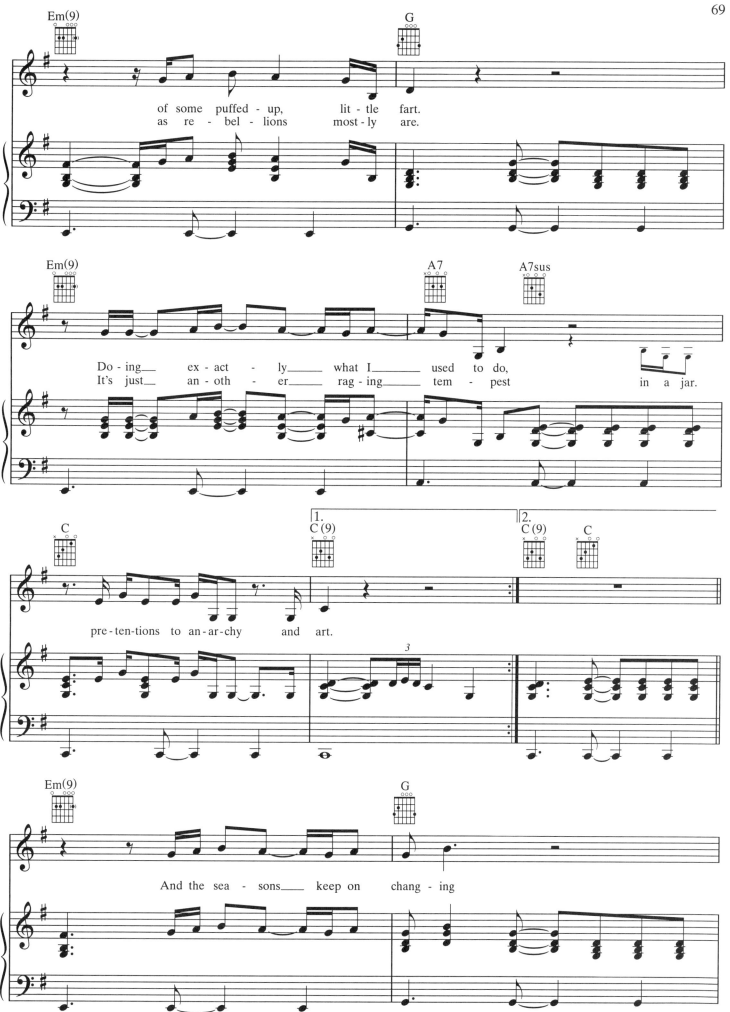

Damn It, Rose - 8 - 7
0448B

MISS GHOST

Words and Music by
DON HENLEY,
STAN LYNCH and JAI WINDING

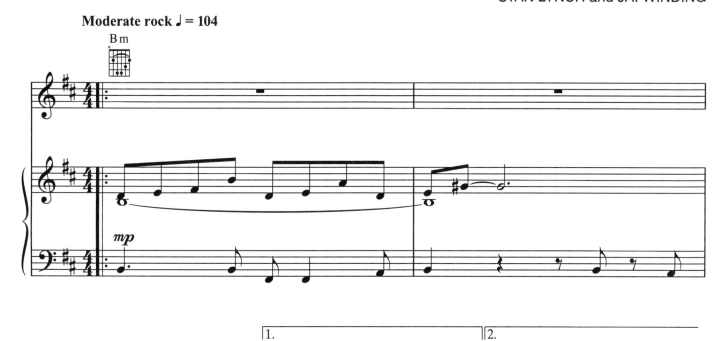

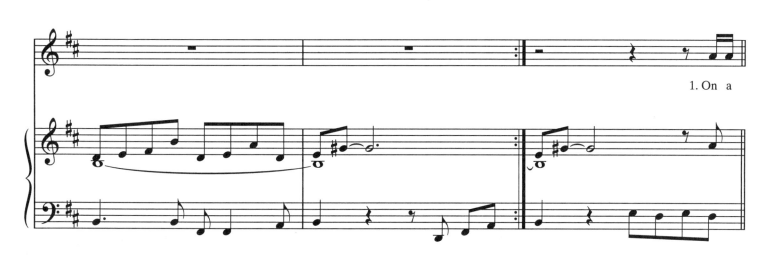

Verse 1:

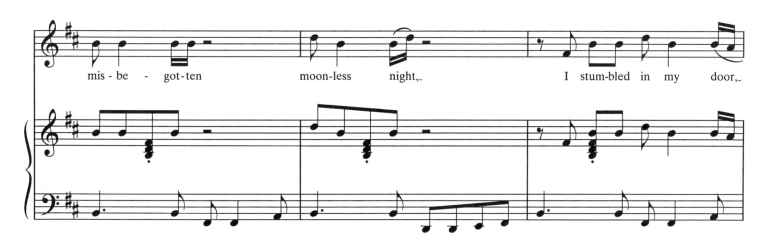

Miss Ghost - 8 - 1
0448B

72

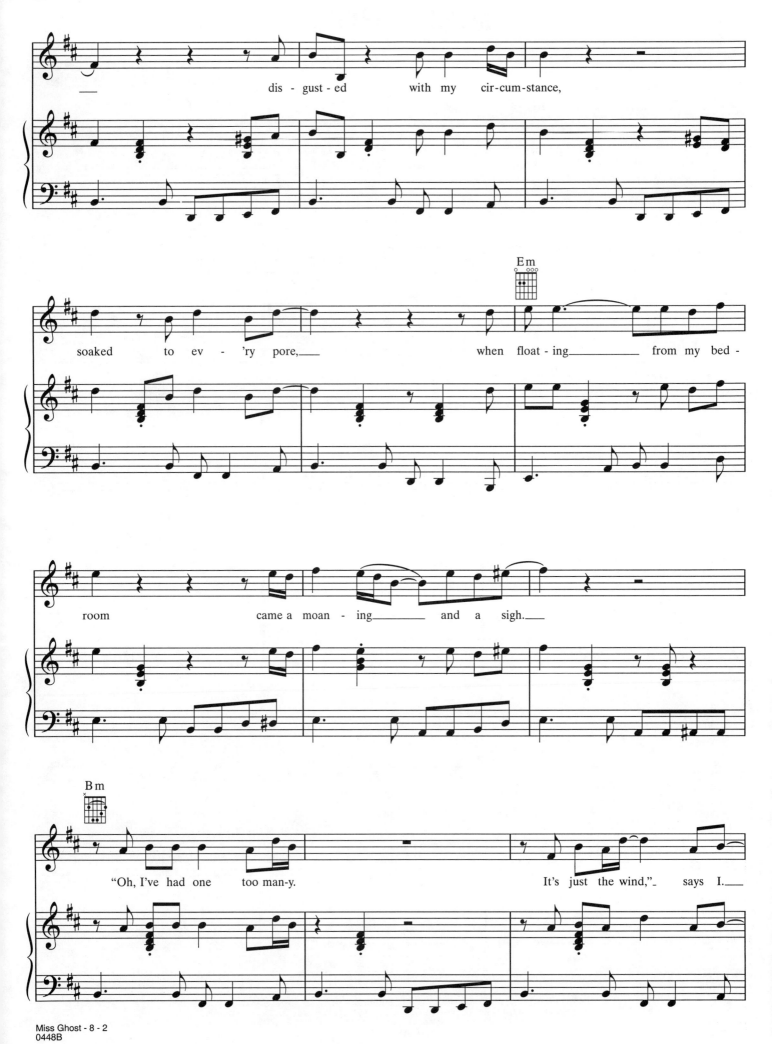

Miss Ghost - 8 - 2
0448B

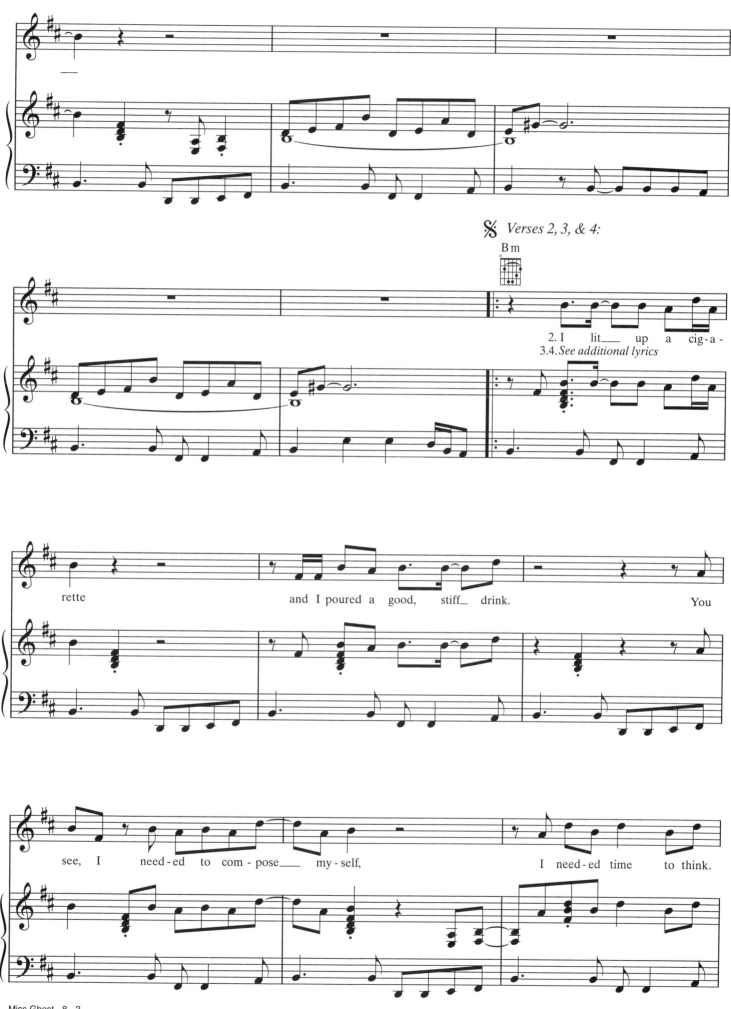

Verses 2, 3, & 4:

2. I lit___ up a cig-a-rette and I poured a good, stiff_ drink. You

3.4.*See additional lyrics*

see, I need-ed to com-pose___ my-self, I need-ed time to think.

74

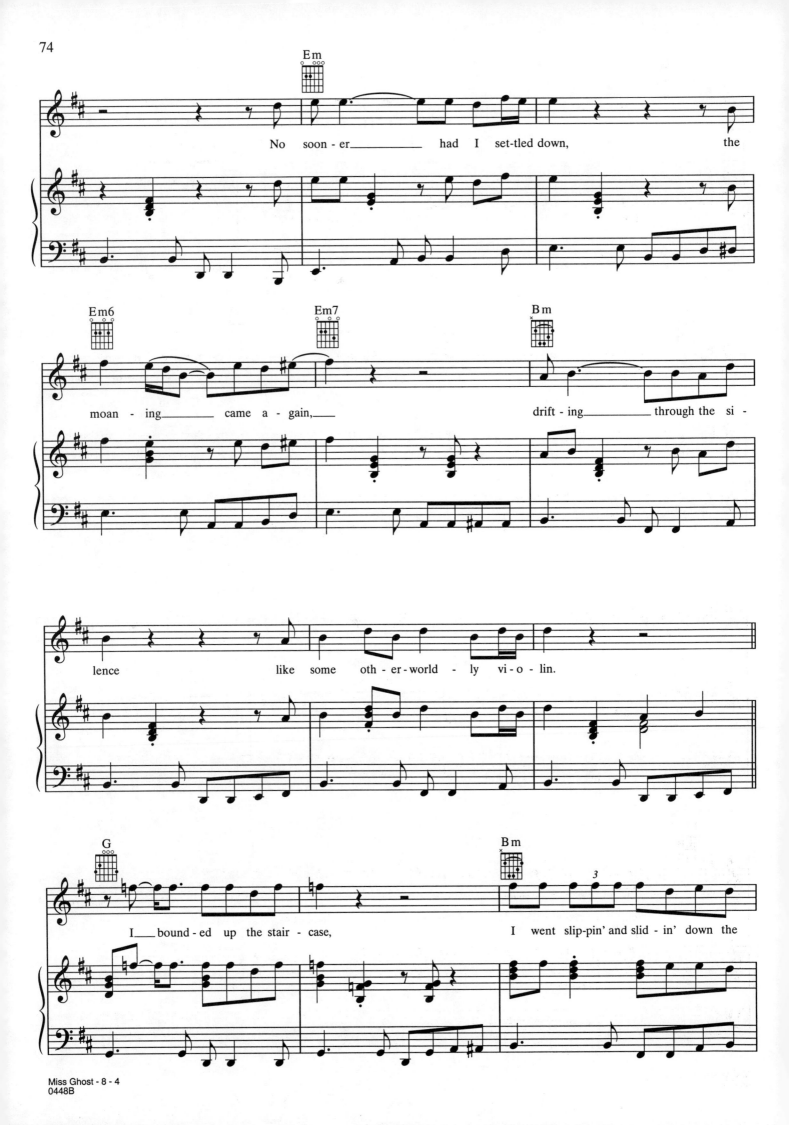

75

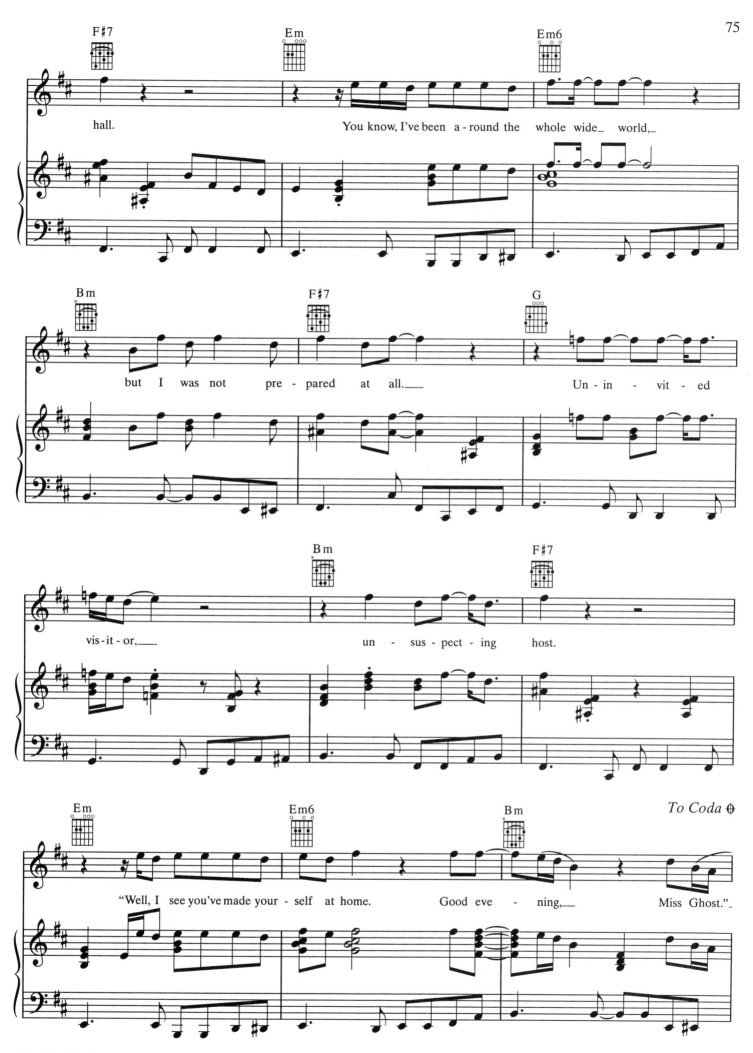

Miss Ghost - 8 - 5
0448B

Miss Ghost - 8 - 6
0448B

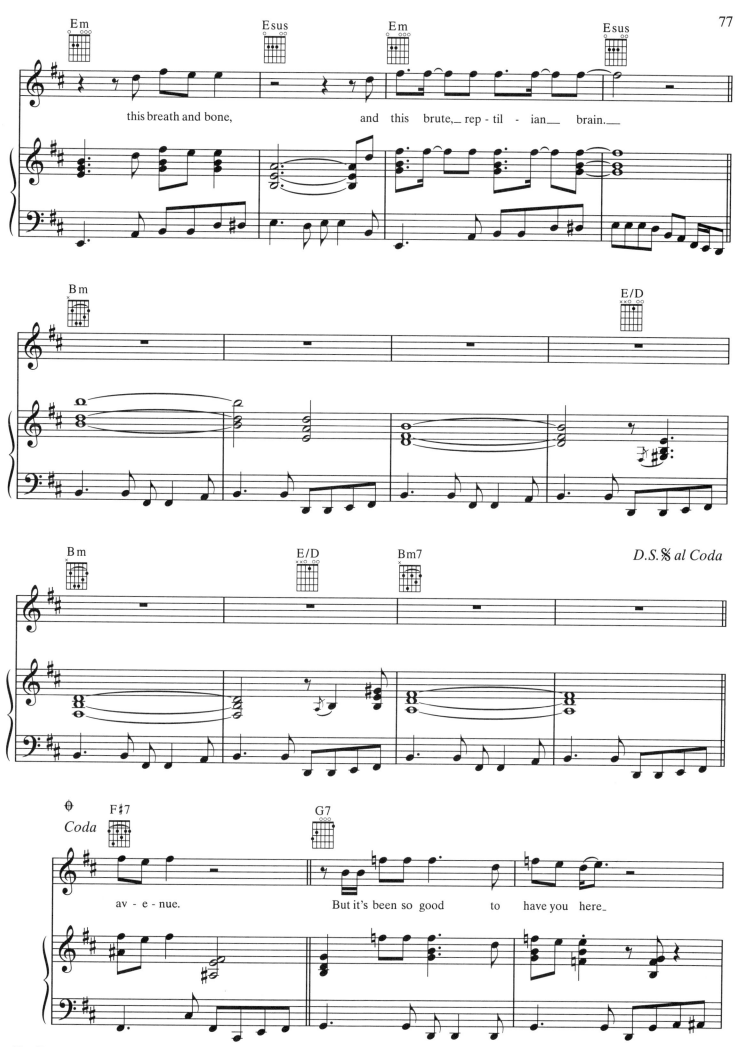

78

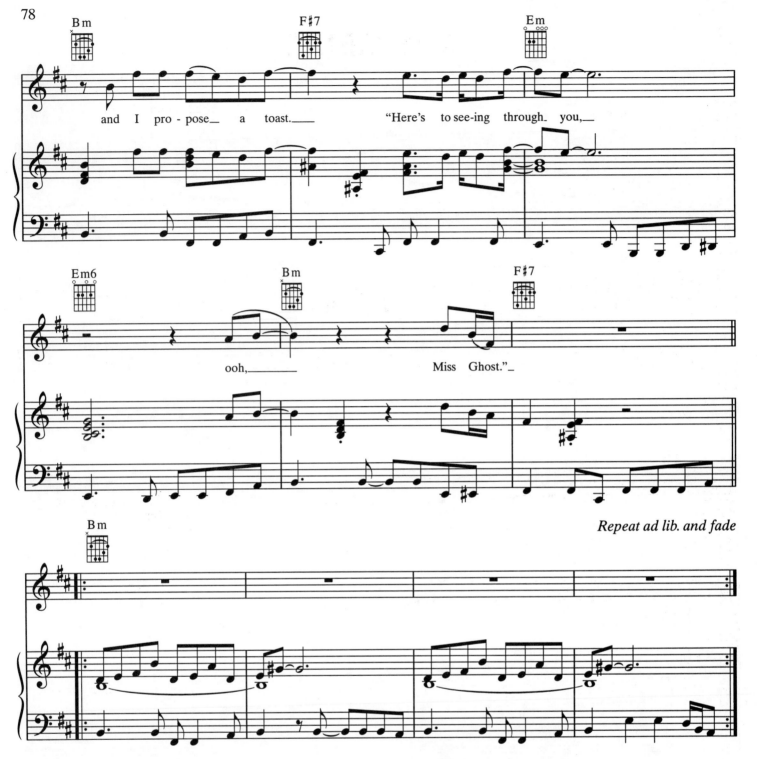

and I pro-pose_ a toast.___ "Here's to see-ing through_ you,___

ooh,_____ Miss Ghost."_

Repeat ad lib. and fade

Verse 3:
You're more beautiful than ever,
I feel just like a kid.
And I commence to trembling
When I think of all the things we did.
Skin as pale as marble, lips as red as blood.
Imagine my surprise, my dear,
I thought that you were gone for good.
You look so lovely lying there,
All stretched out on your back.
But I'm the one who's strung up here
On old temptation's rusty rack.
And in the wee, small hours
Is when I miss you the most.
And I confess it, I have missed you,
Miss Ghost.
(To Bridge:)

Verse 4:
What dirty tricks the mind can play
In the lonely dead of night,
When you bump into the shadow
Of a faded love that wasn't right.
Way down beneath the surface,
Far beyond the light of day,
So many things lie buried deep.
And, baby, they should stay that way.
Oh, my wicked little habit.
We've really made a mess.
Everything's been trivialized
In our vain pursuit of happiness.
And even though you've come for me,
I won't go back with you
To some temporary heaven
Down some empty, dead-end avenue.
(To Coda)

Miss Ghost - 8 - 8
0448B

THE GENIE

Words and Music by
DON HENLEY,
STAN LYNCH and STUART BRAWLEY

Moderate rock ♩ = 108

1. Is this what__ you want-ed?
2. That smol-der-ing tin-gle
3. And when the world be-comes__ too lit-tle or__ too much,

Did you e-ven think__
un-der your__
the shad-ow mind con-

twice?
skin,
trives

Did-n't they tell you__ that an-y-thing__ that feels this_
that sweet__ de-li-cious but__ not so
the tri-umph and the trag-e-dy__

The Genie - 7 - 1
0448B

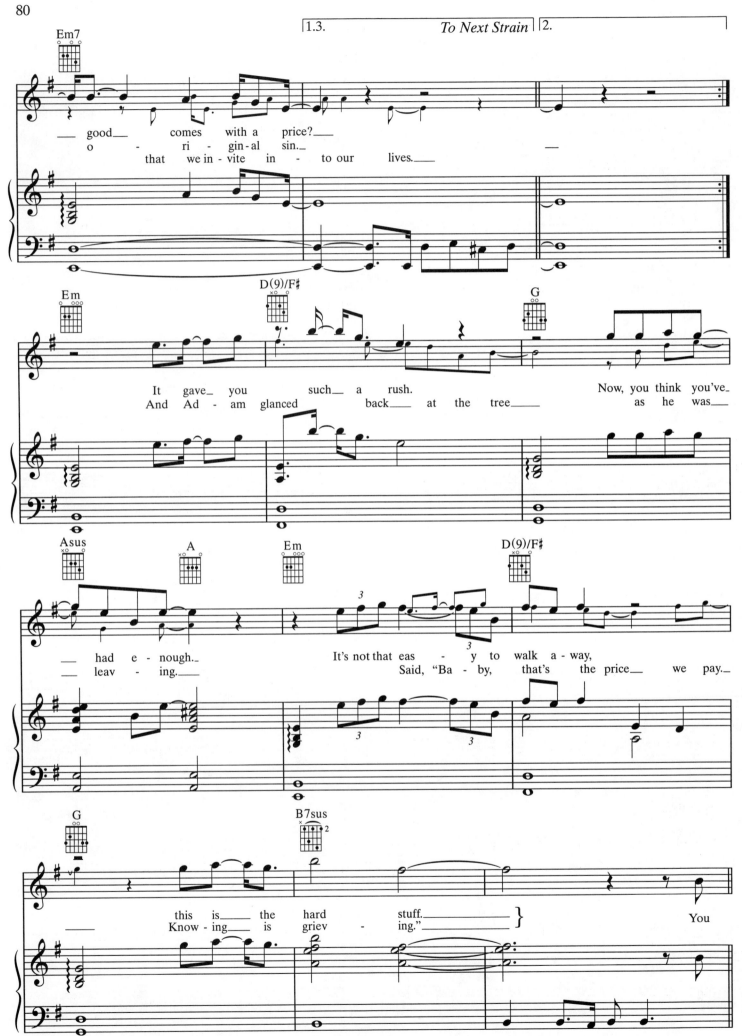

Chorus:

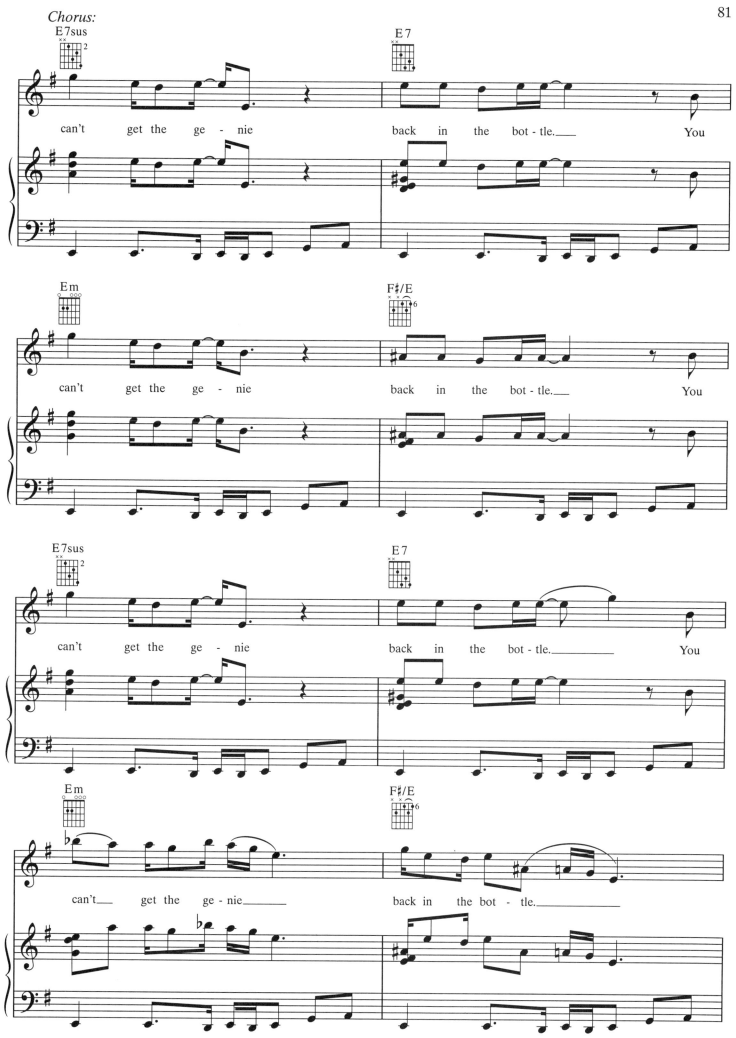

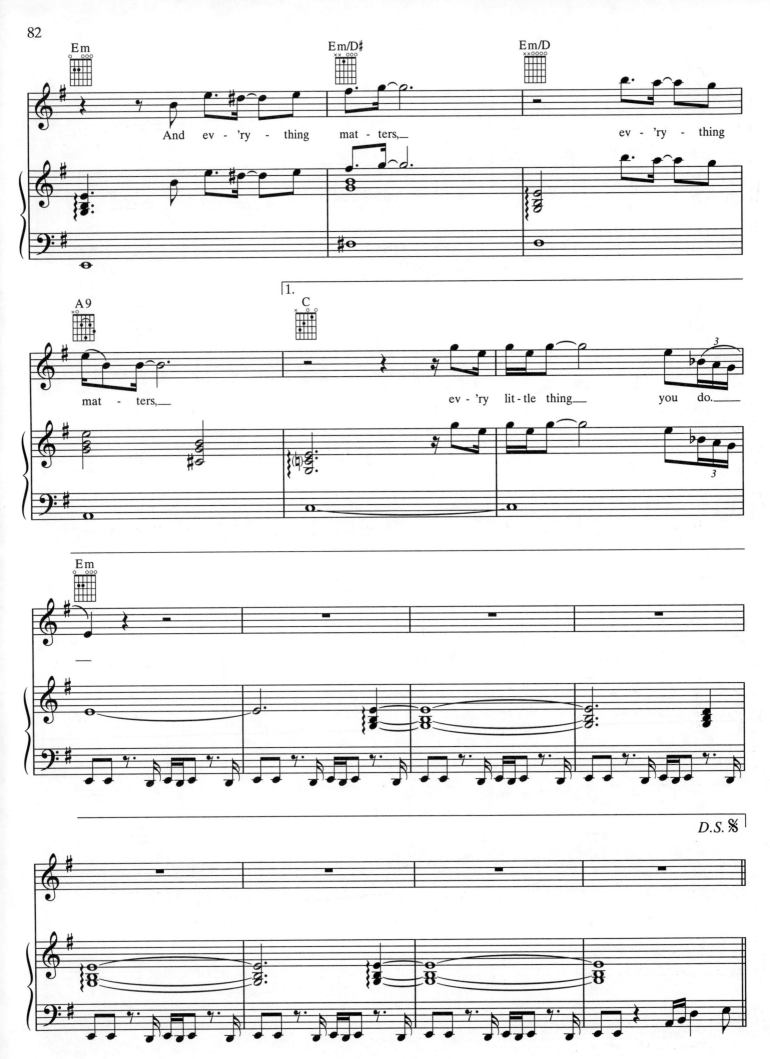

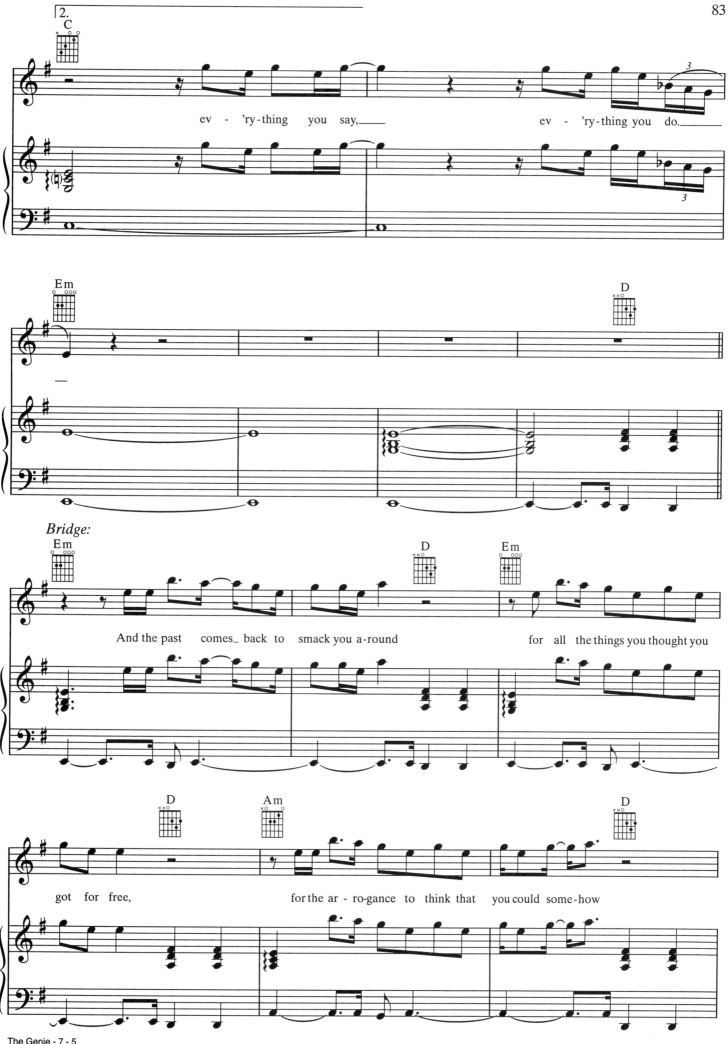

Chorus:

ANNABEL

Words and Music by
DON HENLEY and JOHN COREY

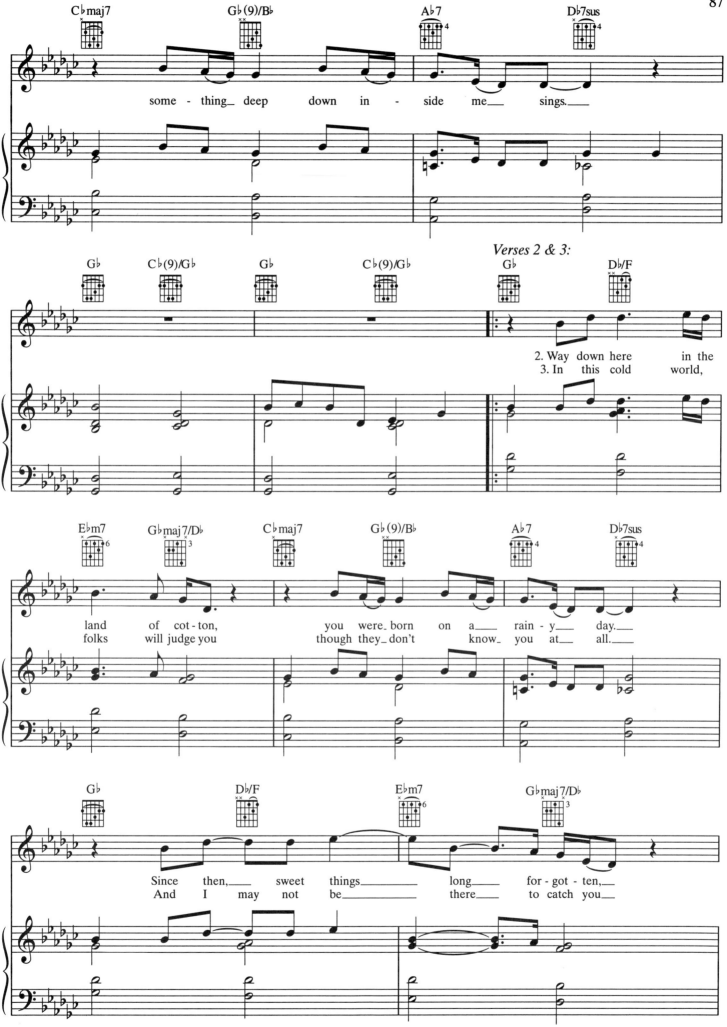

Verses 2 & 3:

some - thing_ deep down in - side me__ sings.__

2. Way down here in the
3. In this cold world,

land of cot - ton, you were_ born on a__ rain - y__ day.__
folks will judge you though they_ don't know_ you at__ all.__

Since then,__ sweet things_____ long__ for - got - ten,__
And I may not be_____ there__ to catch you__

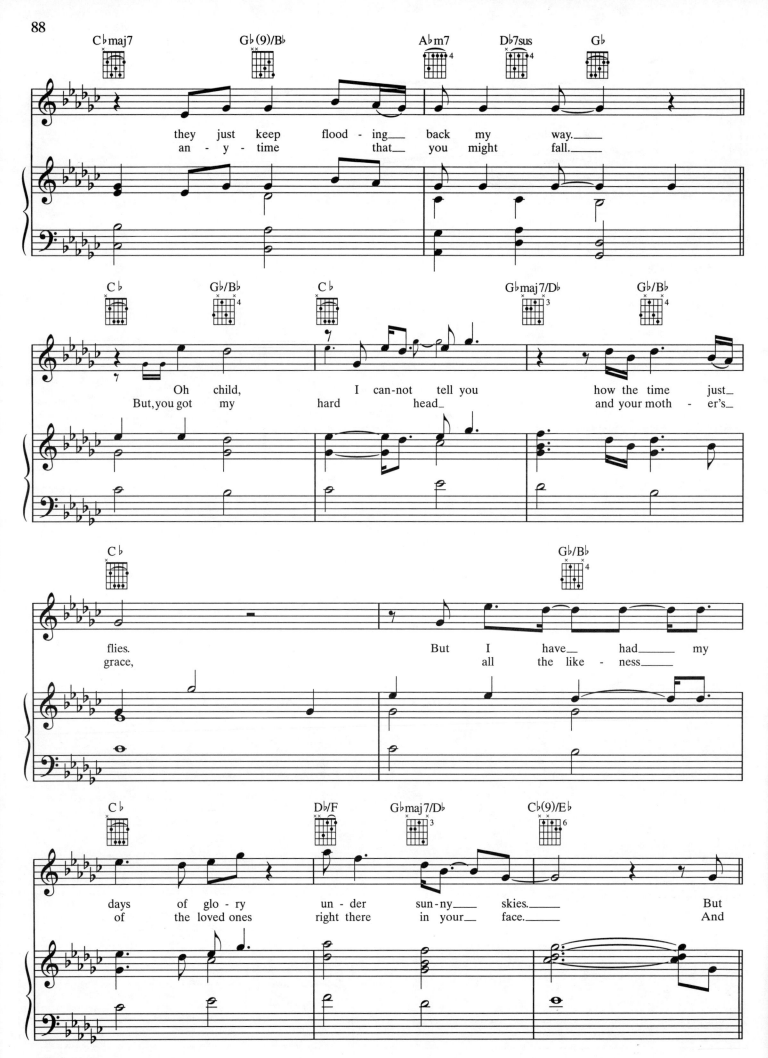

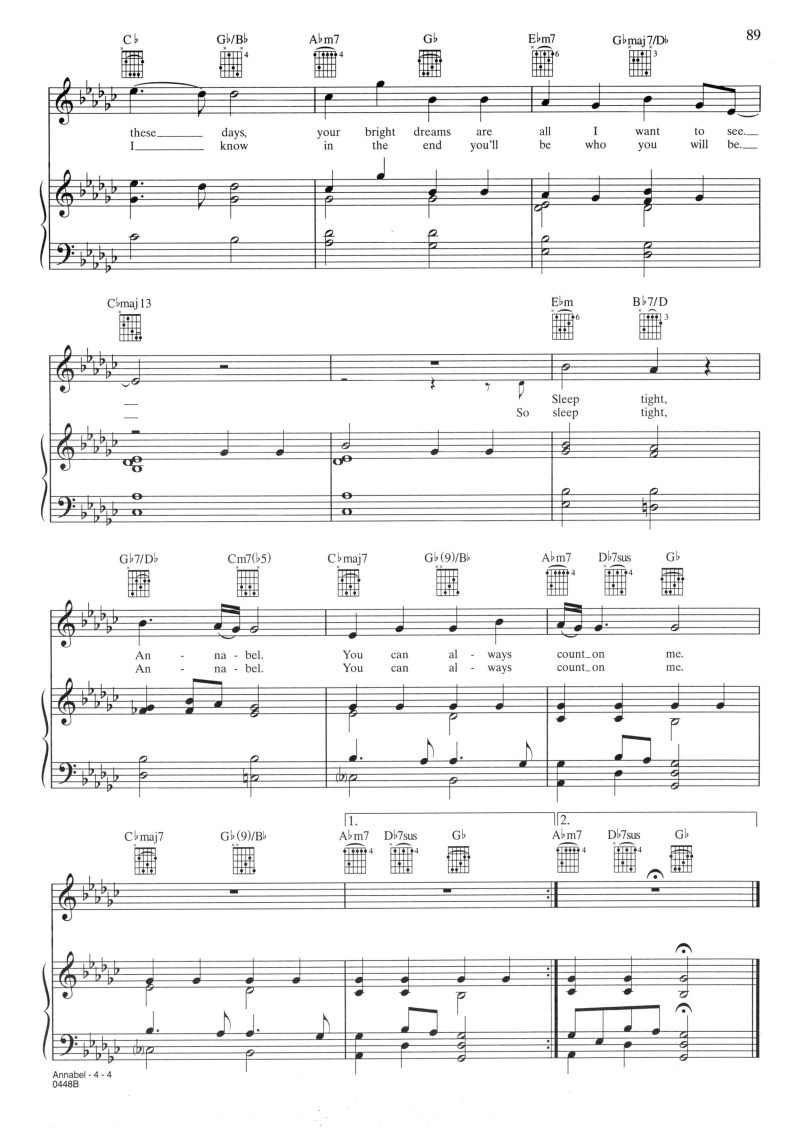

MY THANKSGIVING

Words and Music by
DON HENLEY,
STAN LYNCH and JAI WINDING

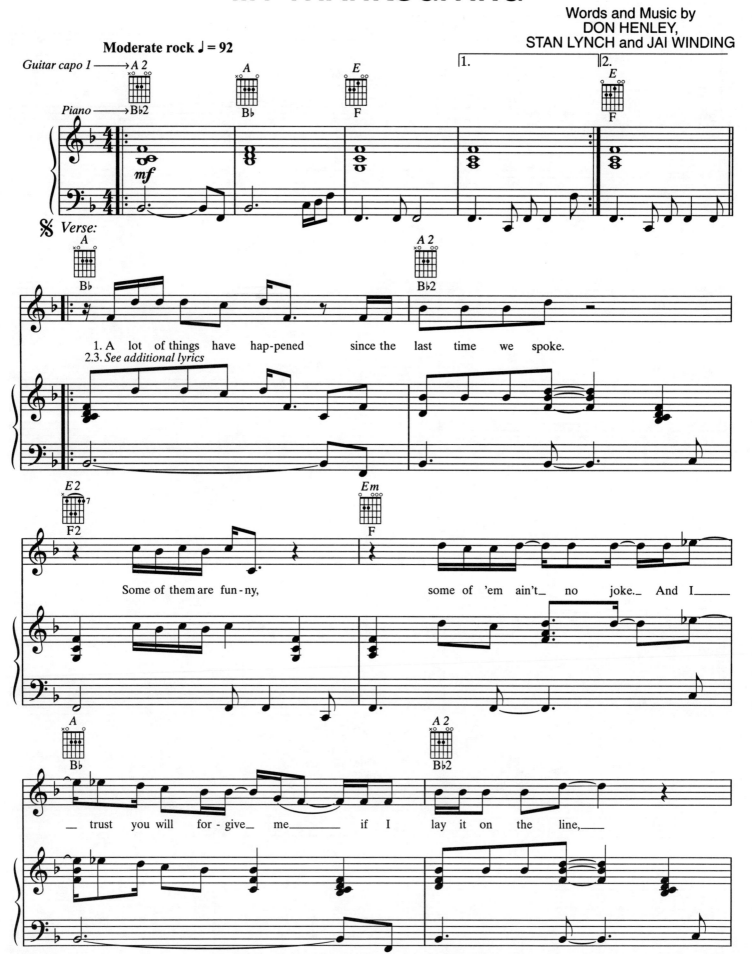

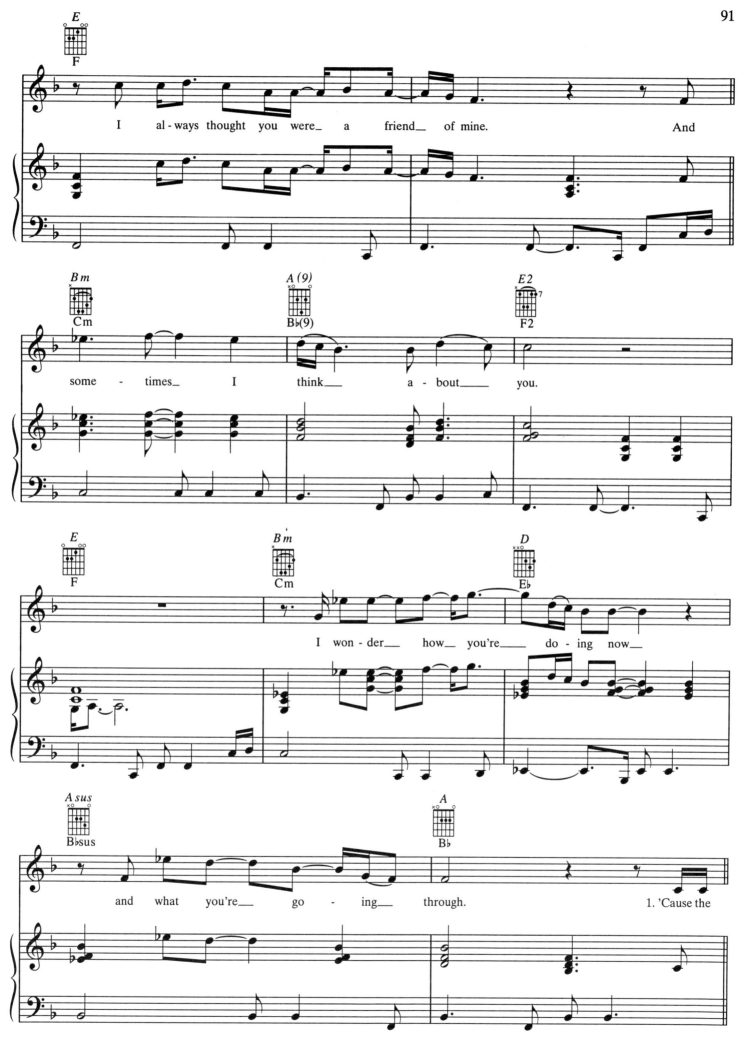

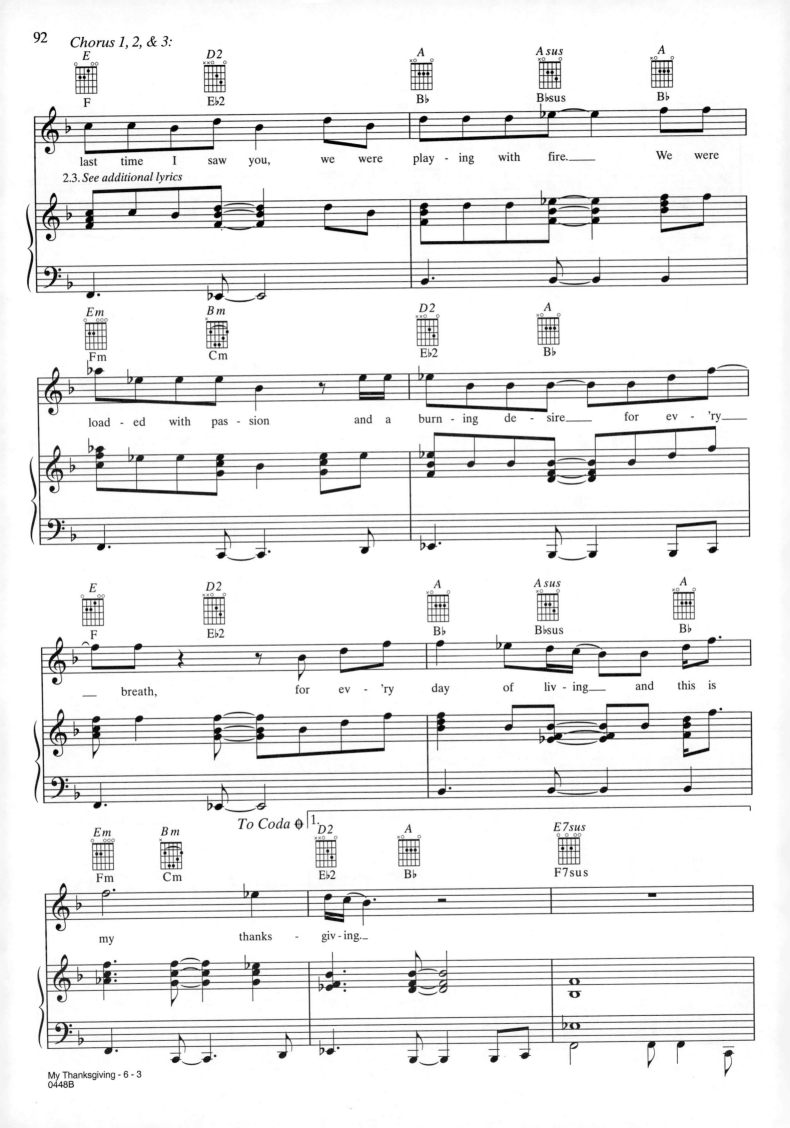

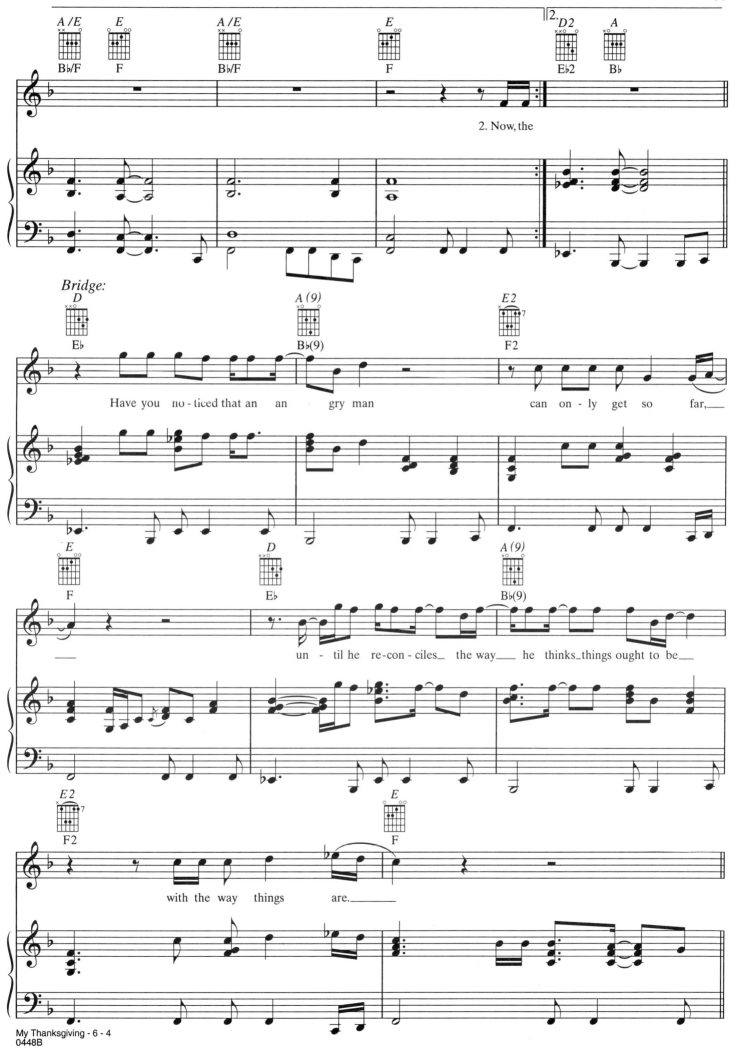

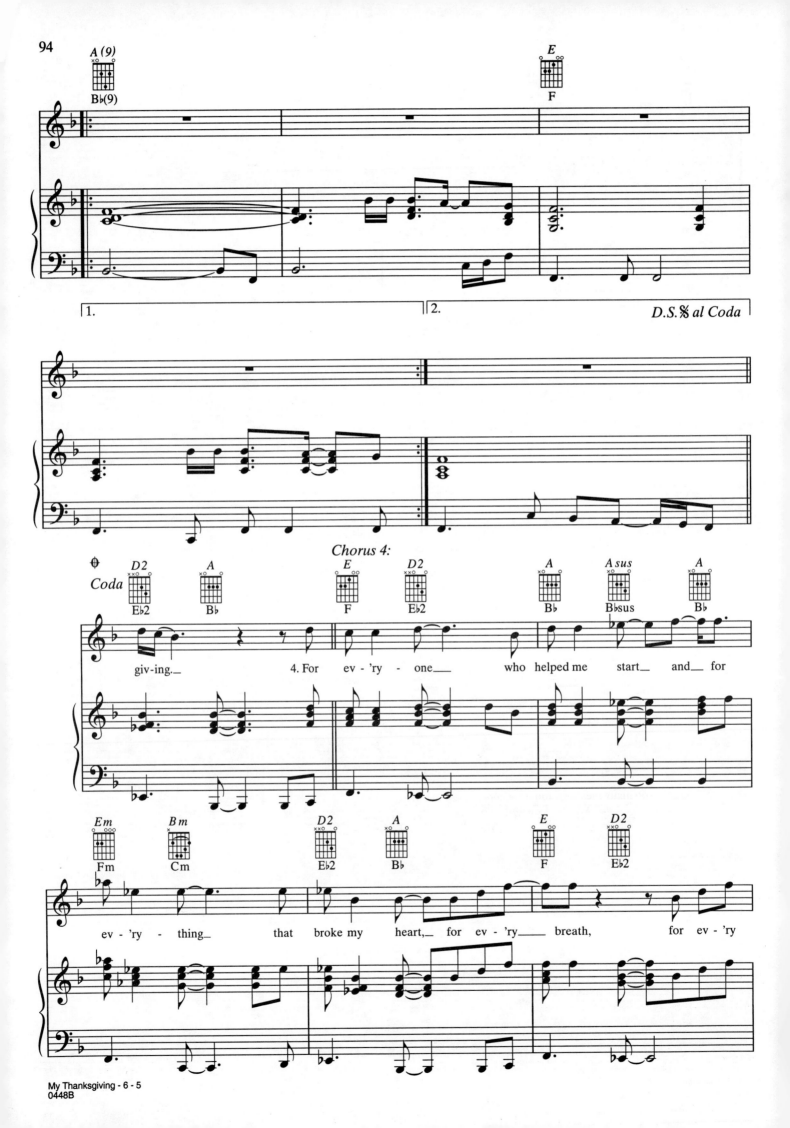

94

D.S. ℅ al Coda

Chorus 4:

Coda

giv-ing.___ 4. For ev - 'ry - one___ who helped me start___ and___ for

ev - 'ry - thing___ that broke my heart,___ for ev - 'ry___ breath, for ev - 'ry

Verse 2:
Now, the trouble with you and me, my friend,
Is the trouble with this nation.
Too many blessings, too little appreciation.
And I know that kind of notion –
Well, it just ain't cool.
So, send me back to Sunday school
Because I'm tired of waiting for reason to arrive.
It's too long we've been living these unexamined lives.
(To Chorus 2:)

Chorus 2:
I've got great expectations,
I've got family and friends.
I've got satisfying work,
I've got a back that bends.
For every breath, for every day of living,
This is my thanksgiving.
(To Bridge:)

Verse 3:
Here in this fragmented world,
I still believe in learning how to give love,
And how to receive it.
And I would not be among those who abuse this privilege.
Sometimes, you get the best light from a burning bridge.
And I don't mind saying that I still love it all.
I wallowed in the springtime,
Now, I'm welcoming the fall.
(To Chorus 3:)

Chorus 3:
For every moment of joy,
Every hour of fear,
For every winding road
That brought me here,
For every breath, for every day of living,
This is my thanksgiving.
(To Chorus 4:)